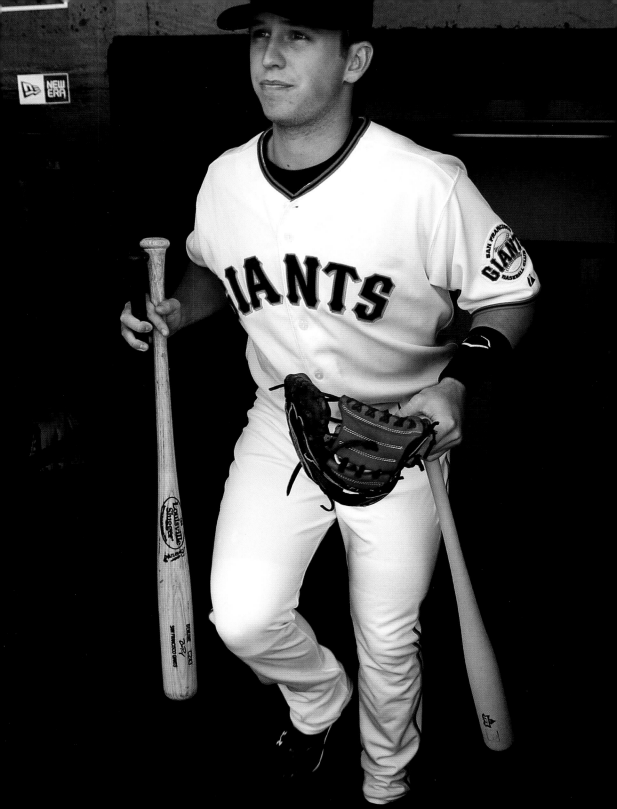

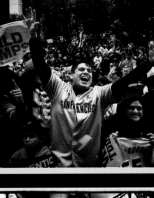

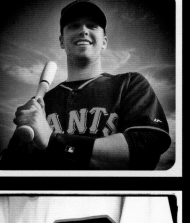

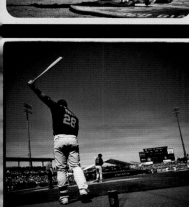
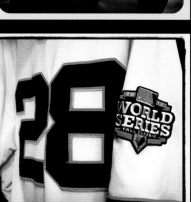
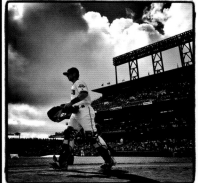

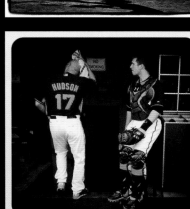

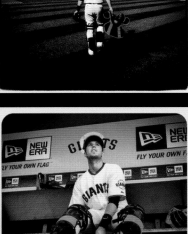

28

A PHOTOGRAPHIC TRIBUTE TO BUSTER POSEY

PREFACE BY BUSTER POSEY

PHOTOGRAPHY BY BRAD MANGIN

CONTRIBUTIONS FROM

MATT CAIN ▪ BARRY ZITO ▪ SERGIO ROMO ▪ HUNTER PENCE
BRUCE BOCHY ▪ BRANDON CRAWFORD ▪ LOGAN WEBB ▪ GABE KAPLER ▪ KRISTEN POSEY

FOREWORD BY BRAD MANGIN ▪ INTRODUCTION BY BRIAN MURPHY ▪ AFTERWORD BY MIKE KRUKOW & DUANE KUIPER

BOOK DESIGN BY IAIN R. MORRIS

CAMERON + COMPANY
Petaluma, California

66/625

BUSTER
POSEY
SAN FRANCISCO GIANTS®

BUSTER POSEY

BUSTER
POSEY

CATCHER
GIANTS

BUSTER POSEY
CATCHER

MLB DEBUT

BUSTER POSEY

SEPTEMBER 11, 2009

Finest
BUSTER POSEY

BUSTER POSEY

BUSTER POSEY
SAN FRANCISCO GIANTS

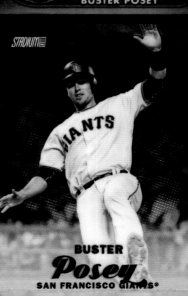

BUSTER
Posey
SAN FRANCISCO GIANTS®

CONTENTS

PAGE 1: Before a game against the Red Sox, San Francisco, 2010
PAGES 2–3: iPhone pictures of San Francisco and Buster
OPPOSITE: Topps trading cards, incorporating photography by Brad Mangin

PREFACE ■ BUSTER POSEY

THIS BOOK is an opportunity to commemorate an era—and it's an era that's not only about me. It's one that I feel very humbled to have played a part in. I can still remember running off the mound in 2010, looking around, and thinking to myself, *What just happened?*

I played my high school career with the goal of getting a state championship and came one game short. I played my college career with the goal of winning the college World Series. We made it there but didn't win it. So being with the World Series champions my first year in Major League Baseball was the culmination of wanting to win for years.

Getting to do it at the highest level was so special to me, and as I think back on that time, I'm hopeful that this book helps fans and my kids and my family—maybe my grandkids, one day—to be able to relive those moments that were so precious to all of us.

I've seen a lot of Brad Mangin's pictures over the years. He used to send stuff to my mom years ago. And when you look at his pictures from 2008 or 2009, whenever it may be, I'm a fresh-faced, chubby-faced, fresh-out-of-college kid. You look now, and you think about when you were twenty-one, twenty-two years old, when you truly were still a kid. And then I look at his pictures from this past season, and I look like I've played Major League Baseball for twelve years and I'm a father of four now.

This book commemorates playing my entire career as a San Francisco Giant, and that means a lot. It was always important to me—and people close to me knew—that I never had any intention of playing on another team.

I knew how special it was, the bond I had built with the City, with the fan base, after winning the first World Series in 2010, another in 2012, and another in 2014. I always tried to put myself in the shoes of a kid watching a game, a kid that might be a fan, and I know that growing up, when I watched the Braves and thought of the key guys that were part of their championship runs, I would have hated to see them go to another team.

Ultimately, some of them do, and everybody can make their own decision. But for me, it was always important that I was going to have one identity with one team, and I was lucky that it was the San Francisco Giants.

You can look at it from two sides of the fence, I guess. You look at guys across sports—Peyton Manning, who went on to another team, and Tom Brady now—and I don't think it hurt their legacy at all that they decided to do it. But it's a personal preference I had and one I'm happy I was able to live out.

Now, I'll say that playing my whole career in San Francisco, the weather was a pretty big shock. I had come from Florida State University, where it was 100 degrees with 100 percent humidity, to San Francisco, where it was 52 degrees with 20-mile-per-hour winds, so that was an adjustment for sure.

But I think what stood out to me the most about Giants fans is how knowledgeable they are. And it sounds cliché—everybody says, "Oh, we've got the greatest fans." But it wouldn't take anybody long to visit West Coast cities that host Major League Baseball teams and see the difference in the fan base. As many games as I played at Dodger Stadium, it's a different vibe down there. They definitely come in droves, but it's a different feel in San Francisco and one that I grew to love. I've always said San Francisco feels like a northeastern baseball town that's on the West Coast. It's always felt more like a New York or a Boston than some of the other West Coast cities do.

And one of the greatest things that the Giants organization did for all its young players was allow them an opportunity to be around the past greats—guys like Willie McCovey. I was around McCovey a lot, and I was around Willie Mays a lot. Gaylord Perry's been around. Juan Marichal, a decent amount. Orlando Cepeda. Just being able to be around those guys, learning their personalities, where they came from, their backgrounds, and then digging into their careers a little bit on my own and understanding the transition that Mays made coming to the West Coast and bringing the baseball allure of the East Coast with him, and then putting together the career that he did—following that definitely helps you identify with the days of old, of the Giants before they were a San Francisco baseball team.

My family and I decided to live in the Bay Area year-round once our oldest kids started school, instead of going back and forth to Georgia in the off season. We knew this

OPPOSITE: Laughing with a teammate during a game against the Astros, San Francisco, 2021

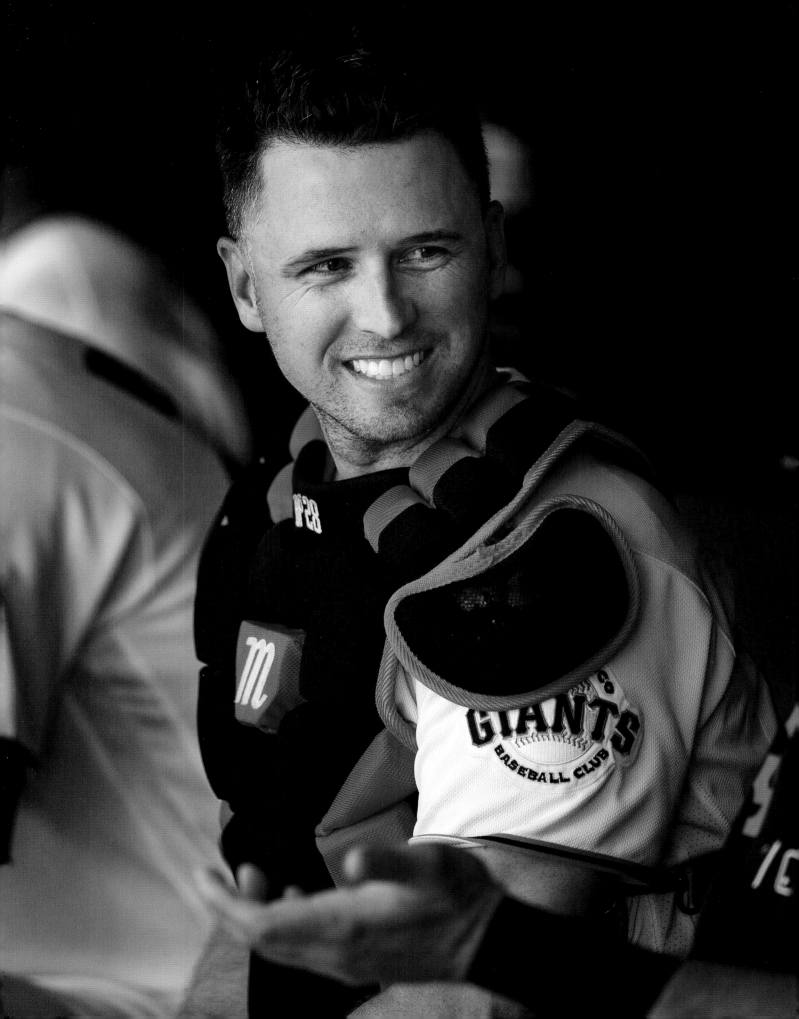

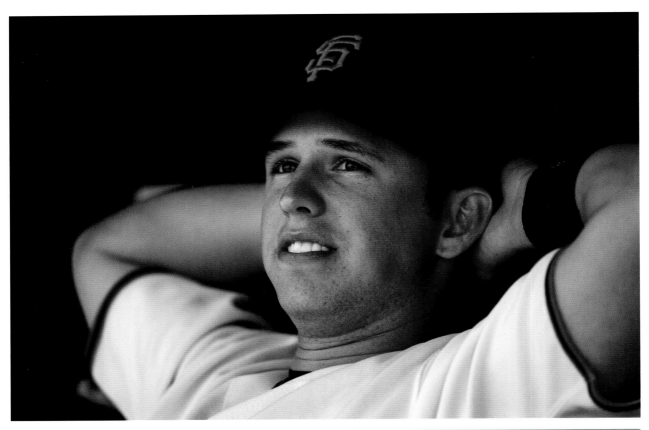

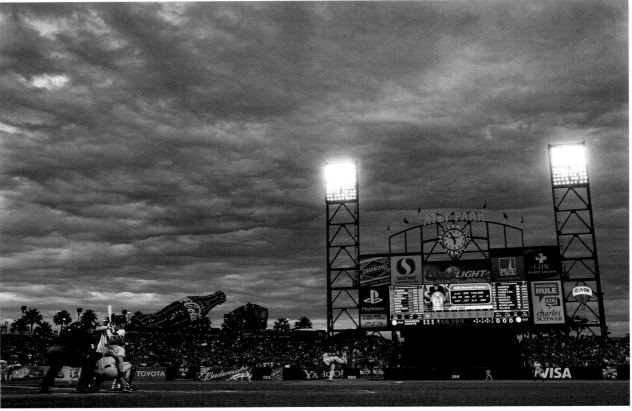

TOP: Relaxing in the dugout during a game against the Orioles, San Francisco, 2010
ABOVE: Batting in Game 2 of the 2010 World Series against the Rangers, San Francisco

would give us the most time together as a family, and it was important to us to have as much time together as possible. We didn't want to be apart during those school months that would overlap with the season—me in San Francisco and Kristen and the kids in Georgia.

We also soon discovered the importance of being part of a community, and we made a lot of great friends in the Bay Area. We feel like we belong in the community and that there are a lot of people who have the same morals. It's a place where we are really comfortable having our kids grow up, and this has been the only community our kids have ever known . . . Addi and Lee were born in 2011 and Ada and Livvi in 2020.

And being part of the community meant starting BP28, our pediatric cancer fund. It started way back with my faith and my wife's faith and knowing that we needed to help others in need. It was important to us to never jump into something that we didn't feel passionate about. But we didn't know exactly what we wanted to do. And then my wife read a book that Melissa Wiggins had written about her son, who is the same age as our oldest twins. They went through a terrible bout of cancer—neuroblastoma—and the chemotherapy really did a number on him. He survived, thank God—he's doing well now—but there are a lot of maladies, a lot of repercussions, for the type of treatment he had, because it wasn't designed for a two-year-old. It was designed for an adult.

And through my wife's relationship with Melissa, she said, "This is what we need to do." The government funding for this is around 4 percent or less. And that's because, sadly, there are not that many pediatric cases compared to the adult population, so there's less funding put into it, because pharmaceutical companies are going to make more money on a bigger portion of the population. It's hard to say—even to believe—that it boils down to money, but it does.

For this to really work, I knew Kristen had to be behind it. When I saw that she was passionate about it, I knew that she could be a driving force, with me helping out. And the Giants have been amazing with pushing this forward with us as well so that we feel like we could make a difference and raise money—we can't believe all the money that has been raised for research. We've been really fortunate to have great donors, and we've been able to underwrite all the galas, so every single penny that's been raised has gone directly to research. And you hear stories about where that money has gone and what it's been able to do for certain kids and families.

This is obviously something that we hope we can build on for years to come. It's very near and dear to us, and the hard part in the last couple of years with COVID-19 has been not being able to see some of the kids. That was something Kristen and I would try to do once a month during the season—visit various hospitals throughout the Bay Area and take a little bit of time to try to put a smile on that kid's face, or their siblings' faces, or parents' faces. Hopefully, we'll be back to that soon, because I think that's just as important as raising the money.

In visiting those kids—I've said it numerous times publicly—I think my wife's tougher than I am, because on my own, I would probably try to put it in the back of my mind and say, "Man, that's tough, but I've gotta focus on this." But she forced me to really be vulnerable—that's the best way to put it.

And you can't say that you know what it's like to be in their shoes. That's not fair, because that's not realistic at all. But you get a small glimpse of what they're going through, and it's tough. It hurts. But at the same time, it's very motivating. It does become such a driving factor when you can see what the child is going through and what the parents are going through. There's really nothing that can be more motivating than seeing a kid who's suffering. Going forward, I think that however we can feel like we can make the biggest impact, that's what we'll do.

Of course, none of this happens without baseball—and it all started in 2010. When I go back to that time, I remember how nobody was really giving the Giants a chance. We were the underdogs the whole way through—which is not a bad place to be. But looking back on it now, you realize just how good that team was. And hindsight's always 20/20, but I think that in the moment, people were scratching their heads, trying to figure out how we did it.

With eleven years in review now, it's not that hard to see why that team did win. There was a lot of talent on that team. And great chemistry. And there were big personalities. And they all meshed together just right.

A rookie catcher like me did a lot of listening. That was number one. At the same time, I understood that my position was important because I was involved in so many plays. I was involved in decision-making. Everybody sees me on the field—the pitcher, the whole infield, the outfield—so I knew how important it was early on to try to maintain good body language no matter what. Even if, in 2010, there might have been moments where I was in over my head, I never tried to act like I knew that I was.

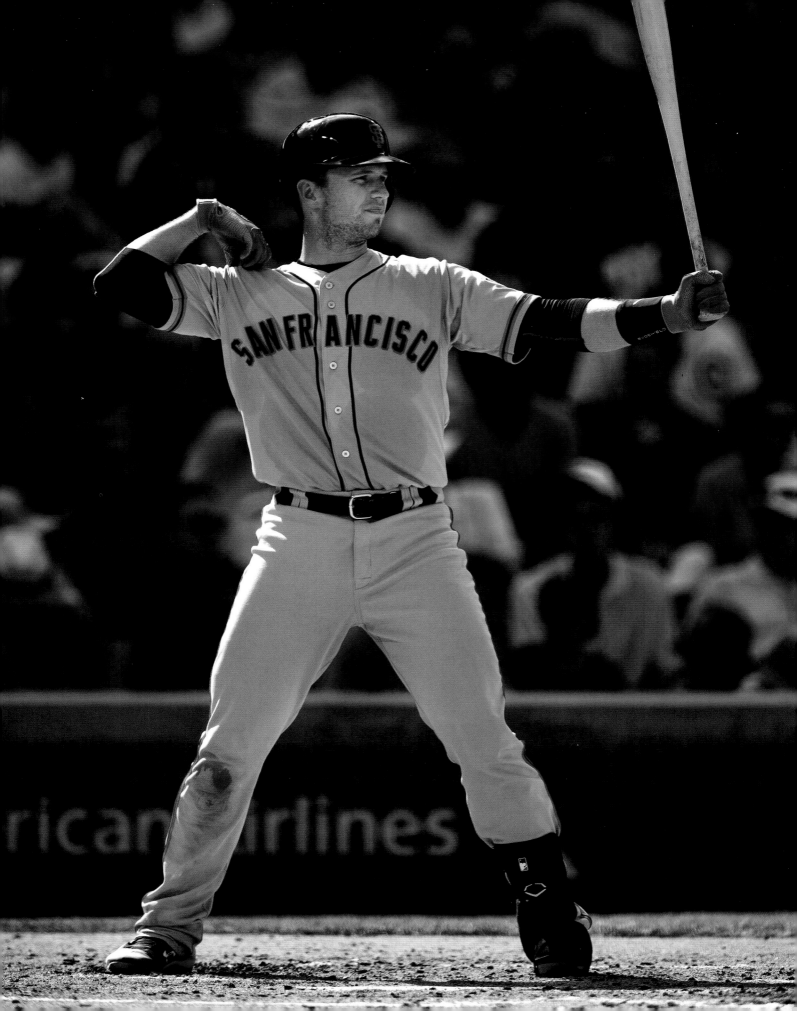

Playing the Braves in the 2010 NLDS was surreal for me. I grew up watching these guys. When we beat them, I saw Bobby Cox come out of the dugout and tip his hat to the crowd. I'm standing on the other side, thinking, *My gosh, I was just part of the team that knocked the Braves out, and my favorite manager of all time is saying goodbye.*

And then there were the Phillies in the NLCS. They had come off winning the World Series in 2008 and being in the World Series in 2009, and they were just absolutely loaded—not to mention that Philly is arguably the toughest environment to play in. Man, I think about how fun that was. I mean, it was electric. They were all over us.

For us to win that Game 6, and clinch, was huge. We would have been up against it in Game 7 for sure. Not to say that we wouldn't have come out of it victorious, but winning that Game 6 really just springboarded us into that series against Texas. And man, Texas was another team that was just loaded with talent. But pitching will always trump great hitting, and our guys really showed that in that series.

We had Matt Cain. He was just unflappable. You're saying to yourself, *This is the guy we want on the mound right now.* You knew what you were gonna get. You knew that if it came time for him to dig deep, he was gonna dig deep. He was a guy that could maybe even go nine innings—which, in 2022, seems impossible—but you just felt great.

We had Tim Lincecum. Oh man. Timmy was ahead of his time. He was a small guy throwing 100 miles per hour before small guys did that.

Electric is what comes to mind. I felt he had no-hit stuff there for a while every time he went out. And you felt like Timmy was a guy who, even if he got in trouble—bases loaded, nobody out—it's like, *Okay, we'll strike out three in a row right here.* And that's what he did sometimes.

He had a charisma that I think the San Francisco fan base—rightfully so—just ate up. The reason they ate it up was because it was so authentic. There was nothing fake. No posturing. That was who Timmy was. He had no problem being himself. And I think that whoever you are, people can always appreciate and identify with that.

We had Madison Bumgarner. He was a lot like Cain—you felt good when he was on the mound. There's a quiet, calm confidence that grew into more of a not-so-quiet ferocious confidence as he got older.

Back in 2010, I remember standing out in the outfield with Bum before Game 4 of the World Series in Texas and thinking, *All right, this guy just turned twenty-one. I'm twenty-three. And we've got a chance to go up 3–1 in the World Series.* And I thought, *How many times has this even come about in the history of the game, with a twenty-three-year-old catcher and a twenty-one-year-old pitcher?* I was glad that I had that ability to sit back and think about that even then.

And then for him to go out and do what he did—eight shutout innings—is one of my favorite baseball memories in my career. We were in sync that night, and it was really special to me. And it was a glimpse into what the future could look like—that might have been it as well.

Then 2012 was a funny year, because we had to play the last three games of a best-of-five NLDS in Cincinnati. They played us tough in Great American Ball Park. And with that lineup and some pretty stellar pitching, you felt that, at minimum, we needed to win one of the games in San Francisco. So, having said that, you can imagine that spirits were a little down going to Cincinnati 0–2.

But as it's been documented, Hunter rallied the troops there in Game 3. And what he did, as much as anything, was take pressure off our guys. It was like, "All right, we know our backs are against the wall, and odds are stacked against us, but the least we can do is go out there and fight tooth and nail to the finish." And we were able to squeak out that Game 3—barely—and win Games 4 and 5 against a really good Cincinnati team.

When I came up with the bases loaded in Game 5 against Reds pitcher Mat Latos, I remember I wasn't feeling great at the plate. I was thinking, *All right, I'm gonna shorten up here, and I'm getting something to the outfield here, and we're getting this run in.*

Sometimes, really good things happen. Fortunately, that was one of the times when really good things happened. Latos left the ball middle-in, and I took a short, quick swing to it. It was a great feeling, because I knew it was gone off the bat. I think I took two steps out of the box, which is really big for me—to take two steps out of the box—and looked at the ball. It was such a strange feeling, because the place was rocking—and then it was deadly silent, except for the one hundred fans we had right above our dugout.

We went on to St. Louis and fell down in the NLCS, three games to one. Then, Barry Zito started Game 5

in St. Louis—and I've thought about that moment so many times. With the current climate of baseball, there's no chance that, in 2021, we would have seen Barry Zito starting Game 5. It would have been a bullpen game. It would have been pieced together from the back end. And to me, that stinks. I'll just say it: That stinks, because now we're missing out on memories.

Baseball is about entertainment. It's about drama. And that's what Zito brought to the table that night. Yeah, he might have been a bit polarizing because of some of his ups and downs, but guess what? He instantly became a hero, and I'm happy that I got to be back there and watch him dominate. The guy had had some really low lows, but I think the high was even higher than those lows. Baseball is more than just seeing how efficient we can be. It's more complex than that.

Then we took on the Detroit Tigers in the World Series. They were loaded. What I think helped us, though, is that we had just ground through a seven-game series, and those guys had been sitting for a while. We came in with a little bit of momentum. Panda had the three-homer game to set the tone. And then we shut them out in Game 2—and Bumgarner went seven innings.

We had another great pitcher in Game 3 in Detroit, Ryan Vogelsong. The at-bat I remember the most in that game was in the fifth inning, facing Miguel Cabrera with two outs and the bases loaded. We were ahead, 2–0. Your common sense tells you, *All right, can we just pitch this guy carefully, down and away? If he hits a single, if he hits a double, fine.* But Cabrera's such a great hitter, you can throw him down and away, and he'll flip-hit the ball out to right field. So we went against the grain, and I remember Vogey just running it in on him, and he popped it up to Craw.

That was, for me, the turning point in Game 3. Vogey has become such a great friend of mine, and I was really happy that he got to have that moment there. He is one of the hardest workers I've ever come across in the game.

Game 4 was the coldest game I ever played. It was 40 degrees, but it was an East Coast 40 degrees, rainy, with a 15- to 20-mile-per-hour wind. And we were facing Max Scherzer.

The weird thing about that game is, thankfully, there was a real sense of urgency in our dugout to finish it off in Game 4. We knew that we were gonna be up against some really tough pitching. And, looking back on it, I

think it rained for three or four days straight after that, so that would have given the Tigers a chance to reset. I don't think it's an overstatement to say that even though it was a sweep, it was really important that we went ahead and won in Game 4.

We didn't win, though, until Sergio Romo, looking to end it, struck out Cabrera. He caught Cabrera looking on a fastball when I called for a slider. That was 100 percent his call to shake there. Maybe Cabrera thought it was a fake shake—it certainly looked like he did. He was sold for the slider, and why wouldn't he be? I would have been, too.

And that personifies Romo's career. He's not the biggest guy, but he's got one of the bigger hearts and mentalities of anyone who has ever stepped on a mound. And in that situation, he shook—and slipped one right past him there. I was glad he shook.

Two years later, we were back in the postseason, but this time, it was something different—a Wild Card Game in Pittsburgh. I remember walking from the bullpen after warming Bum up. Their bullpen's in left center. And I took it in. They were on what the fans called a blackout—they all had black shirts on, so the whole stadium had this menacing aura about it. Even before the game started, you couldn't hear yourself think. But then Crawford hit a grand slam, and it got really quiet really quick.

With Bum on the mound, the fan base knew they were in trouble. Bum had another great performance, another shutout performance, in the playoffs. That's another one where a lot of managers today wouldn't let him go nine, but Bochy did.

Someone mentioned that in 2021, Logan Webb was the only pitcher in either the American League or the National League to have two outings of seven innings or more in the postseason. That's crazy. That's not good for the sport. People can identify with grittiness. We can all identify with a little grittiness.

The NLCS that year finished on Travis Ishikawa's grand slam. I can remember sitting in the dugout and watching him. Michael Wacha was pitching. He went 2–0 on Ish. Ish hadn't been playing a ton. Huge moment. Wacha's all over the place. I was sitting there thinking to myself, *All right, Ish, take one right here, right?* And he walloped the next pitch into right field. You knew off the bat that the game was over. But then, to see it hit the metal up there above the archway and go out—that's a top-five moment for me in my career to see the excitement of the crowd, of Ish. Everybody was going nuts—you felt like a little kid.

We all know the World Series went to Game 7 in Kansas City. But I remember reading a quote after we won Game 5 in San Francisco behind Bum. I think it was Jarrod Dyson of the Royals who was quoted as saying, "Now we don't have to deal with Bumgarner anymore." You felt like that was the sentiment of the team and the Kansas City fan base: "Enough with this guy—we're over it." And they took it to us in Game 6.

In Game 7, Mike Morse, who had a huge homer for us in Game 5 of the NLCS—a 6-foot-6-inch, 300-pound guy floating around the bases—had a hit that put us back up on top.

And Boch was before his time, right? Most managers weren't going to the bullpen, to their ace starter, in the playoffs as much as they are now—and honestly, I don't think everybody can do it. There's 1 percent of guys that can do it.

Bum happened to be one of those guys. Now, everybody's saying, "Well, he did it—now my guy can do it." But it's not that easy. I remember that the Royals were in business, and Boch came out and pointed at the bullpen. And the gates swung open, and it was like a western movie with Bum walking out. And you could hear a pin drop.

That silence was a confidence booster for us. I'm sure it was for him as well—to walk out and have fifty-thousand-plus people be like, "Oh, shoot." And the rest is history.

I kept thinking, *All right, let's get him through the seventh, and then we can get the last two innings with our bullpen.* And it's like, *Man, he's cruising through seven.* And Dave Righetti's asking me, "How's he doing?" I'm like, "He's great."

And they just ran him back out there in those last two innings. The ninth was not without drama, for sure. I feel so fortunate that I was able to play Game 7 with the tying run on third with two outs and the winning run at the plate. And I am glad I was twenty-seven at the time, because I don't know if I would enjoy it now like I did then.

Oh, and people ask about Alex Gordon of the Royals—if he should have tried to score on the previous play, when we made an error in the outfield. My take: He'd have been out by 15 feet. And after he held at third, Bum and I were both adamant that we wanted to throw high fastballs to Salvy Pérez. A curveball in the dirt—100 percent, the game's over.

But there were a lot of things that were going through my head—and probably Bum's, too. His execution of the fastball at the top of the zone was just so consistent that I felt there was going to be less of a chance of a mistake than if we threw a curveball, and it hung, and Pérez hooked it down the line for a double or a homer—or, heaven forbid, the ball hit the corner of the plate and bounced over my head. All these things were going through my head. And I kept on standing up higher and higher, asking for that high fastball. And to Bum's credit, as exhausted as he probably was, he kept on getting it up there.

It's hard to even describe the emotions you have. As soon as Game 6 is over, you're 100 percent off. Sleep's not great. You wake up, and your mind's on it. You're thinking to yourself, *Okay, you need to enjoy this—this is what you dreamed of as a kid.* At the same time, you say, *We have to win this game—we can't come this far and not win this game.* And so, when it was over, I was excited, no doubt, but I was very much relieved as well.

To do it three times with Bruce Bochy as my manager, I think what stands out to me the most about Boch is how well he was able to read his players and how he knew how to get the most out of a lot of different personalities. And that may be in the game, that may be on the bus or on the plane or in the clubhouse, or it may be in a team meeting. He was so good at knowing what made certain guys click. He taught me a lot.

As an example, there might be a guy who was rubbing people the wrong way. Boch knew how hard he could push on that guy, or if he should just pull back a little bit and say, "We'll take our lumps in one aspect of this system, but in the long run, we're going to get the most out of this guy if I treat him this way." He's a psychologist. He's a manager, but he's a psychologist.

And that's not even getting into how well he runs the game, how well he runs the bullpen. You can see it in the playoffs. He changed in the playoffs, and it's important to do that. He would manage the bullpen a little bit differently in the regular season than he did in the playoffs, and those guys in the pen were rested enough. They weren't worn down. He could ask a little bit more from them in the playoffs. I know I'm excited to see him inducted into the Hall of Fame here soon.

I'm sure he didn't like some of the pitches I called at times, but he never wanted to call the pitches. I think he knew, from being a catcher himself, that I had the best view of everything. We would go over hitters at the start of a series. He would have his input. Rags would have his input.

Ultimately, the fact that I felt like they trusted me from early on gave me a lot of confidence. It can't be overstated how important it is for a young catcher to feel that he's got the support of the manager and the pitching coach—and then you hope to gain the trust of the staff as well as time goes on.

I was so fortunate to play for the Giants in what's now called Oracle Park. What stands out to me the most is being in different parts of that ballpark. Obviously, the most time I spent was behind the plate, and then the dugout. I played first base a little bit. But when I think about that ballpark from a fan's perspective, what's so unique is that you can be in a different part of the stadium and get a different feel anywhere in the stadium.

And they're all equally special, whether it's a view of the Bay or the Bay Bridge, or seeing the field from a different angle. It's such a special place that hopefully will one day be like the Fenways or the Wrigleys of the world. Hopefully, it's here a hundred years from now.

From a player standpoint, there are certain ballparks that you step in where there's a buzz—there's an energy. You have that at Wrigley. You have that at Fenway. And you have that at Oracle Park. And I'd say Dodger Stadium has that as well. The couple times I played in Yankee Stadium, the new one, I didn't really feel that.

Now there's a whole new era in Giants baseball, and we made history in 2021. The coaching staff, and Gabe Kapler and Farhan Zaidi, deserve a lot of credit for the team they put together. And the players deserve a lot of credit—especially some of the older guys, who were able to be open-minded. A lot of the stuff the coaches were coming at us with was different—very different—than guys like Crawford and Brandon Belt and I had experienced under Boch and the staff our entire career.

I think it's important to note that there was a mindset the group had, a goal. At the beginning of spring training, some of the veterans—me, Longo, Craw, and Belt—went to Kap before spring training started. We said, "Kap, the media is saying that the Dodgers and the Padres are the heavyweights of the division. And we respect that. But at the same time, if we don't set out and have the goal to win the division, we're wasting our time."

Kapler did a great job delivering that message to the group before the first day of practice so that the younger players who weren't going to be on the team got to hear it, and the players who didn't start the season with the team got to hear it. So now, you've got a mindset—the whole group has this goal in mind that we're working to-ward every day. And I don't think that without that tone being set, we would have won the division in 2021.

A few things contributed to the success of my final season. I was two and a half years removed from hip surgery—that helped a lot. And during my training I did in the off-season, strength training and movement training, I got to work with some new hitting coaches—Dustin Lind, Donnie Ecker, and Justin Viele—and we worked on moving efficiently and fast.

That's the name of the game with hitting. Obviously, hand-eye coordination has to be world-class, but being able to explode through the zone was something I hadn't felt in a while—the combination of my hip working well, working with those guys, and putting my head together with Kapler and coming up with a schedule that we felt was going to be advantageous in keeping me fresh and healthy.

And then there was October 2021. I've been very fortunate to accomplish a lot of things in my career that I wanted to—like winning a world championship and doing it three times—and I remember Henry Schulman of the *San Francisco Chronicle* asking me a few years back, "If you could do one more thing, what would it be?" And I told him it would be to play the Dodgers in the postseason. To have that opportunity, I was so grateful, because I knew that after being in a rivalry for ten-plus years, it would be as electric an atmosphere as you're going to get in a baseball game—and I think that held true.

Game 1 at Oracle Park was up there at the top for me for atmosphere. We played in a lot of cool atmospheres, but that one is up at the top. That homer I hit in the first inning of Game 1—it was almost like a dream homer that you have as a kid.

But then it was time to retire. I'd always been a guy who really enjoyed practice and preparation. But now, getting ready to practice and prepare, there was a step before that that I had to get to in order to be able to do that. And you hate to say it, but it's the reality of it—it takes away some of the fun. It takes away some of the joy. And I don't care who you are and how much you love something—and I've loved baseball since before I can remember—if you're constantly going out there and knowing you're going to have to deal with a certain amount of pain, it takes away a little bit of the fun.

I never wanted to be one of those guys who walked into the clubhouse and the younger players looked at me and thought, *Oh gosh, here comes the grumpy old man,*

who's sitting in the training room all day getting ready and not bringing anything to the table but griping. I felt like if I had tried to play another two, three, four years, there's a chance that was going to happen.

And I am, again, very grateful and happy that I was able to be a part of the 2021 team when we won a franchise record–setting number of games.

In the end, I'll remember the parades in San Francisco. It really hit me how special, meaningful, impactful, and important it was to a lot of people who had grown up in San Francisco or grown up in the Bay Area, all Giants fans their entire life or most of their life. The parades—and talking with people after the World Series—gave me a greater understanding of what baseball is and what's so great about baseball: It's because baseball can transcend generations—look at the people at the parade with their children, or grandparents, or aunts and uncles, or cousins, or whomever they may be.

It's on TV 162 times a year. You can go to the ballpark eighty-one times a year, watch a team play, and share memories with your family and your friends. And man, I feel fortunate that I got to play a small part in making some of those memories for people. Seeing that in 2010 definitely inspires you to try to do it again.

My granddad and I bonded over the Braves—and who knows, if you didn't have baseball, would you have had that same bond?

It's a great sport.

ABOVE: Batting practice before Game 4 of the NLCS against the Phillies, San Francisco, 2010
OVERLEAF: Going to right field during a game against the Cubs, San Francisco, 2013

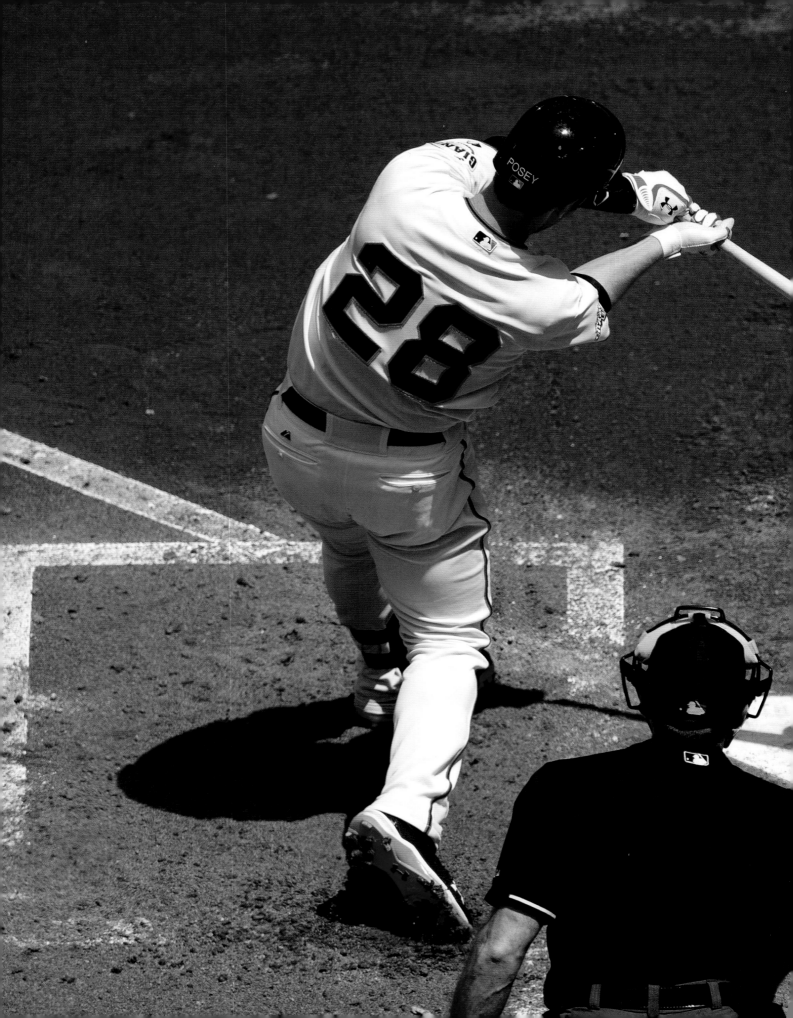

FOREWORD ▪ BRAD MANGIN

AS A YOUNG San Francisco Giants fan growing up in the East Bay surrounded by A's rooters in the 1970s, I was used to cheering for a dreadful ball club. Getting to .500 was a pipe dream, and when the 1978 team led the National League West for most of the summer, it was a wish come true. But who was I kidding? At thirteen years old, I knew my Giants were not going to win the World Series that year. They were never going to win the World Series. The Dodgers always kicked the crap out of them, the Giants played in a lousy park, and I was one of those kids who just couldn't have nice things.

Sure, I had some really good players to root for over the years, from Bobby Bonds to Willie McCovey and Jack Clark to John Montefusco, but it didn't seem to matter. I also had a handful of favorites over the years who were never star players, like Mike Ivie and John Tamargo, but I loved everything about them. Through it all, the Giants were a part of my life, and I knew I would be a fan forever.

As a kid, I had another pipe dream: becoming the next Lon Simmons or Al Michaels, calling Giants games on KSFO. But about midway through high school, I found my real voice in photography, which eventually led to photojournalism and shooting big league games at Candlestick Park by the time I was in college in 1987. Suddenly, I was on the field shooting pictures of Will Clark, Mike Krukow, and Robby Thompson. Over the next several decades, I photographed over one thousand games, including many in the postseason, but the Giants never won it all.

Whether I was on the field or in the stands, in my mind, I was still that kid from Fremont throwing temper tantrums every time a ground ball went between Johnnie LeMaster's legs. After they lost to the Angels in 2002, it was official: They were never going to win a World Series.

Then June 2008 rolled around, and Major League Baseball's First-Year Player Draft was fast approaching. The Giants had a history of going after pitching in the draft, but the word was that this year was going to be different. Many fans had become frustrated over the years by the lack of homegrown talent being nurtured in the minor leagues and prepared to play in front of big crowds in San Francisco. It had been over twenty years since the Giants had drafted and produced an everyday position player who went on to be an All-Star. With the fifth pick in the draft, the Giants had a chance to change history.

They selected a junior catcher out of Florida State who was closing games for his squad on ESPN in the College World Series. Gerald Dempsey Posey III was the kid's name. Around these parts, he's better known as Buster, and because of him and what he brought to the Bay Area from a small town in Georgia, local fans will never forget his name.

Buster was called up in September 2009 to get a taste of the big leagues, and what I remember most was how much I wanted to photograph the new kid and how many times I watched him run to the bullpen down the left field line to warm up a relief pitcher. Late in the season, I like to shoot from the outside third base photo position on the far side of the Giants' dugout because the light gets so pretty from out there in the fall. From there, I would always see bullpen catcher Taira Uematsu run out of the dugout and down the line to do his job. Not anymore! Gotta break the rookie in! This was the big leagues, and it was all a part of learning the ropes and getting Buster ready for his rookie season in 2010.

Once Buster became the regular Giants catcher in July 2010, there was no stopping him. He could hit for power and average, had a cannon for an arm, and called a great game. He was also a dream to photograph. I had always loved shooting catchers, but now I had a catcher who was really worth shooting. And have I mentioned his swing? Oh my gosh. Buster had one of those rare swings that looked great in pictures from both first and third base. He was so good at taking the ball to right field that he would make great pictures by looking up the line right at you from the first base photo well. If you were shooting from third base and he pulled the ball, his smooth turn and follow-through with his two-hand finish was a thing of beauty. I have been shooting baseball for thirty-five years, and Buster had one of the prettiest right-handed swings I have ever seen.

OPPOSITE: Brad Mangin at age three, 1968

We all know what happened next: In 2010, the rookie helped lead his team to its first World Series championship in San Francisco history, and its first since 1954. As I shot Buster hoisting the trophy over his head on the field at the Ballpark in Arlington, I could not believe this was really happening—the team I had rooted for my entire life had finally won the World Series, and Buster Posey was one of the main reasons why. There was something very special about the rookie catcher, and you could tell he was just getting started.

By the time Buster hugged Madison Bumgarner after the final out of Game 7 of the 2014 World Series in Kansas City to clinch San Francisco's third title in five years, he had cemented himself into a category all by himself in Giants history. In such a short span, he had been named MLB Rookie of the Year, Comeback Player of the Year, and Most Valuable Player. He had won the Hank Aaron Award and caught a perfect game. Buster was Giants royalty.

Buster was the most important player for me to photograph every game I shot, because I knew I was documenting history—and a future Hall of Famer. It's rare that a photographer has the opportunity to witness the entire career of a player like Buster, and I was not going to waste this chance. Over the next several seasons, as Buster fought his way through injuries, I continued my mission to photograph him from every conceivable angle.

Over time, it became clear to me that Buster was going to finish his career in San Francisco. I just didn't know when it would end. I really missed not seeing him on the field during the 2020 season, when he took time away from the game during the shortened season to be with his family, but I was really happy to see him back in 2021. The 107-win season and the division race with the Dodgers was historic and crazy to watch, as was the five-game playoff series. And Buster was right in the middle of it, having one of his best seasons ever, winning his second Comeback Player of the Year award and blasting a home run to right field in Game 1 of the playoffs against the Dodgers that sent a packed house at Oracle Park into a frenzy. I was shooting next to the Giants dugout behind the on-deck circle, and it's a moment I will never forget.

When Buster announced his retirement from baseball a few weeks after the Giants' season ended, I was stunned but not surprised. His body had been so banged up over the years. Heck, I remember him taking so many balls off his mask back in 2011 that there was talk of moving him to first base. Of course, he wasn't having any of that. He was a catcher, and he would always be a catcher.

I went to the press conference to see Buster announce his retirement at Oracle Park on November 4, 2021. I needed to document the event to give closure to his career—and I had to be there to make sure it was really happening. The finality of it really hit hard: This was the end of an era. An incredible Giants run of excellence was truly over. Buster was the Giants star who had played in the orange and black for his entire career and had led his team to three championships. Buster displayed grace and elegance on the field and had an air about him like Derek Jeter had while playing for the New York Yankees. I had photographed Jeter in many World Series, and he had been so special. Clutch. Poised. Fearless. There had been a mythical quality about him that reminded me of stories about the great Joe DiMaggio. On this day, I felt like I had seen the last of my Jeter. Of my DiMaggio.

I was emotional after the press conference, and I didn't want to leave. I wanted to stick around so I could see Buster after he talked to many of his family and friends. After a while, I got the chance to get his attention and reach out to shake his hand. It was hard to get the words out as I looked him in the eye and told him I had been doing this for thirty-five years, and it was the greatest honor of my career to photograph his entire run. He thanked me, and I left. I needed to go after that.

My partner Brian Murphy and I had previously authored three books about the Giants after they had won their World Series titles in 2010, 2012, and 2014. Now we needed to do a fourth—but this time about not a team, but one man: Buster Posey. The outpouring of fan affection for Buster upon his retirement announcement was overwhelming. Buster was special, and we needed to do something about it. Nobody has documented his career with the Giants in pictures like I have, and no one knows the fan base and has writing skills like Murph. We wanted Giants fans all over to be able to have a book of memories that they could hold on to forever so they will never forget what Buster means to them and the Bay Area.

We couldn't be more thrilled to team up with Buster and present this book to everyone to help the BP28 Fund fight pediatric cancer. We hope you enjoy it.

OPPOSITE: Photographed from third base, Buster displays his picture-perfect swing in a game against the Dodgers, San Francisco, 2013

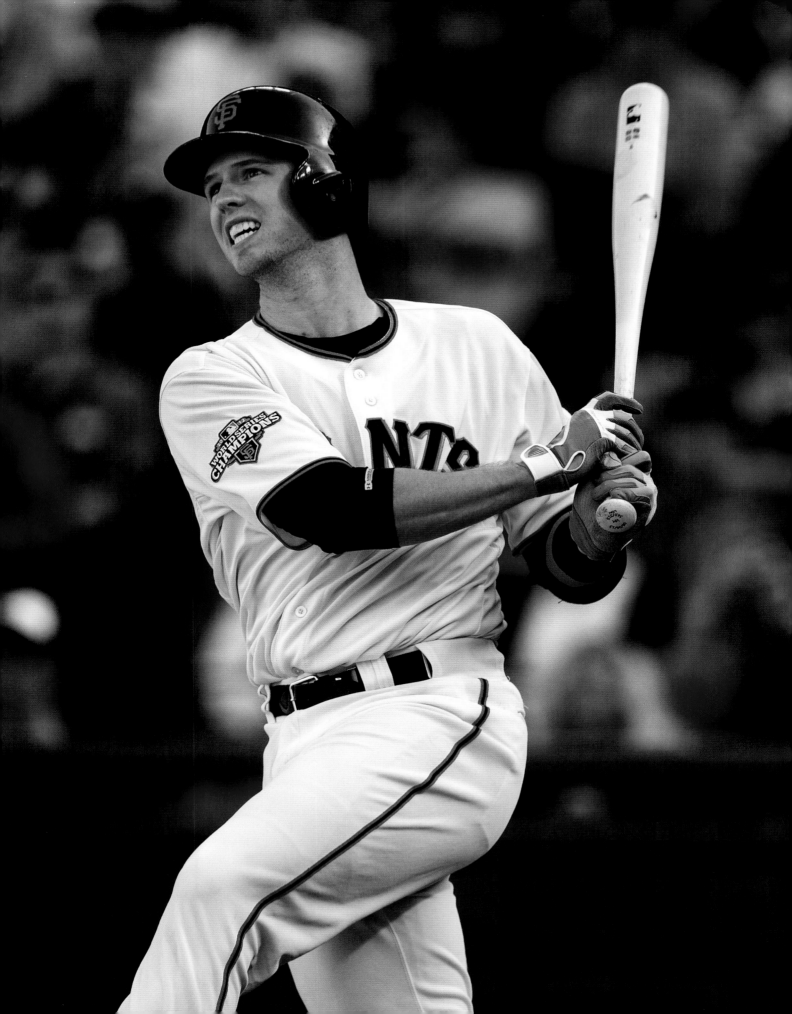

INTRODUCTION ▪ BRIAN MURPHY

IT WAS BUSTER ALL ALONG.

That was my thought, when all was said and done, when the thorough and professional and mature and competent words from Buster Posey floated off into the ether on November 4, 2021, at the club-level retirement press conference at Oracle Park. When the tributes poured in all week from Bruce Bochy and Brandon Crawford and Hunter Pence and Matt Cain and Ryan Vogelsong and Brian Wilson and Javier López and Jeremy Affeldt and Sergio Romo and Mike Krukow and Barry Zito. When we ventured off into a Giants world without No. 28.

It was Buster all along.

Never the headline grabber. Never the first guy mentioned. Nope. In 2010, that was Brian "Fear the Beard" Wilson or rally thongs or misfits—and, of course, Timmy. In 2012, even in Posey's MVP year, it was Hunter Pence as the "Reverend" or Marco "Block-buster" Scutaro or Pablo Sandoval, the World Series MVP, hitting three tanks in Game 1. In 2014, a "Fire on the Mountain" broke out, and the legend of Madison Bumgarner came, single-handedly gunslinging the Giants to a historic third World Series in five years.

And yet, it was Buster all along.

How Buster Posey is it that he is the only player from those World Series teams to have a shot at the Baseball Hall of Fame, and yet he was the quietest of the bunch? As quiet as his crouch behind the dish, as quiet as church as he sized up another hitter with his eyes through the catcher's mask before carefully and deliberately flashing fingers to any one of those pitchers named above.

They threw the pitches. They got the glory. Buster caught them and, as Wilson told us, tucked them in his back pocket to hand over for posterity after all the hugs.

It was Buster all along, providing the beat, the spine, the heart.

Don't get me wrong. He wasn't forgotten. Of course he was worshipped by Giant fans. Dogs were named after him. Kids listed him as their favorite player. Jerseys with No. 28 dotted the stands.

And yet, I don't think, until he announced that November day that he was retiring from baseball—at a relatively young thirty-four, after a brilliant season that showed he has more great ball left—that we fully came to

grips with how much Buster meant to the team, the franchise, the fan base, the City. I don't want to say we took him for granted, but maybe we took him for granted.

All of a sudden, every intellectually called pitch, every artfully framed strike, every blocked ball in the dirt, every back pick, every runner caught stealing, every jog to the dugout before the umpire signaled strike three, every gorgeous inside-out swing, every right-center field approach, every consistent, grinding at-bat flashed before our eyes.

And all of a sudden, we didn't want to live in a world where Buster Posey wasn't playing baseball in the home creams.

It went too fast. Only ten full seasons. Willie Mays played with the Giants from 1951 to 1972. Willie McCovey was in San Francisco from 1959 to 1973 and 1977 to 1980. Barry Bonds wore the orange and black from 1993 to 2007. Buster's streak across the sky, by comparison, was too meteoric. None of those guys—Mays, McCovey, or Bonds—played catcher, though.

The toll burned Posey's candle at both ends. He wouldn't go into the details of his physical pain, but his retirement said all you needed to know.

And so, as he leaves, we find ourselves wanting more baseball from Buster Posey. It took him uttering the words "to announce my retirement from baseball" to make us want to stand up in front of Bochy and Kapler and Farhan and Kristen Posey and shout, "No! Don't! We need more baseball!"

Because it was Buster all along.

That's why Brad Mangin and I had to do this book. We had to call his friends and teammates and ask them to frame their memories, their emotions, their historical perspective. We had to do this book so you could see the pictures again, through the years and parades and light shifts at Third and King. Maybe, by doing so, we could keep the memories alive.

The baby-faced Buster stood at City Hall after the parade in 2010, pounded the lectern, and urged the Giants to "go do it again." He made good on that. Twice more. Legacy, secure.

Eleven years later, with some gray at his temples, Buster said it was time to go. He's not a Giant anymore.

Damn.

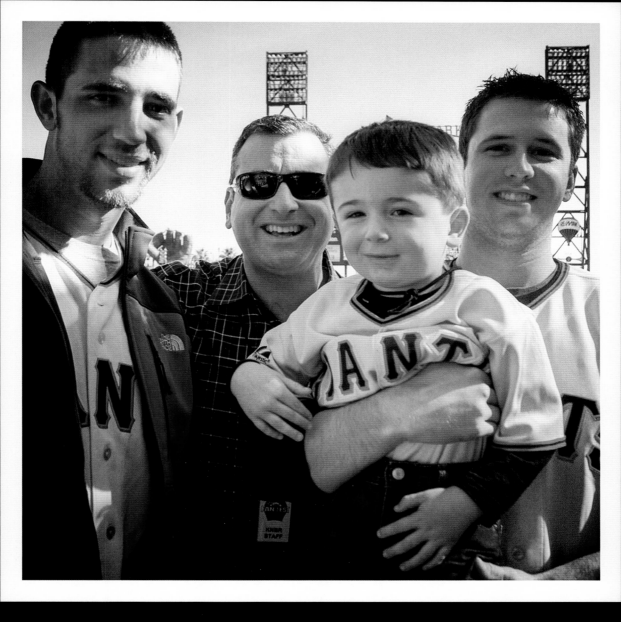

ABOVE: *(left to right)* Madison Bumgarner, Brian Murphy, Declan Murphy, and Buster Posey at FanFest in 2011.
Photo by Candace Murphy

"I can still remember running off the mound in 2010, looking around, thinking to myself, What just happened?"

2009
—
2010

OPPOSITE: Twenty-two-year-old Buster Posey embarking on his career, Giants vs. Padres, San Francisco, 2009

OPPOSITE: Batting against the Cubs, San Francisco, 2009

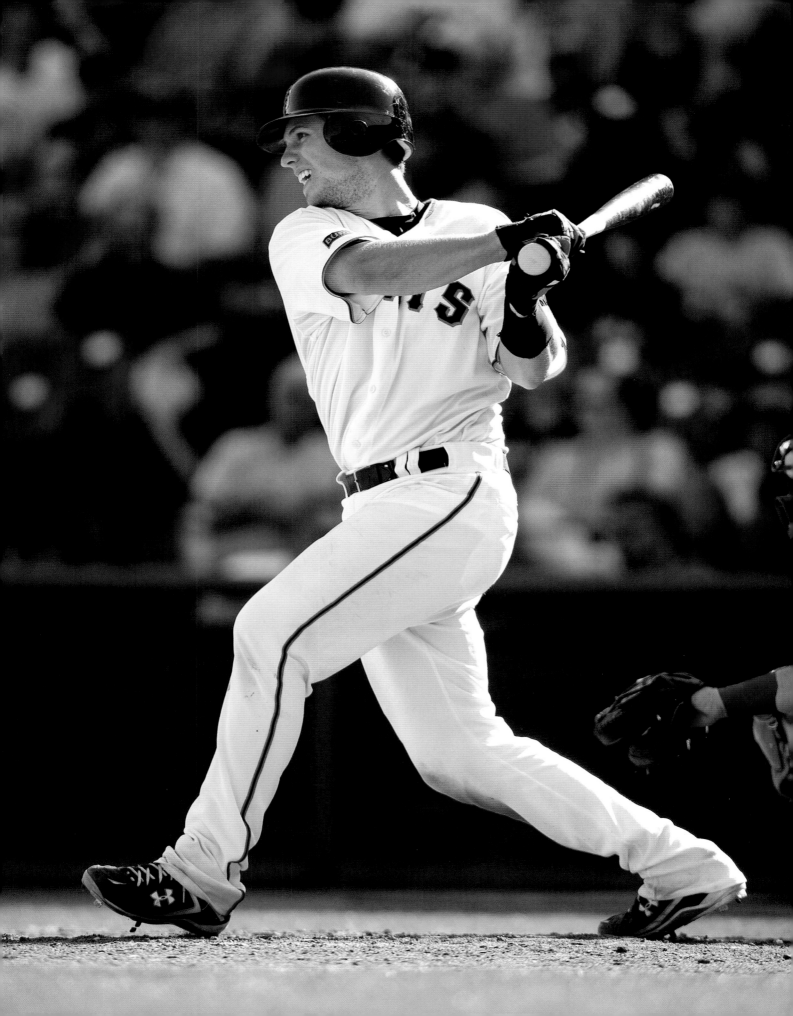

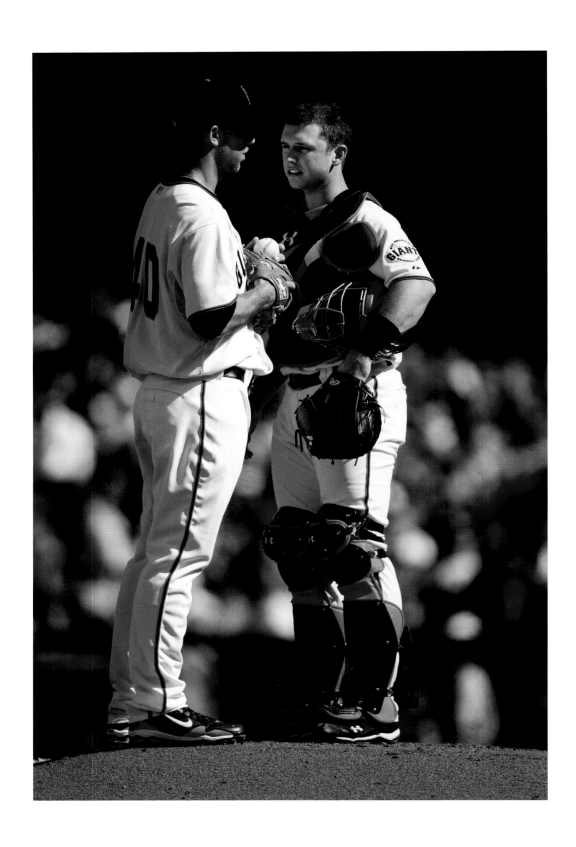

ABOVE: Madison Bumgarner and Buster talk on the mound during a game against the Red Sox, San Francisco, 2010

ABOVE: Chasing a pop-up in a game against the Diamondbacks, San Francisco, 2010

FIELD AWARENESS ■ MATT CAIN

A MEMORY CAME TO ME the other day, an example of when Buster really coaxed me through a huge moment.

It was in the 2012 NLDS against the Reds. Game 5. He had just hit that huge grand slam in the top of the fifth inning.

But the Reds began to wake up in the bottom of the sixth. They were on the brink of having a huge inning. Ryan Hanigan was putting up a battle with me at the plate, and a couple of guys were on base, nobody out.

The at-bat finally came down to a 3–2 count, and Buster called an outside fastball, the eighth pitch of the at-bat. I went with him—like normal—and spotted it on the outside corner. The call could have gone either way.

Luckily, it went our way.

But the more impressive part was that Buster still had the field awareness to see the runner at second, Jay Bruce, breaking for third. Buster made a perfect throw to third for an absolutely huge double play to kill their momentum.

He knew that he needed to not give up on the pitch at the plate, to give the umpire a decent look at it, and that he also had to be fast to third base.

He was huge at getting the most of moments like those, moments that could have easily been game-changers.

My first memory of him was when we tried to razz him a little bit in spring training, and he really had nothing to do with it.

He got up there, answered the questions we asked—the silly, uncomfortable questions that most guys get embarrassed by. But he did it in front of everybody, as if he was saying, "All right—I get where this is going. But I'll be up there with you guys in a few years. We're not going to play that game."

It was almost as if he kind of took the joy out of it a little bit, but also almost like he was saying, "I'll be there in a little bit. I get it. I know how it goes. I'll kind of play with it a little bit."

He didn't overentertain it. He didn't get embarrassed. He didn't worry about it. He just took it in stride.

And that's what he did when he came up in 2010. He just came right in and dominated as the starting catcher. That's what Buster is known for. That's what he did when I first threw to him in spring training.

He wasn't worried about who was pitching. He was going to do what he does, relay the information back to the pitcher, and we'd go from there.

He was so easy to work with. And he was straight-forward, which made it even better.

The night I threw the perfect game against Houston in 2012, I don't know that we really had any conversations during the game.

I let him call the game. He was in total control. I never shook off that night. Everything seemed to be going right, and I didn't think about it until later on—that I never shook off a single pitch that night. I had all the confidence in what he was going to call, and I had the confidence in myself that night, and we just rolled with it. That's kind of what he does. He has the ability to take over a game but never vocally do it. He just naturally does it.

He was just instilling confidence in throwing change-ups or breaking balls in counts where I normally wouldn't. Now I'll even look back and watch some of the game and think, "Wait a minute! I threw a change-up on a 3–2 count, with this on the line? What was going on here?"

It was just that he felt confident in it that night, so that's what we were going to do.

I watch the game now, and I'm nervous, even though I know the result. So yeah, he just has that ability to instill confidence in the guys. I think he might have learned that a little bit from Bengie Molina. That's the same thing that Bengie did. They have similarities that way behind the plate.

While playing golf together the last few off-seasons, we've brought up the perfect game. He'll always say that was one of his special nights playing the game, catching and calling that game. He's told me he was probably more nervous than I was. You never would have known.

Both of us were around the same age when we retired.

It's tough. We both came in at a young age. That's the hard part, what you wrestle with—you look at it and think, "Wait a minute! In society, you're only thirty-three or thirty-four years old. This is not normal." When in reality, you've been doing it since a young age, at a really high competitive level since your early twenties. It just takes a toll on your body.

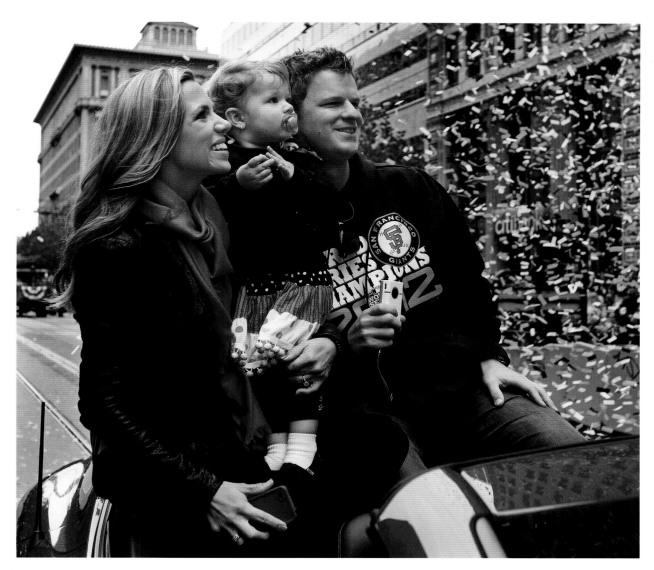

It's hard to wrestle with "Wait—I'm retiring from a job for the rest of my life? At this age? What am I going to do?" Then again, baseball is such a young person's sport, it's hard to keep up. There are so many factors that start to play in.

I know he has a lot going on with his family. He wants to enjoy them. A lot of guys come to that point: Do you keep pursuing and pushing the baseball career? Or do you have to say, "You know what? I've enjoyed this time. Time to move on. I need to be able to see my wife, my kids."

In 2021, it looked like he was healthy and finally comfortable doing a lot of things. He was running well. Behind the plate, he looked really good.

He also may have been of the mindset of "Look, I'm pretty sure I'm done." He might have known that at the beginning of the year and might have gone out and just enjoyed himself.

And that gives you a lot of freedom.

As the years went on, you started to get to know Buster. He's definitely a deep thinker. There's a purpose or a lot of internal thought when he makes a decision or says something to someone.

And there are a lot of things he'll end up pursuing for the rest of his life.

ABOVE: Chelsea, Hartley, and Matt Cain ride in the 2012 World Series Parade, San Francisco

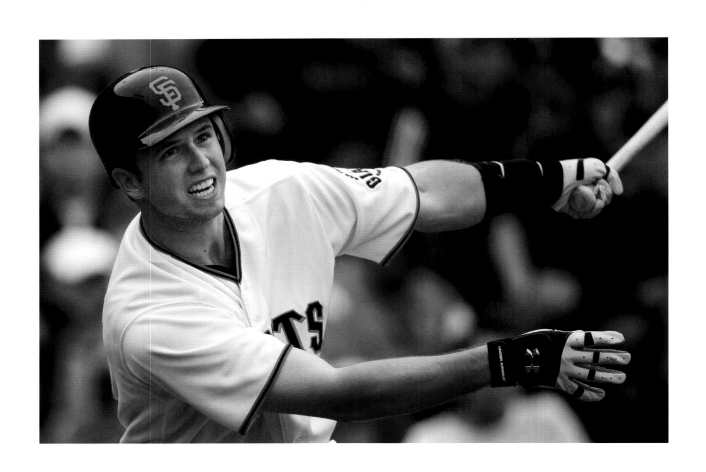

ABOVE: Going the other way for extra bases, Giants vs. Brewers, San Francisco, 2010

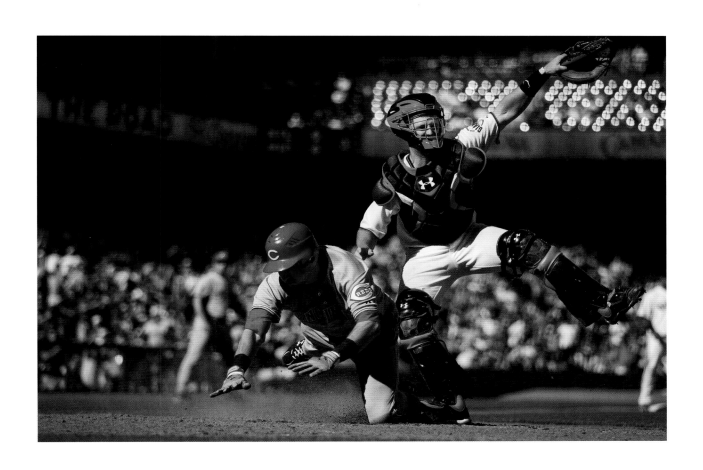

ABOVE: Tagging out Paul Janish at home plate in a game against the Reds, San Francisco, 2010
OVERLEAF: Sliding home safely, Giants vs. Padres, San Francisco, 2010

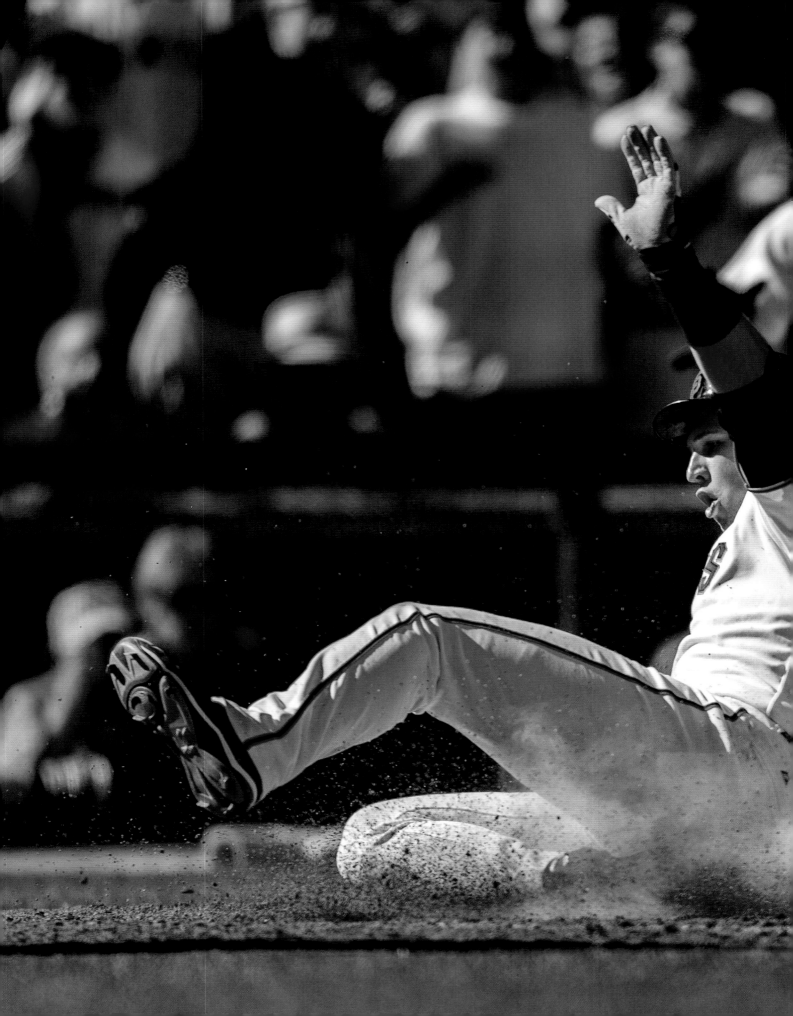

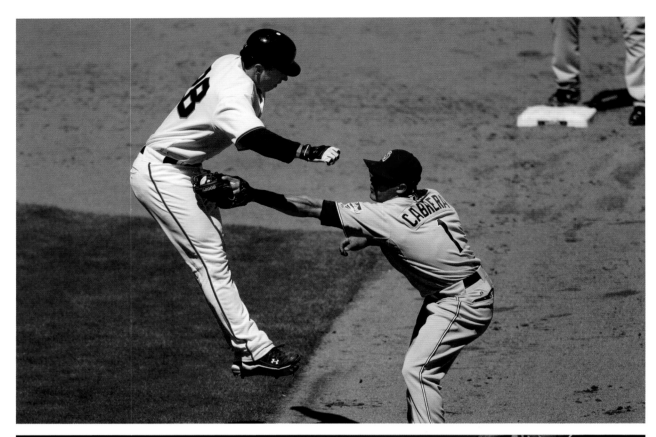

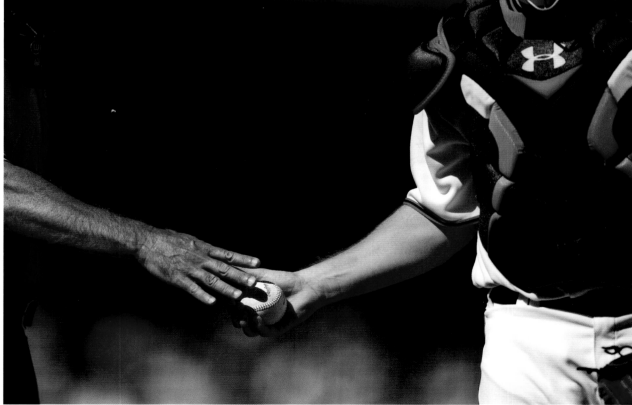

TOP: Buster is tagged out by Everth Cabrera in a game against the Padres, San Francisco, 2010
ABOVE: Getting a new ball from the home plate umpire in a game against the Reds, San Francisco, 2010

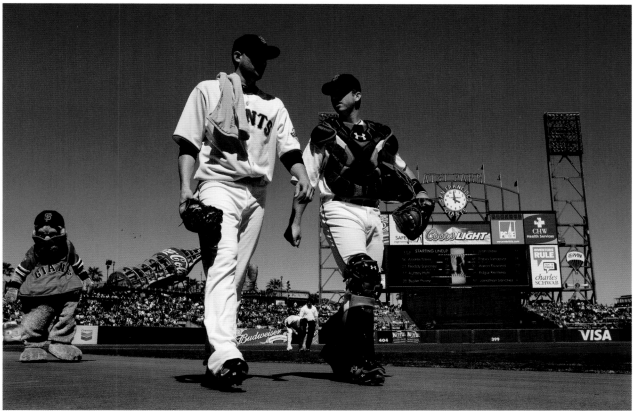

TOP: Chasing a pop-up during a game against the Marlins, San Francisco, 2010
ABOVE: Jonathan Sánchez and Buster walk in from the bullpen before a game against the Marlins, San Francisco, 2010

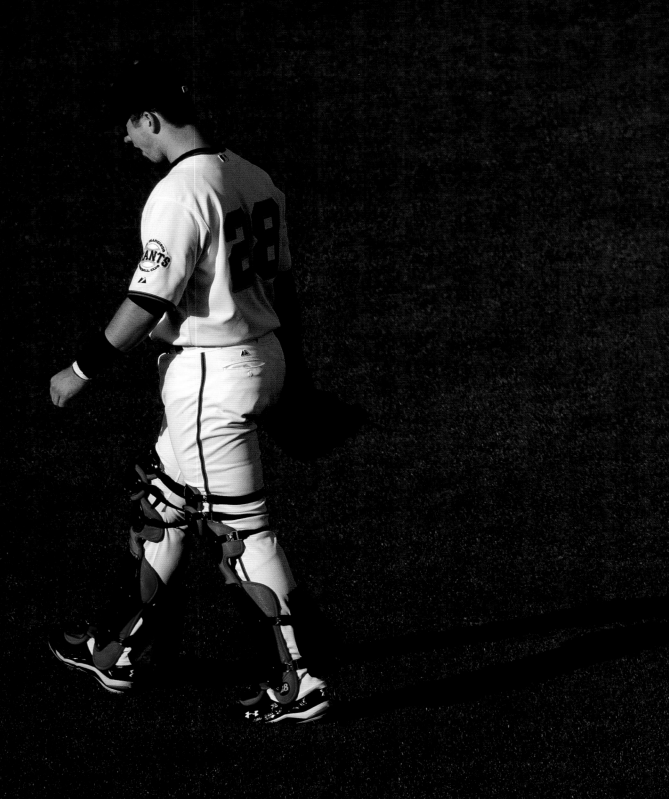

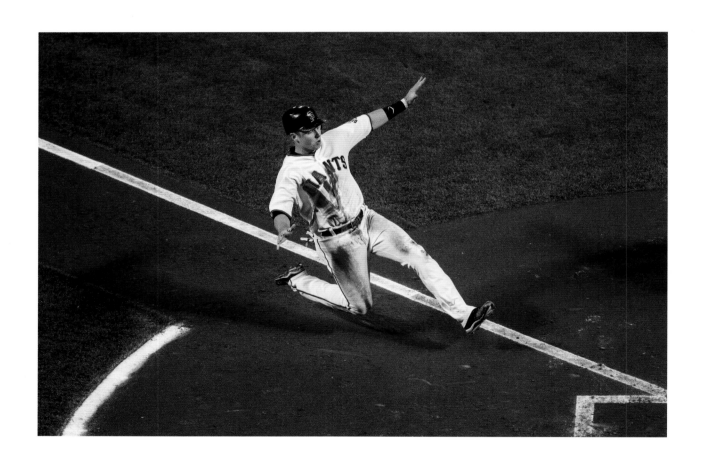

PREVIOUS SPREAD: Before Game 4 of the NLCS against the Phillies, San Francisco, 2010
ABOVE: Sliding home safely with the only run in the Giants' 1–0 win over the Braves in Game 1 of the NLDS, San Francisco, 2010

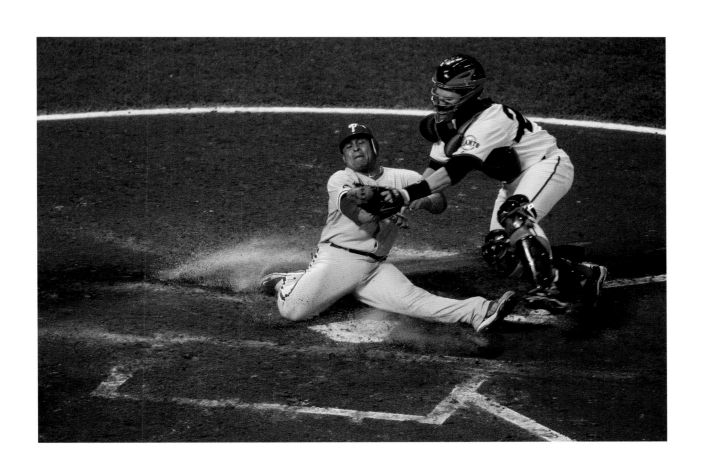

ABOVE: Tagging Carlos Ruiz out at home plate in Game 4 of the NLCS against the Phillies, San Francisco, 2010
OVERLEAF: Buster was only twenty-three years old when he took the field for Game 2 of the 2010 World Series against the Rangers in San Francisco

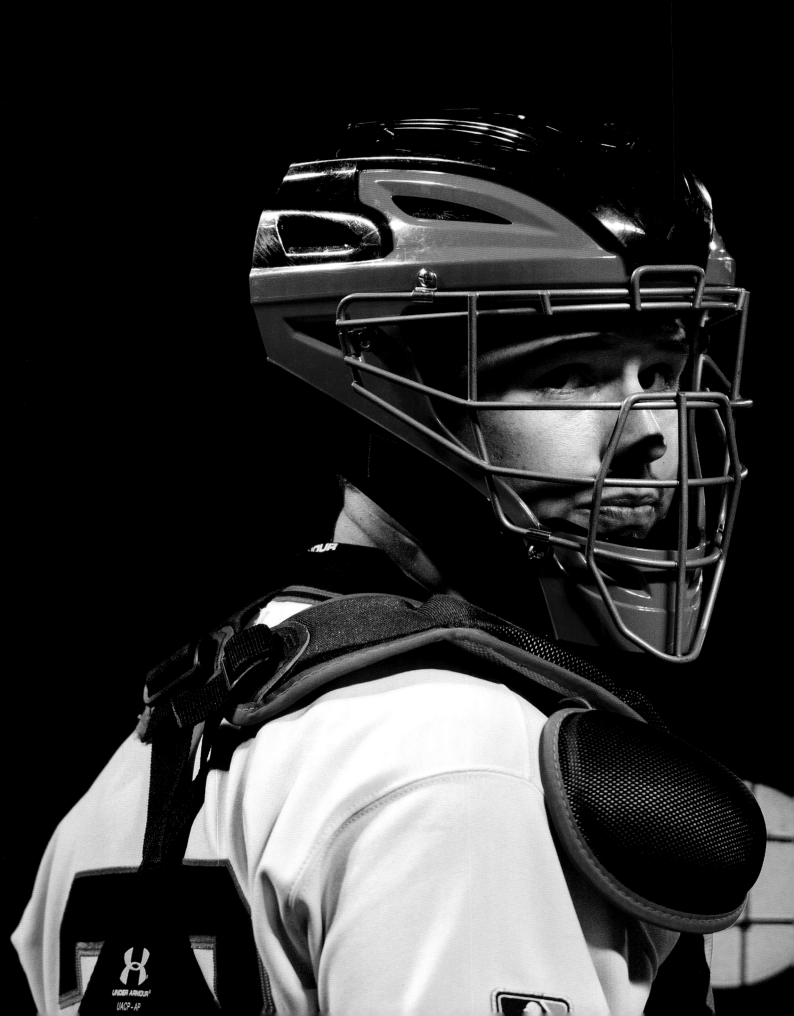

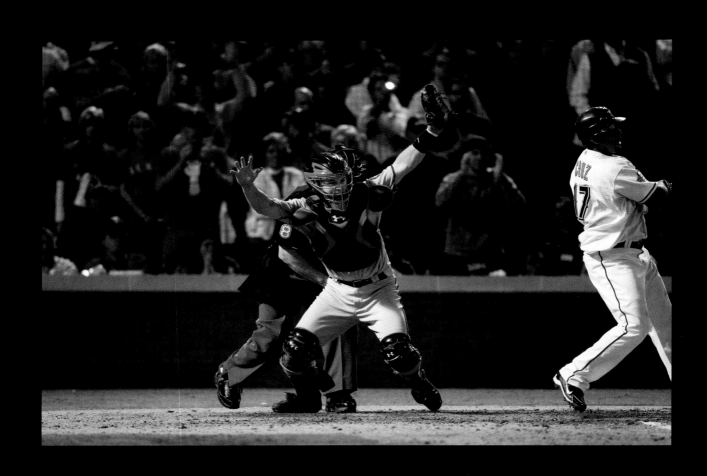

ABOVE & OPPOSITE: Celebrating after Nelson Cruz of the Rangers struck out for the final out in Game 5 of the 2010 World Series at the Ballpark in Arlington, Texas

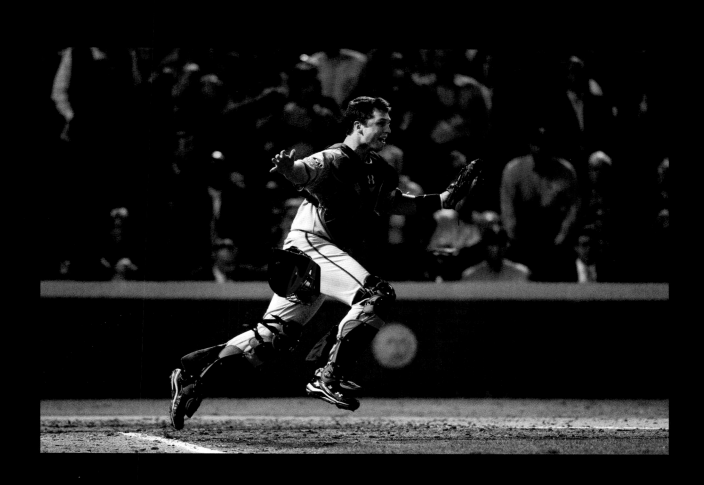

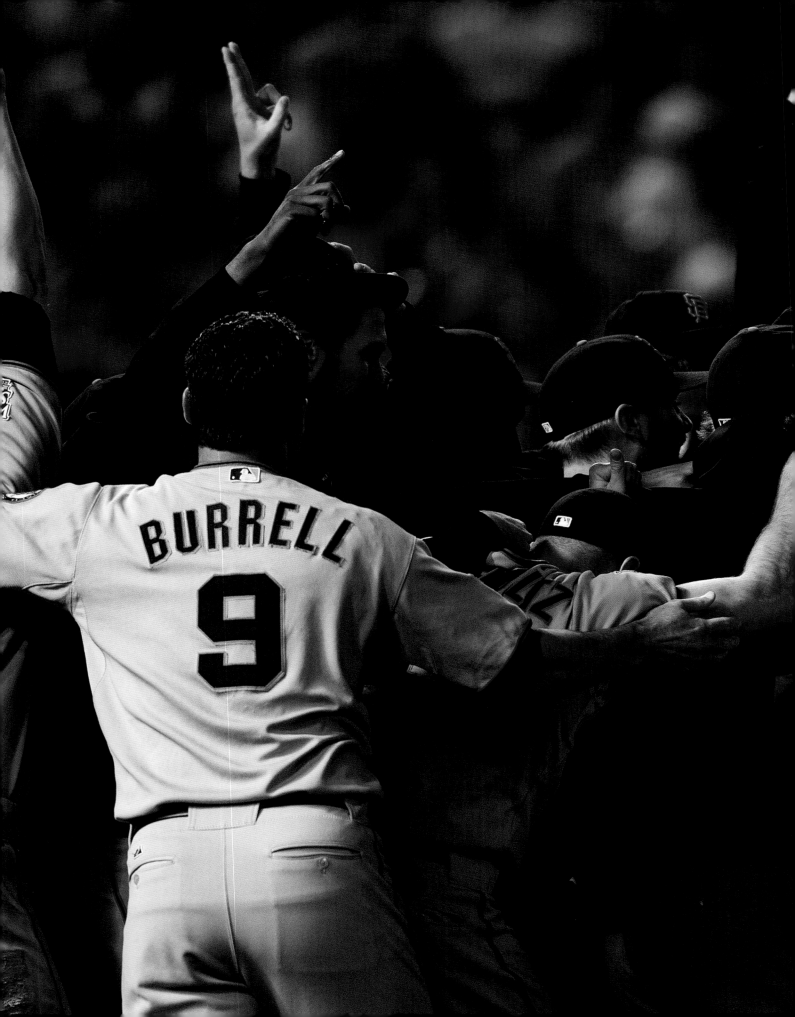

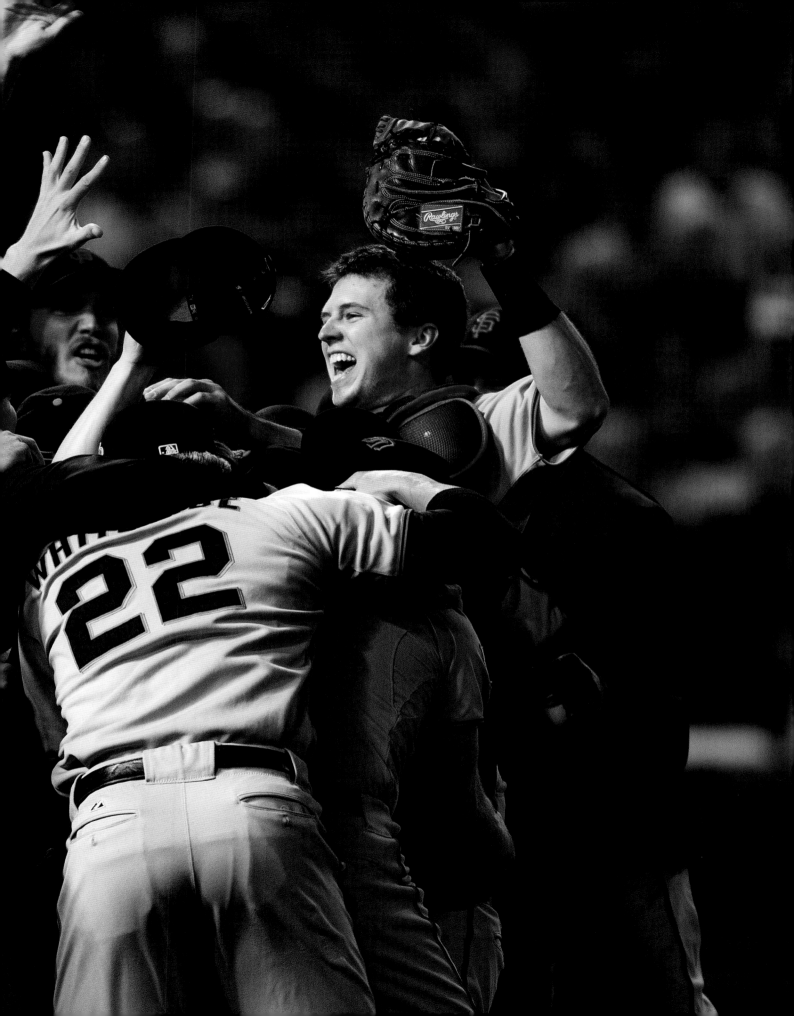

OPPOSITE: Holding up the trophy after winning the 2010 World Series against the Rangers at the Ballpark in Arlington, Texas

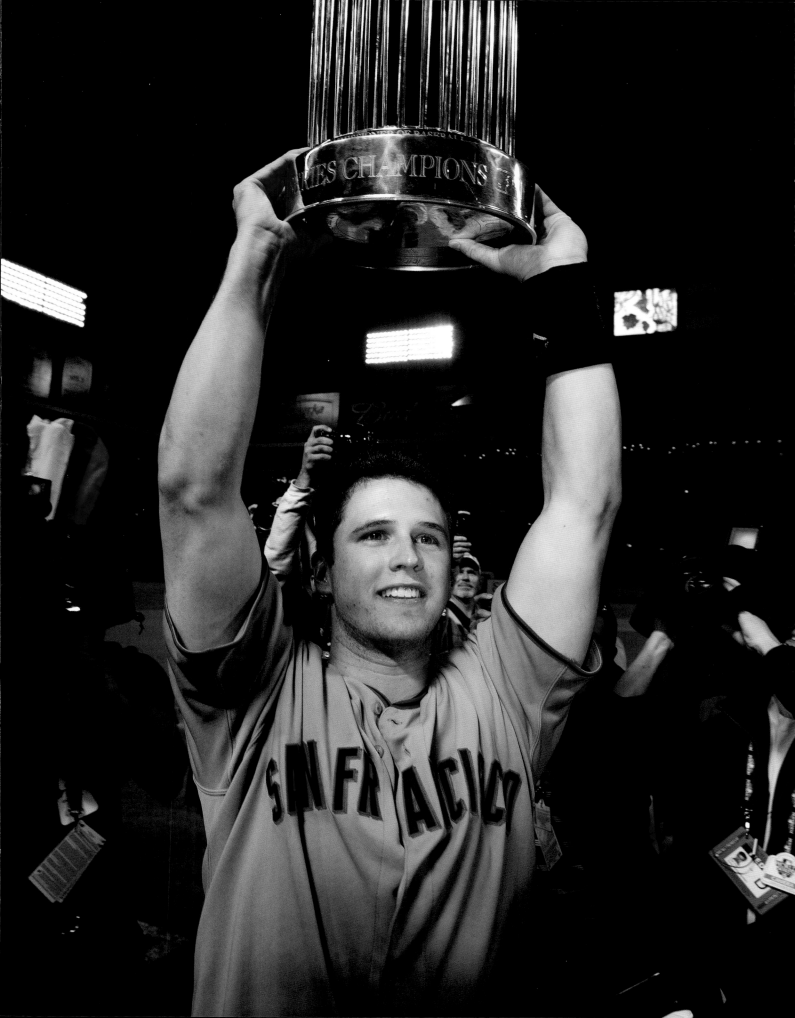

"...the least we can do is go out there and fight tooth and nail to the finish."

2011
—
2012

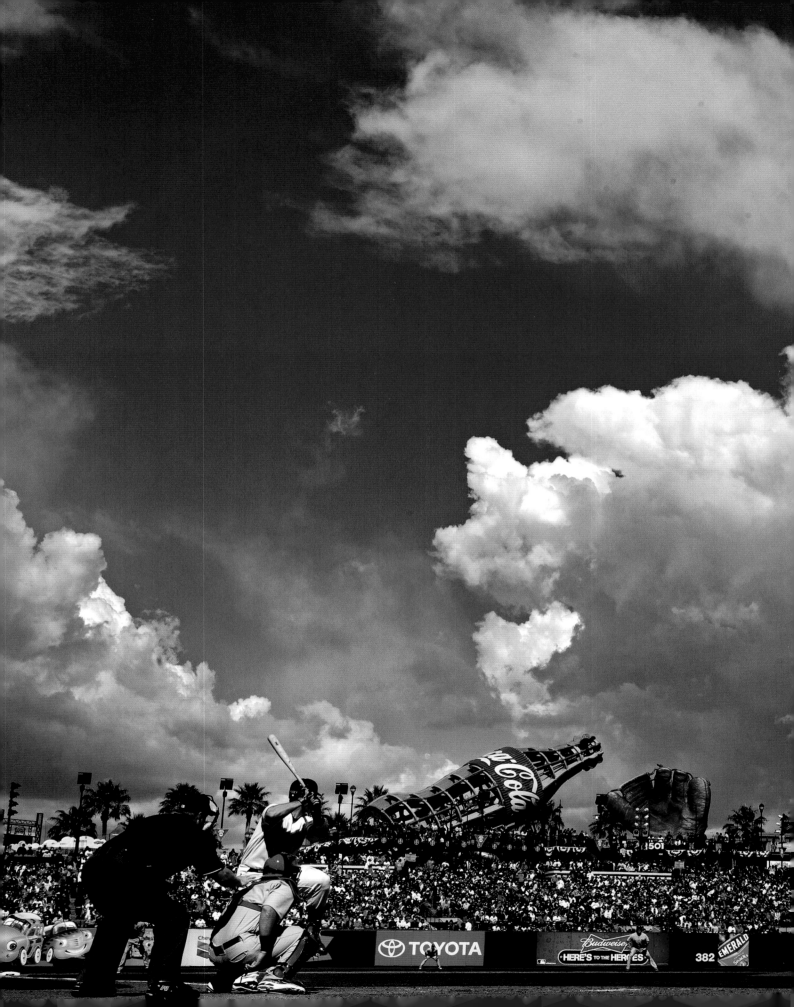

2010
WORLD
CHAMPS

WORLD SERIES
CHAMPIONS

AT&T PARK

SAN FRANCISCO

GIANTS

DIAMOND
OF CALIFORNIA

Culinary Walnuts

SAFEWAY
Ingredients for life.

Coors LIGHT

PG&E
wecandothis.com

CHW
Health Services

salesforce

PlayStation 3

IT ONLY DOES
EVERYTHING.
at&t

SAN FRANCISCO GIANTS
TORRES .292
F. SANCHEZ .360
HUFF .286
POSEY .296
SANDOVAL .391
AFFELDT .000
BELT .200
TEJADA .222
SCHIERHOLTZ .000

SEASON
.296 1 5 .345

Giants Bullpen

49 Javier Lopez L

ST. LOUIS CARDINALS
3 THERIOT SS .167
28 RASMUS CF .381
5 PUJOLS 1B .160
21 CRAIG LF .278
23 FREESE 3B .158
12 BERKMAN RF .261
4 MOLINA C .143
27 GREENE 2B .250
41 • BOGGS P .000

41 Mitchell Boggs SEASON
0-0 4.15 2 4

TALK TO
CHUCK

RE/MAX

charles
SCHWAB

at&t CARDINALS 0 1 0 0 0 0 0
 GIANTS 0 0 2 0 0 1

MITSUBISHI ELECTRIC

R H E LOB
1 4 2 4
3 8 0 8

1 1 1
at&t

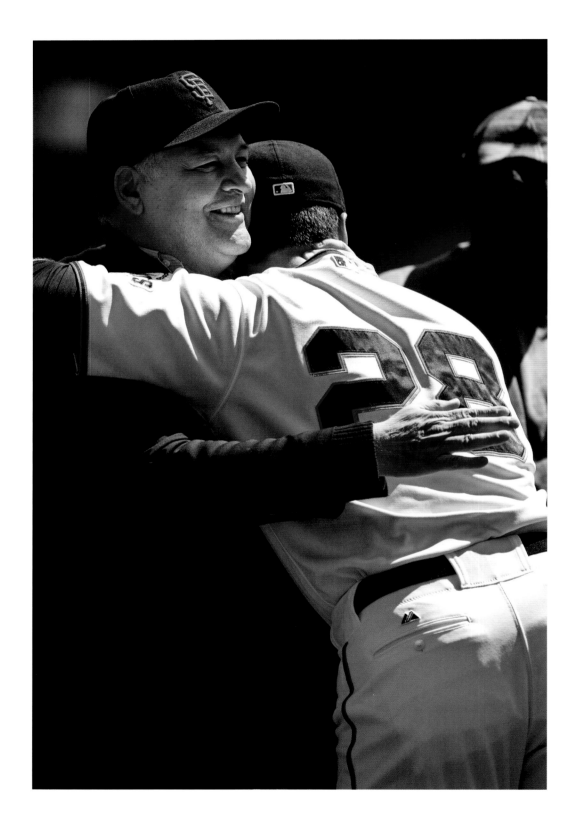

PREVIOUS SPREAD: Opening Day against the Cardinals, San Francisco, 2011
ABOVE: 1975 National League Rookie of the Year winner John Montefusco hugs
Buster as he wins the 2010 award during the ceremony, San Francisco, 2011

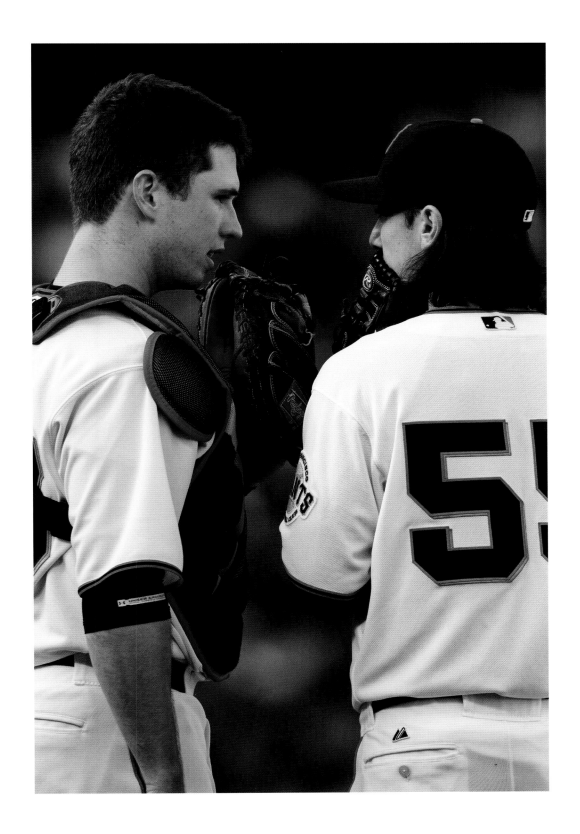

ABOVE: Buster talks to Tim Lincecum on the mound during a game against the Padres, San Francisco, 2012

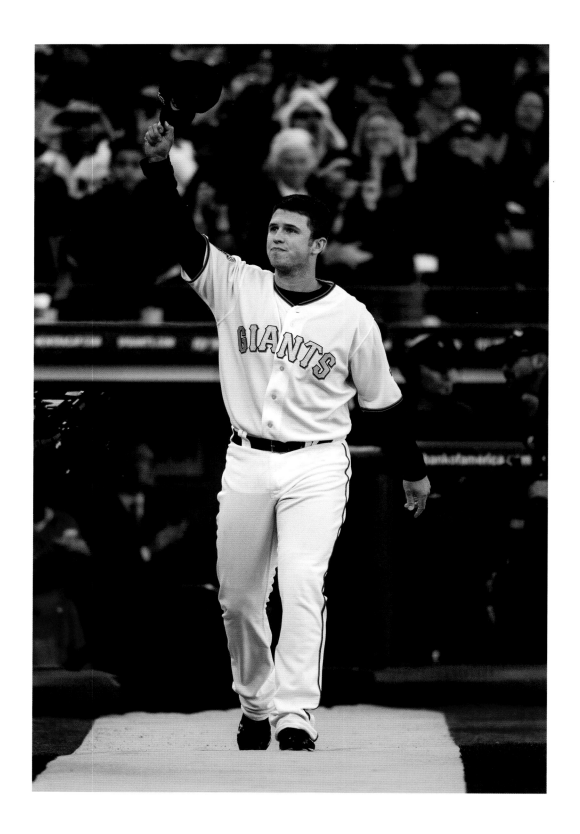

ABOVE: The first of three World Series ring ceremonies for Buster, San Francisco, 2011

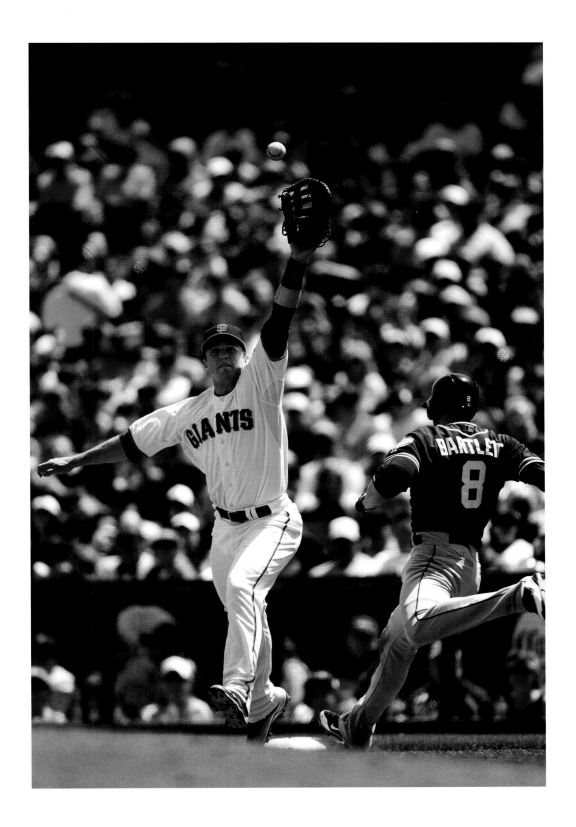

ABOVE: Reaching for a throw at first base in a game against the Padres, San Francisco, 2012

I **WROTE AN INSTAGRAM POST** when I heard Buster had retired, because once my brain settled on everything I wanted to say about Buster, I realized I had a lot to say about Buster.

I actually didn't know that about myself.

That's just a testament to Buster—how much I love the guy.

We can all resonate with the fact that this guy just has something that we all want to be a part of, whether on the field or off. He's got that presence, that calmness about him, you know? I was always taken with that. I was always taken with the fact that Buster didn't put getting attention on a pedestal the way that I always had, with my inability to regulate that stuff—but he always seemed regulated.

And I always admired that about him and always felt that that was going to lead to his ultimate success in the game.

People in any creative field—or any field, for that matter—succeed more when they care about the process and don't focus on the result. Buster seemed to do this in a special way. He had a perfect balance of, not in an in-different way, of being like, *My family and faith are what's really important in my life*, and that allowed baseball to take care of itself in a big way. I don't think he was ever invested in it to a point of malice to himself, which a lot of us were.

The Buddhists talk about being present. You know how it is when you get in that flow? And time slips away? That's it. Being intentional, getting in the zone—that's not something I figured out how to do when I played. The zone either did or didn't come to me, and sometimes it didn't, and it sucked.

But with Buster, I feel like he just knows. Some guys know how to get themselves there, day in, day out. Years ago, an old coach told me, "Michael Jordan said he can put on the zone like a coat." I feel like Buster could do that too.

His rookie year was 2010. I was in my own world in 2010. It was not good. But I think what we all knew from the start was Buster's presence—this aloofness, in a beautiful way—about the game. I think that was the first thing I noticed about Buster. Baseball was not who he was. Even though he was only in his first year, there was this collectedness about him.

Next thing I knew, we had won the World Series.

For me, through my most difficult years as a man, I do feel like he was steady for me. It all comes to a crux when he is able to catch me in these most magical games of my career. That played a role with the Instagram post, right? It had to. I'm just realizing that. My lowest of lows, my highest of highs in my career—both with Buster behind the plate.

Game 5 of the 2012 NLCS in St. Louis, when we were down three games to one—oh man, we were locked in. And I was just trusting him. He was calling that game. I probably shook a few times, but I just remember saying, "Hell yeah, Buster." I have total trust. He just called an amazing game. I remember those pitches. He's just call-ing stuff, and we were going with it. It gave me that exact feeling of being in the zone with Ramón Hernández back in the day. It was that kind of connectedness.

It was magical, dude.

I remember when Boch came to get me in the eighth inning, and Buster tapped my chest with his catcher's mitt. For anyone else, that's like kissing a guy in the middle of the field.

We got to the World Series against the Tigers, and I remember being in a headspace, thinking, *This is all icing.* Because I was pretty surprised at the St. Louis game myself.

So I thought, *Hell, yeah—this seems like a wave. Let's ride it.*

I was lying on the training table before Game 1, and I remember Gruzzie—our trainer, Mark Gruesbeck—was stretching me out. I looked over at the TV. ESPN was on. They had Justin Verlander's picture up, and I looked at his stats, and I saw something like 7–0, with a 0.63 ERA in his last seven games—playoffs included.

And I looked back at Gruzzie, and I just started laughing. I said, "Do you see that stat over there? Oh my God—we have zero chance tonight." I was in that mindset—know what I mean? I was like, "Whatever, this is gonna be fun."

It was the top of the fourth, and we were ahead, 4–0, but Prince Fielder singled to open the inning. Delmon Young was next, and he hit this weird chopper on the plate. Buster comes out, makes this frickin' genie-in-a-bottle play—throws the ball down to second—and we turn two.

I thought, *Oh man. Wow. That was incredible. Thank you very much for that.* A total momentum changer.

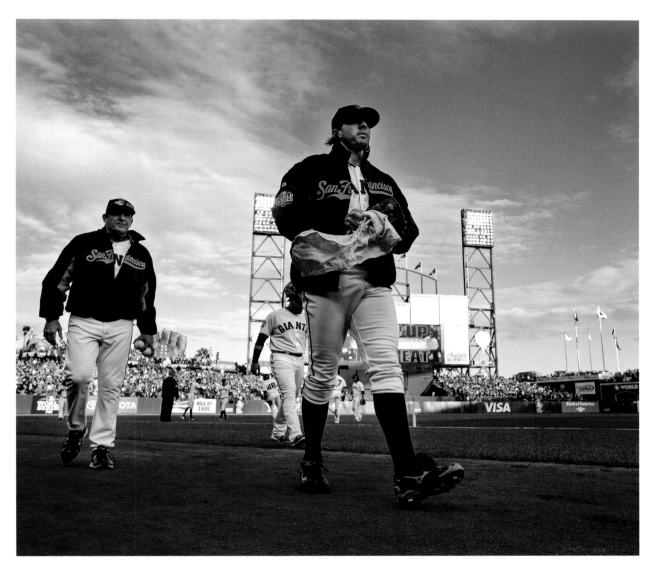

For a night or two, I got to feel what it was like to be on Buster's wavelength. Buster is the cool cucumber. He is the guy in the World Series, in the playoffs, and I'm saying, "Dude, do you know where we're playing right now? We are not in Leesburg. We are not at the local county fair."

He had the ability to ground the entire team, and to let us enjoy the game and let us not have a tight rear end. The team that loses is the team that suffers from that.

He's got the light, man. He's got the light. And it's contagious.

Look at his 2021 season after taking the entire 2020 season off. That's just going to work. Punch the time card. Be a superstar. Go home. Take your PTO for a year, whatever.

And for him to be able to walk away from the game on his own terms? Nobody gets to tell the game that! Greg Maddux walked away from an offer to keep playing. He and Buster. That's an all-kinda-different Hall of Fame right there.

Dude, that's just him. He gets the ultimate last laugh on everything. But he doesn't care to, which is the part that pisses you off even more, you know? He's the dude that we all hung out with in high school, and he didn't even have to try—he just got every girl. And you're over there, a rat running on a wheel, just trying to freakin' get shredded and go out and impress girls. And—nothing.

That's Buster, though. He always wins, dude. Whatever that currency is, he's the Bezos of swag.

ABOVE: Barry Zito, followed by pitching coach Dave Righetti, strides toward the dugout after warming up in the bullpen before starting Game 1 of the 2012 World Series against the Tigers in San Francisco. Zito went 5.2 innings, giving up just one run on six hits, earning the victory in the Giants' 8–3 win, igniting the Giants' 4–0 sweep and their second World Series win in three seasons.

OPPOSITE: Turn Back the Clock Day, Giants vs. Cubs, San Francisco, 2012
OVERLEAF: Buster catches a Ryan Vogelsong fastball against the A's, San Francisco, 2012

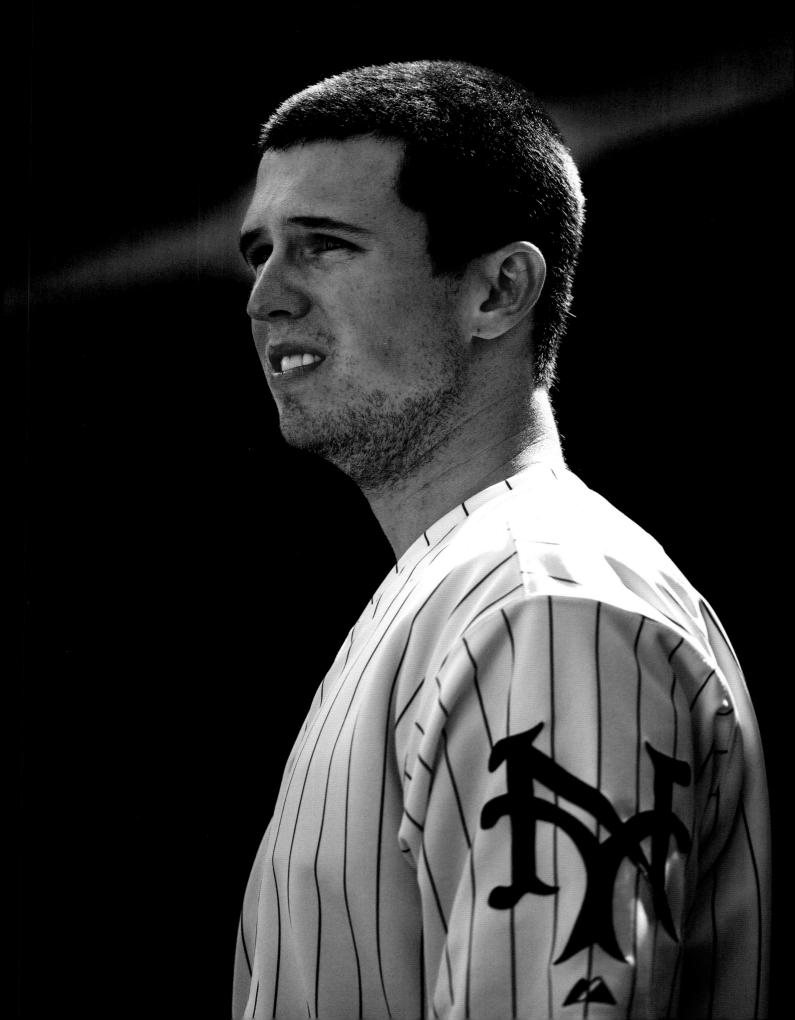

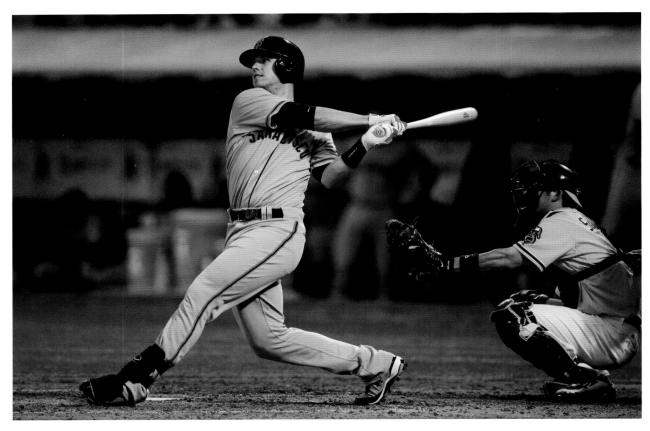

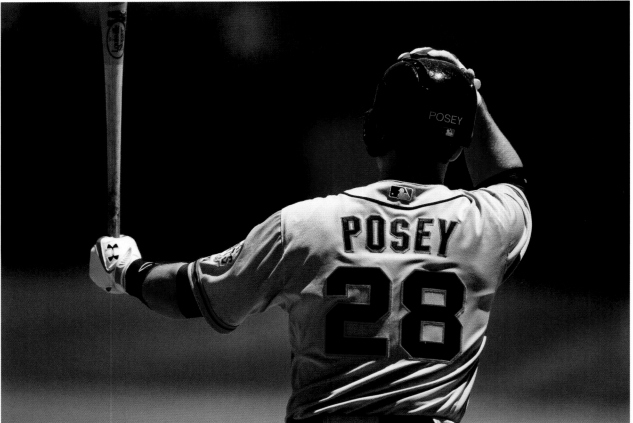

TOP & ABOVE: Batting during a weekend series against the A's, Oakland Coliseum, 2012

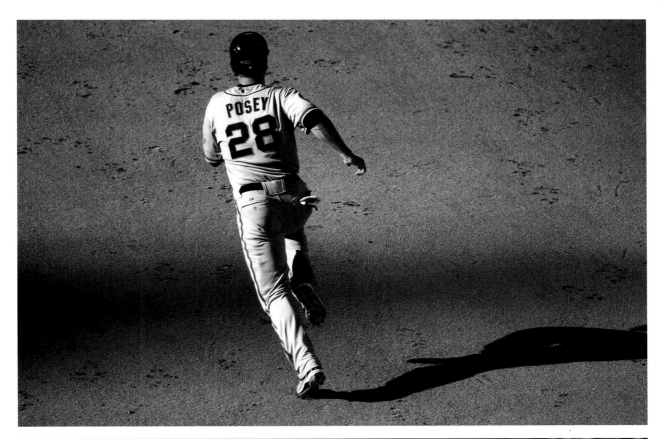

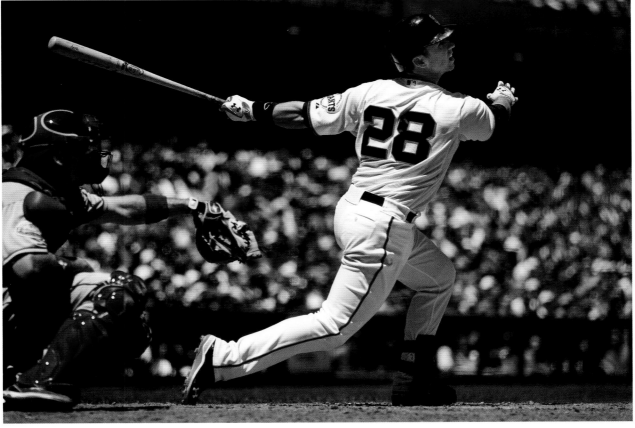

TOP: Sprinting toward second base during an extra-inning win against the A's, Oakland Coliseum, 2012
ABOVE: Buster shows off his beautiful opposite-field approach during a game against the Dodgers, San Francisco, 2012

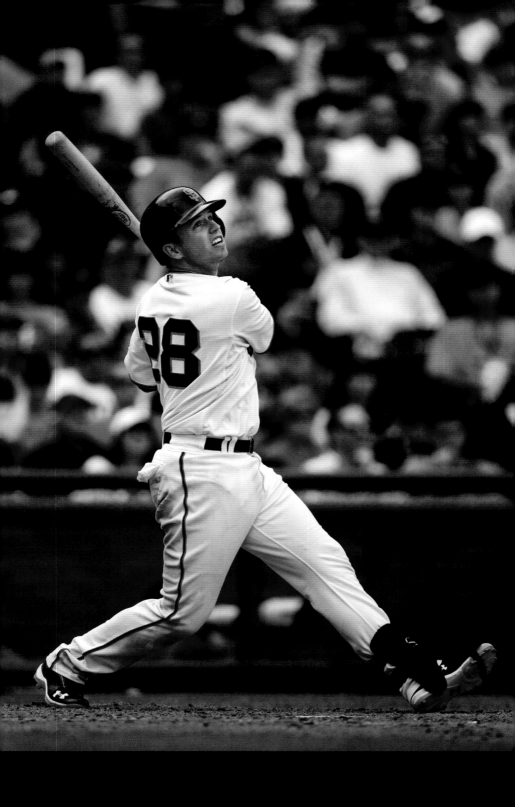

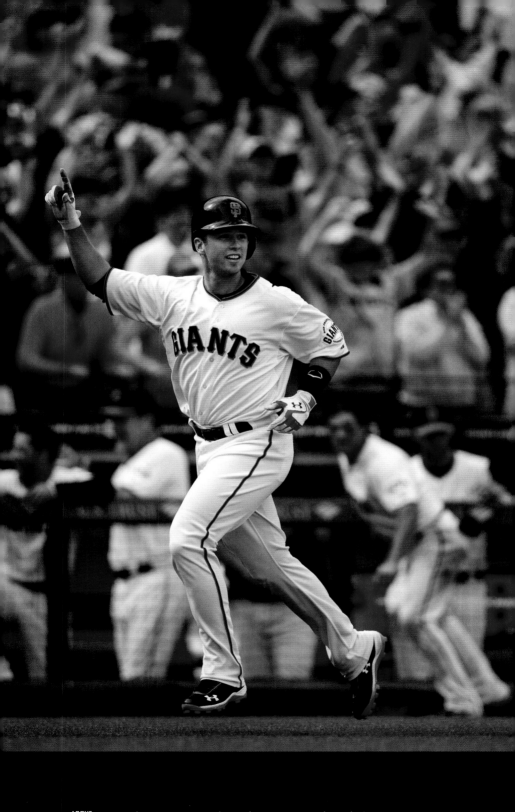

ABOVE: Scoring the winning run in the ninth inning against the Reds, San Francisco, 2012

OVERLEAF: Leaping for a wild pitch during Game 1 of the NLDS against the Reds, San Francisco, 2012

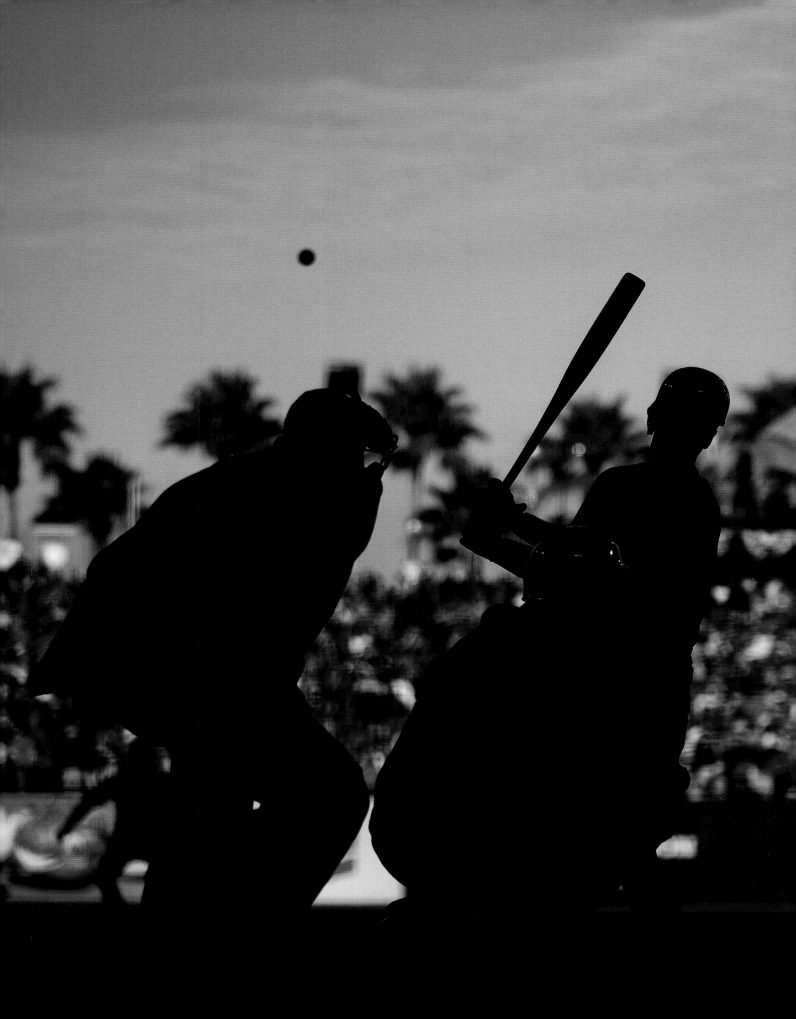

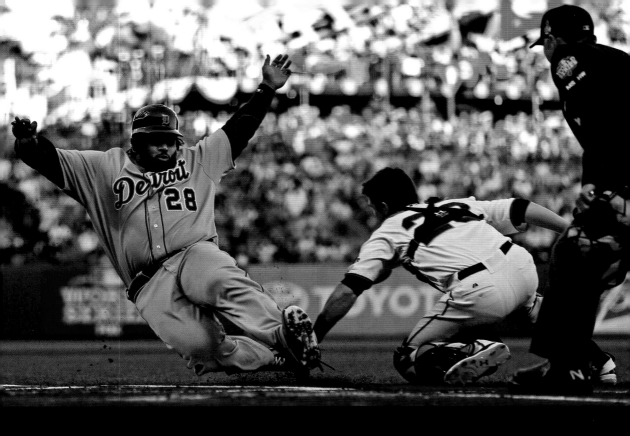

PREVIOUS SPREAD, LEFT: Buster's helmet sits in the dugout before Game 1 of the 2012 World Series against the Tigers, San Francisco

PREVIOUS SPREAD, RIGHT: Batting in the Giants 6–1 win over the Cardinals in Game 6 of the NLCS, San Francisco, 2012

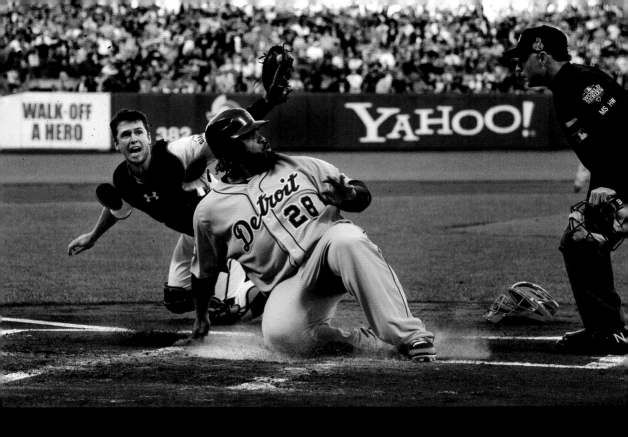

OPPOSITE & ABOVE: Buster tags out Prince Fielder at home plate during Game 2 of the 2012 World Series against the Tigers, San Francisco

OVERLEAF: Waiting in the on-deck circle during Game 4 of the 2012 World Series against the Tigers, Comerica Park, Detroit

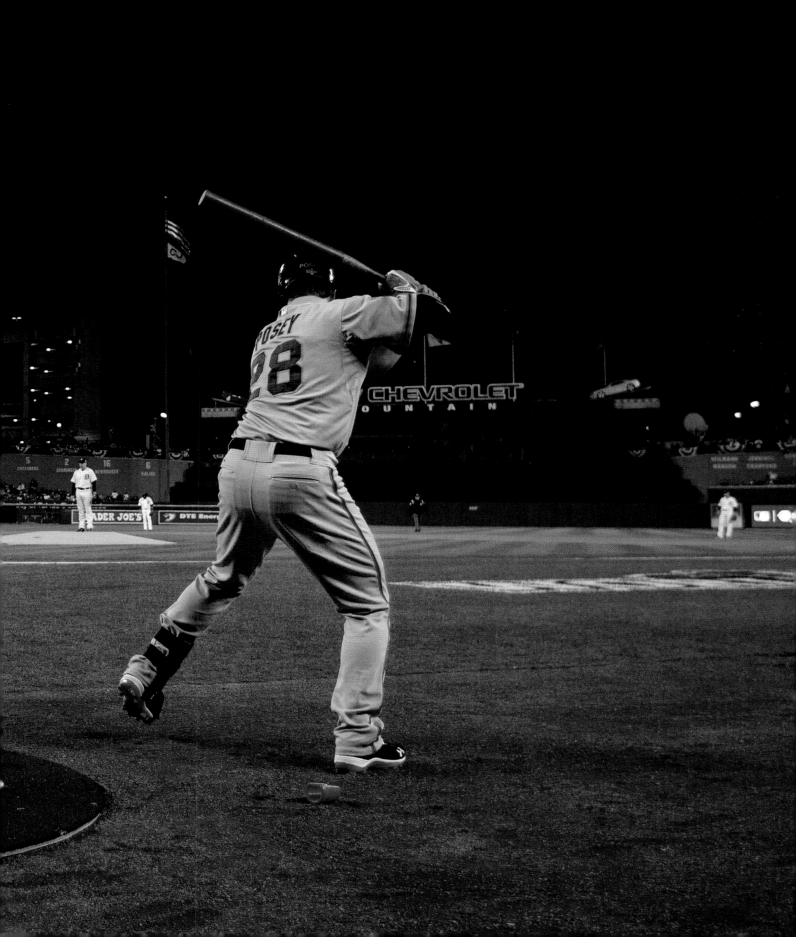

HIT THE GLOVE ▪ SERGIO ROMO

WHEN I MET BUSTER POSEY, I was on a rehab assignment in San Jose in 2009.

I got an opportunity to meet him and a couple other of those young lads that were there at the time. I don't know if you guys know the name Brandon Crawford? Yeah, there were quite a few guys down in San Jose in 2009 that did some things.

I did a rehab start and pitched to him in San Jose. I was excited, just because Buster was there. There was a lot of talk about him. My first full big league season was 2009, and I already knew who that dude was—especially knowing he had played all nine positions in college and had won the Golden Spikes Award, and all that good stuff he did in college. You know, stuff that most people have forgotten about already because of all the good stuff he's done as a pro.

First batter I pitched to him, I walked him on four straight pitches to start the game.

But this was the cool part about it.

First pitch to the second hitter—this is High-A, mind you—after four straight balls, Buster threw the guy out trying to steal second base.

From his knees.

So yeah, I remember meeting Buster. Put up a zero that day in that rehab start, that's for sure.

What set Buster apart then, and all the way through, was his preparation.

The guy was ready for just about every situation. It didn't seem like anything caught him off guard. I never saw him rattled. When he would shake his head, you couldn't put it past him that he was setting up the hitter, or setting up the pitcher, or setting up the other team in a situation. He knew who he was playing with; he knew who he was working with. He knew who was on the mound. He knew strengths, weaknesses of each pitcher. He knew how to work.

Even his personality in the clubhouse, he was ready. His demeanor. His presence. He doesn't really talk much, but those comments, those one-liners—they're sneaky and hot. You listen when he talks. It's hard to not be entertained, amazed, at the fact that the guy's been in the spotlight since he was, what, twelve? And yet, he's been the same model of consistency the whole time. The same figure. The same demeanor. Family first. Team. Respect. Work. Like clockwork with that

guy. You always knew what you were going to get. One thing you got for sure—he was ready for just about every situation.

Think about it: The guy's got a high stolen-base percentage for his career—he stole twenty-three bases in thirty-two tries during his career. He's very smart. He's instinctive. He's intuitive.

I do remember one pregame meeting—he said, "Hey, just hit the glove. You've done it all year. Hit the glove. Just do it." It was like he was saying to me, "Are you worried?" And it was like I was saying to him, "Okay, you can be the mature one. Cool, cool."

I do remember stuff like that. I remember him being as simple as can be and as direct and calm as can be in those moments.

I've had a few moments come my way where I thought, *Wow, that was tough.* It was so hard. The pressure was real. I can sit here and say, "No way I got through that."

But I don't think there have been situations too big for that dude, for Buster.

Guys that were part of those championship teams— I don't really think there was a moment too big for us. I do feel Buster was part of that mindset, part of that confidence. Whether it was quiet or loud, having him on our team—the Lincecums, the Cains, the Bumgarners, the Sánchezes, the Vogelsongs—those guys carried a certain confidence, and it bled to the rest of us.

And Buster was one of those guys who had that extra to give.

For the kids on the Giants, hearing the news that he had decided to retire must have hit them right away. When they saw "Buster Posey is going to announce his retirement," every single one of those young bucks, every guy that's three service years or fewer, they literally hit the "Oh no!" button a million times. The way Buster talks, the way he helps, the little things he notices, the attention to details—every one of those guys were thinking, *Oh no. Oh my goodness. I thought I had the best example possible. And now it's gone.* They felt it immediately.

Heck, I felt it. And I haven't played on the same team as Buster in how many years?

And even I was like, "Dang. Ooh!"

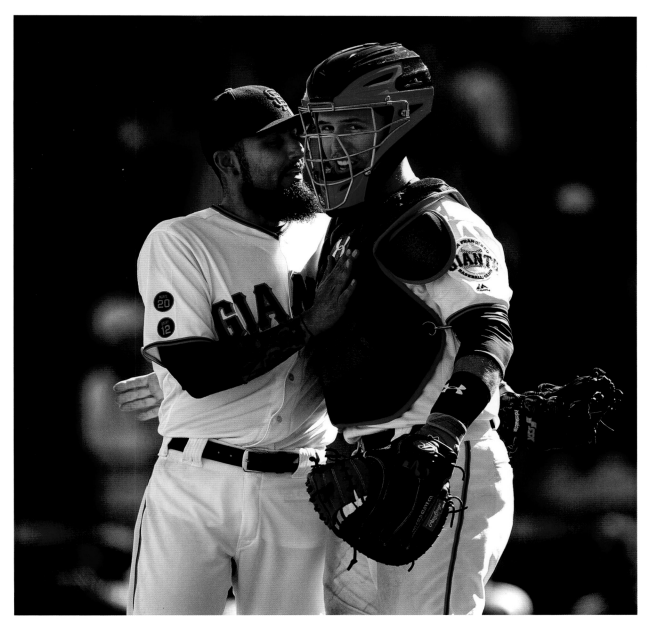

At the same time, I wasn't totally surprised he retired.

Through everything that happened to that team in 2021—yeah, you heard about Crawford, you heard about Belt, you heard about Logan Webb, you heard about Longoria, you heard about the trade for Kris Bryant, you heard about LaMonte Wade's breakout year—the one thing you always heard about was, "Buster took last year off and did this, and look at what he's doing"—and every single guy was turning around and pointing at Buster.

Every single guy kept saying, "Buster, Buster, Buster, Buster."

And then, during the celebrations, Buster was the only one, it seemed, staring out and seeing what was happening for what it was worth.

It was like he was taking everything in. I wouldn't say he was taking it in for the last time in those moments—but what if he was thinking, *Man, I'm gonna give this up?*

It's something he's always wanted.

Something he's always worked for.

Now, something he's achieved.

Not just making it. Not just reaching the best level.

Being one of the best, at the best level, every stinking year.

That's impressive.

ABOVE: Sergio Romo and Buster congratulate each other after beating the Dodgers 7–1 on the final day of the season to clinch a postseason wild card berth in the National League, San Francisco, 2016
OVERLEAF: Champagne celebration after winning the 2012 World Series against the Tigers, Comerica Park, Detroit

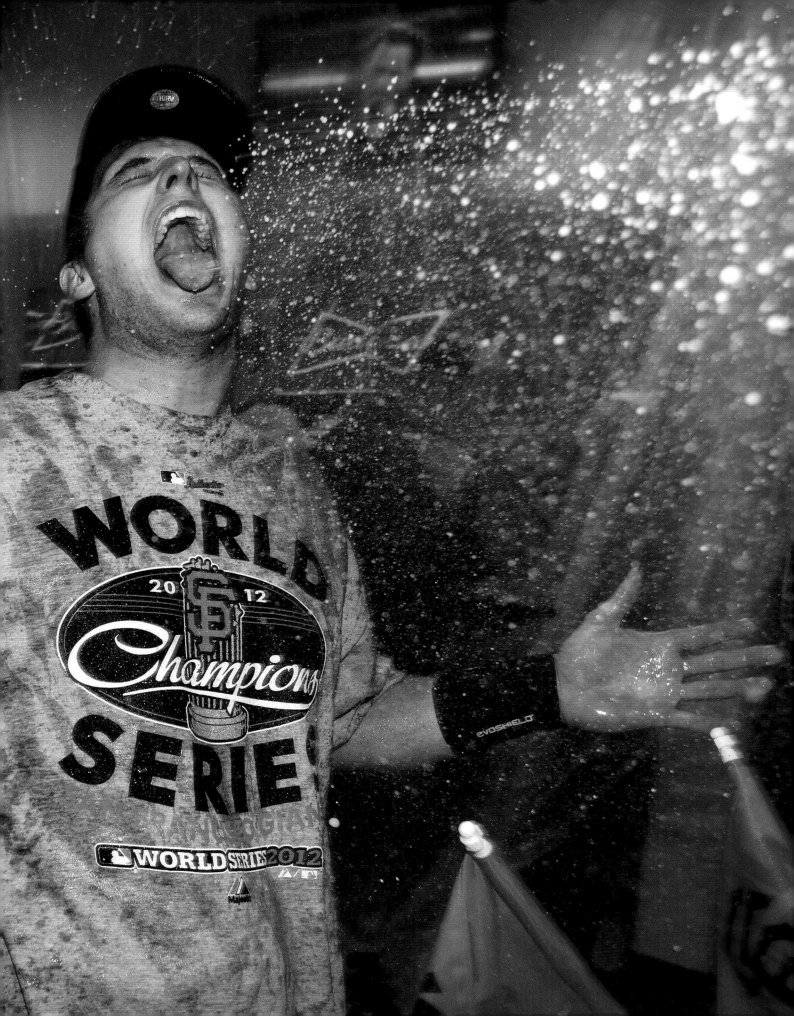

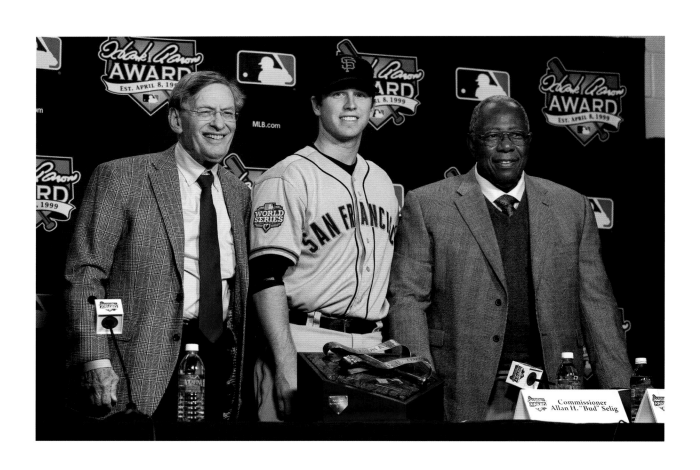

ABOVE: Buster, pictured with commissioner Bud Selig and Hank Aaron, wins the 2012 Hank Aaron Award during the 2012 World Series against the Tigers, Comerica Park, Detroit

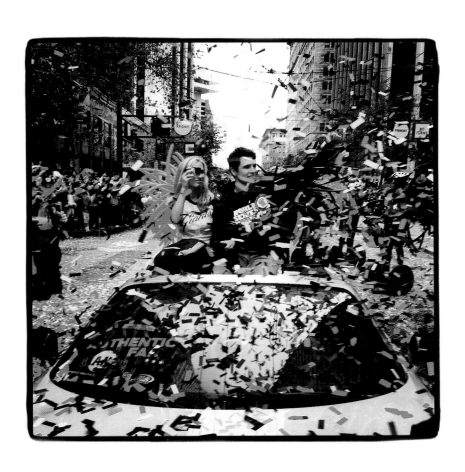

ABOVE: iPhone picture of Buster and Kristen Posey at the World Series parade in San Francisco, 2012

"I am glad I was twenty-seven at the time, because I don't know if I would enjoy it now like I did then."

2013
—
2014

OPPOSITE: Buster laughs with teammate Brandon Crawford in the dugout during a game against the Rockies, San Francisco, 2013

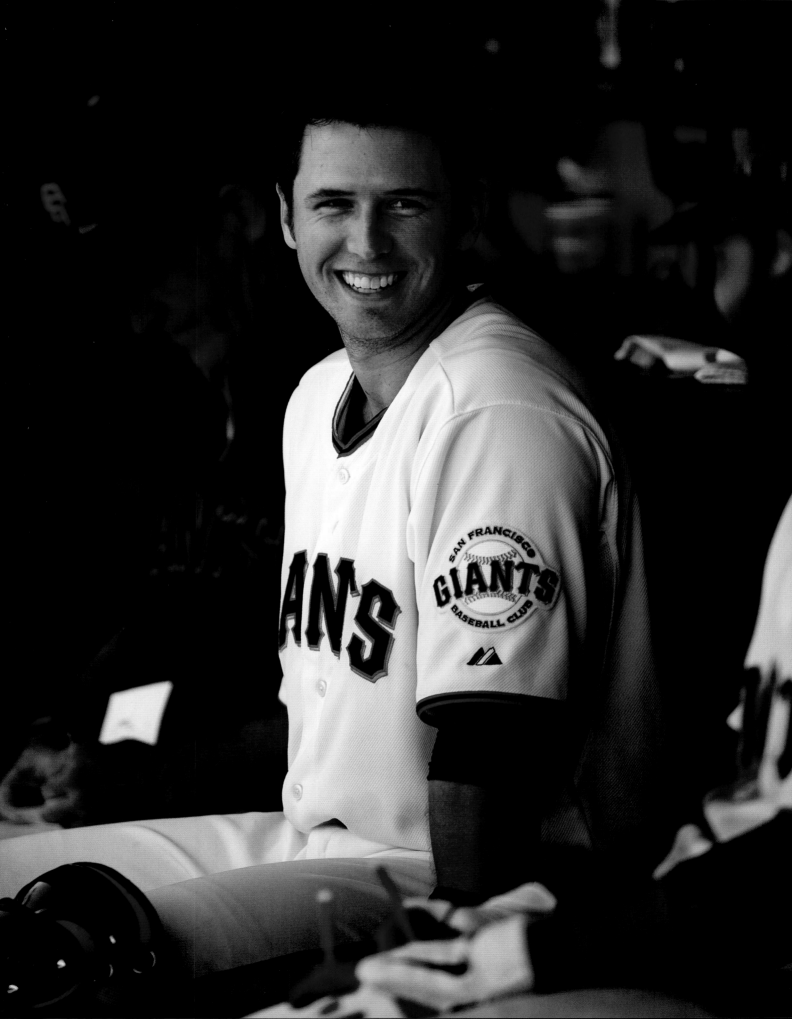

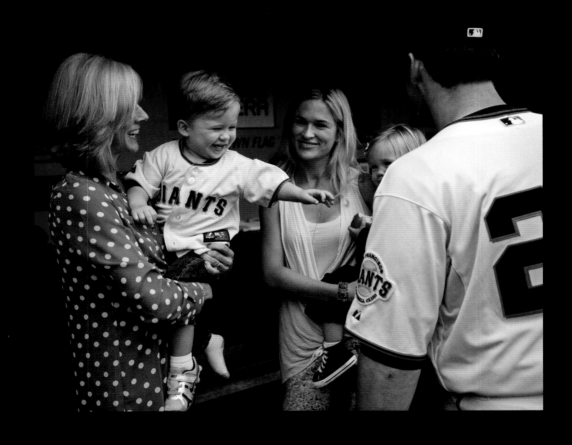

ABOVE: Buster with his mom, Traci Posey (holding his son, Lee Dempsey Posey), and wife, Kristen Posey (holding daughter Addison Lynn Posey), in the dugout before the 2012 National League MVP Award ceremony, San Francisco, 2013
OPPOSITE: Buster holds his son during the 2012 National League MVP Award ceremony, San Francisco, 2013

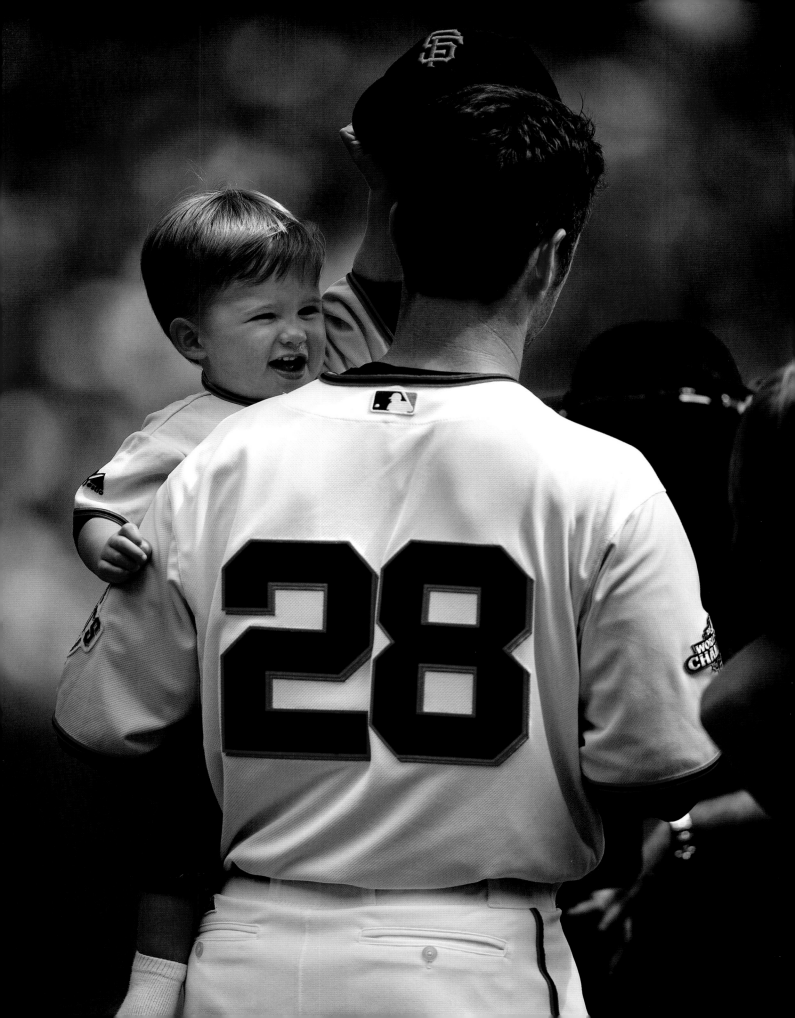

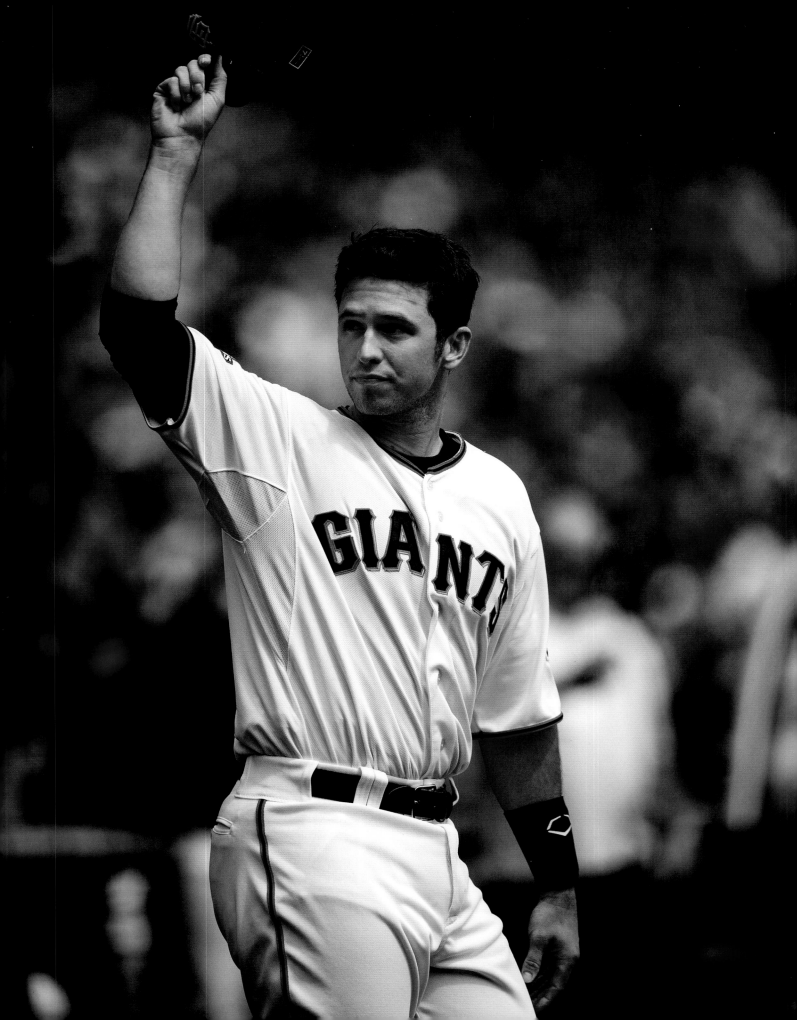

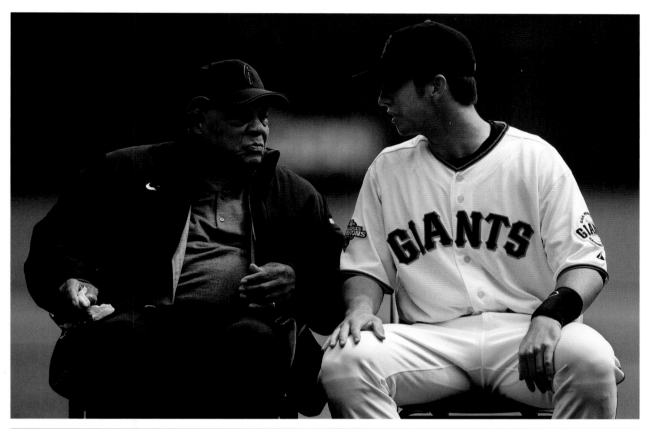

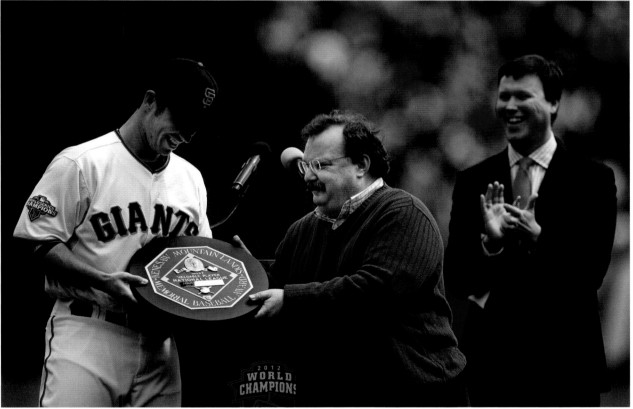

OPPOSITE: Tipping his cap to the fans during the 2012 National League MVP Award ceremony, San Francisco, 2013
TOP: Legend Willie Mays and Buster share stories during the 2012 National League MVP Award ceremony, San Francisco, 2013
ABOVE: Receiving the 2012 National League MVP Award from Ray Ratto during the ceremony, San Francisco, 2013

OPPOSITE: Standing on third base while the 2012 World Series banner flaps
in the breeze during a game against the Dodgers, San Francisco, 2013

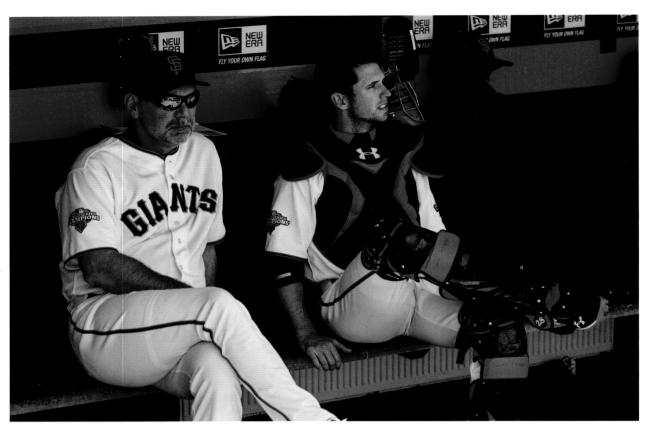

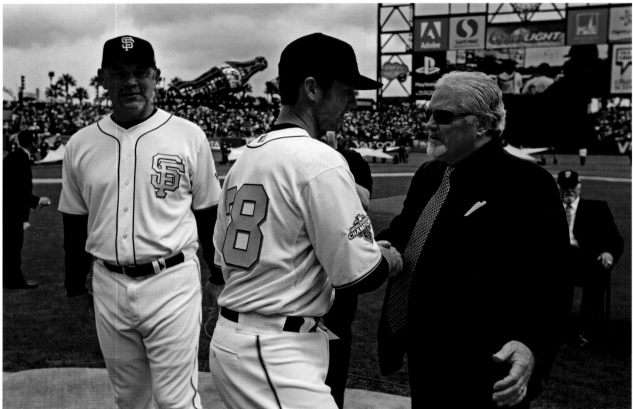

OPPOSITE, TOP: Bruce Bochy and Buster before a game against the Marlins, San Francisco, 2013
OPPOSITE, BOTTOM: Bruce Bochy watches Buster receive his 2012 World Series ring from Brian Sabean during the ceremony, San Francisco, 2013
ABOVE: iPhone picture of spring training, Scottsdale Stadium

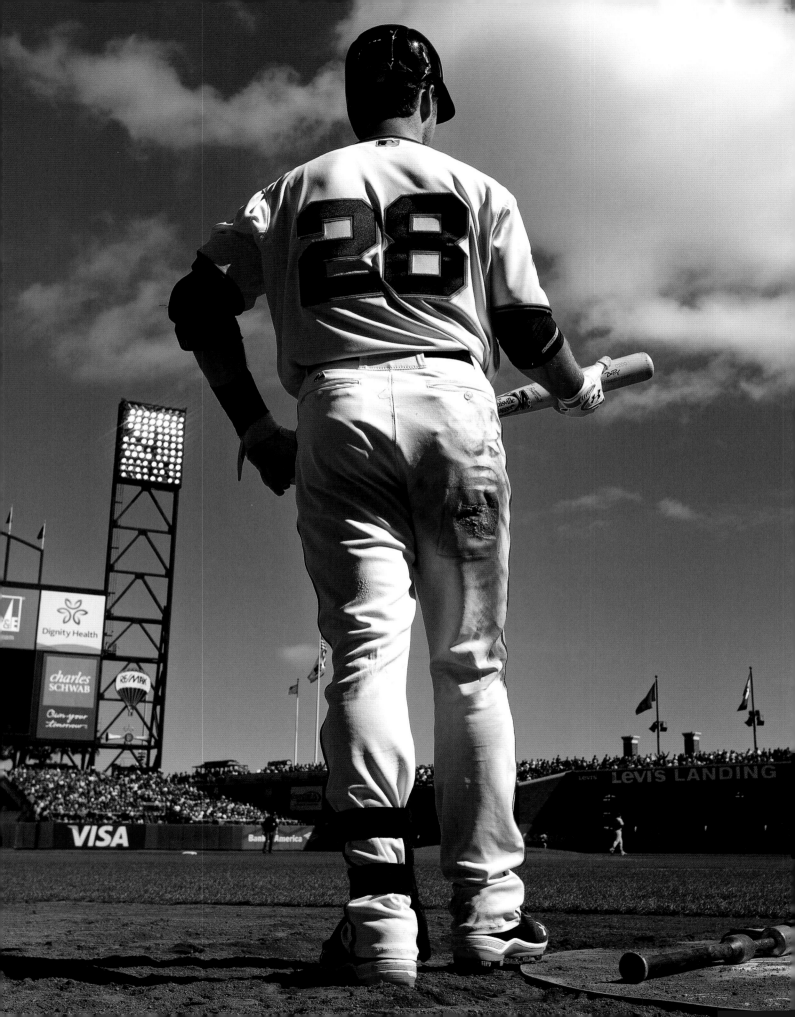

OPPOSITE: Waiting for his next at-bat in a game against the Padres, San Francisco, 2013
ABOVE: iPhone picture of AT&T Park at night
OVERLEAF: Swinging against the Padres, San Francisco, 2013

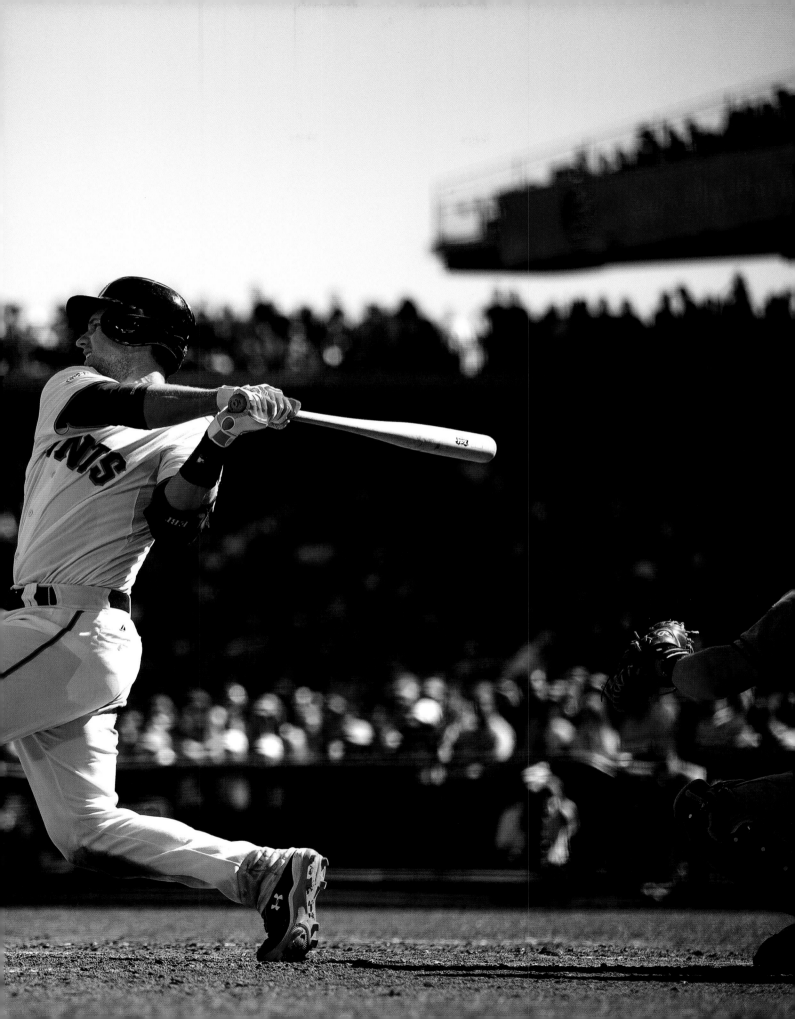

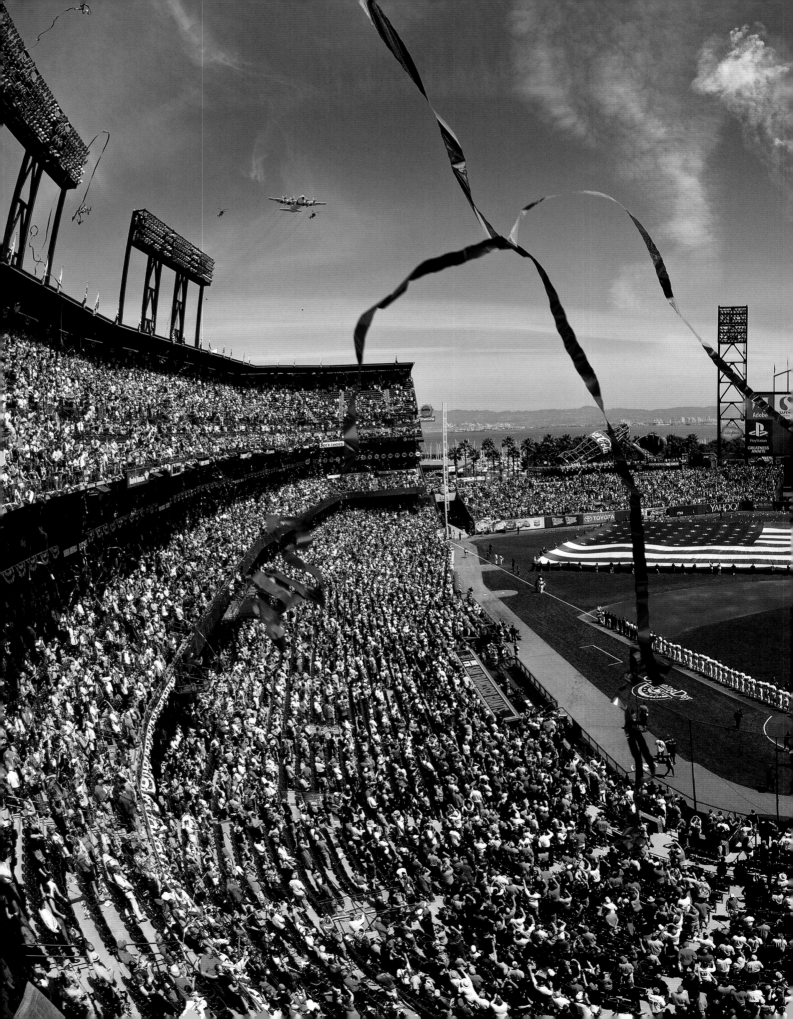

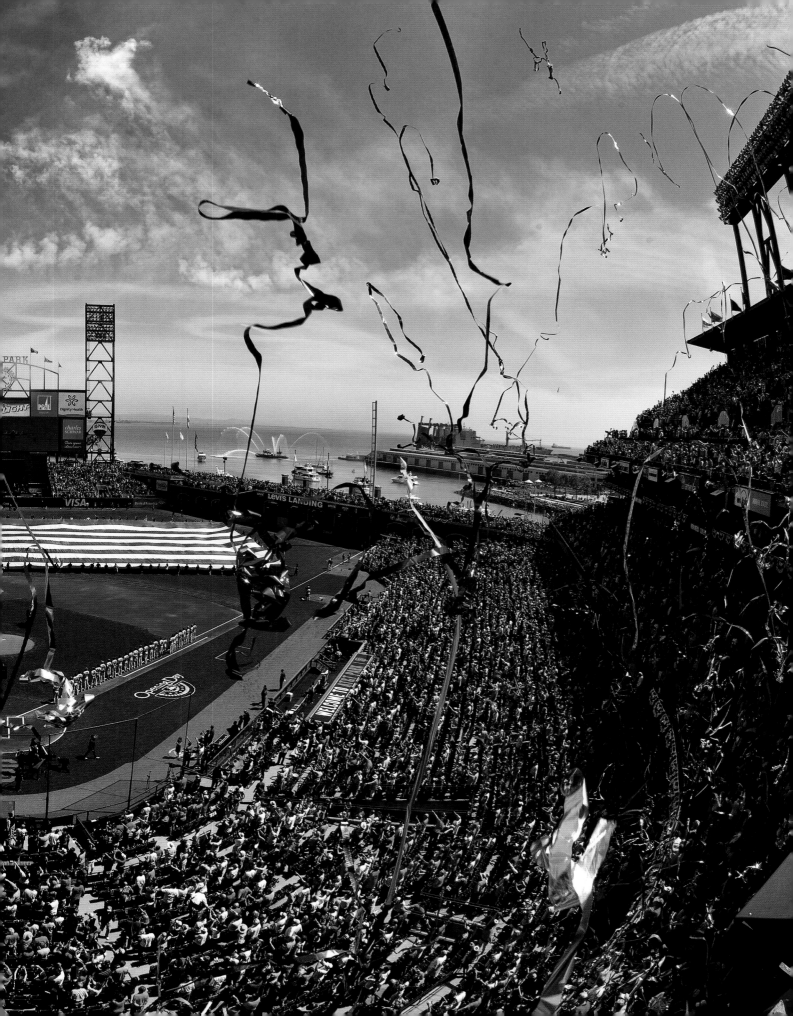

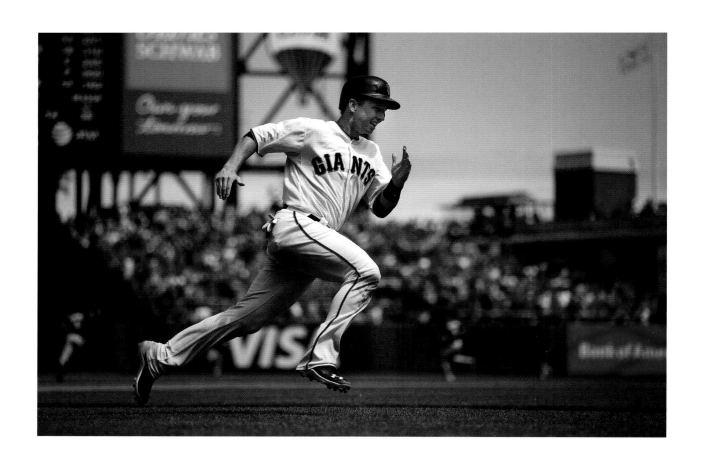

PREVIOUS SPREAD: Opening Day against the Diamondbacks, San Francisco, 2014
TOP: Rounding third and heading for home to score a run against the White Sox, San Francisco, 2014

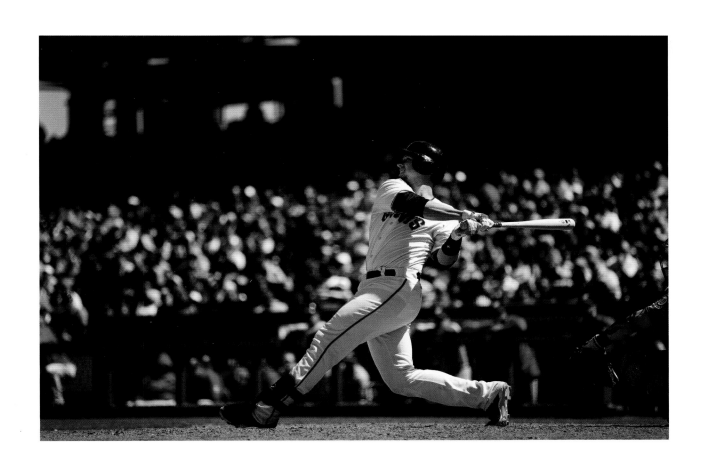

ABOVE: Batting against the Nationals, San Francisco, 2014
OVERLEAF: Stroking one to center field during a game against the Dodgers, San Francisco, 2014

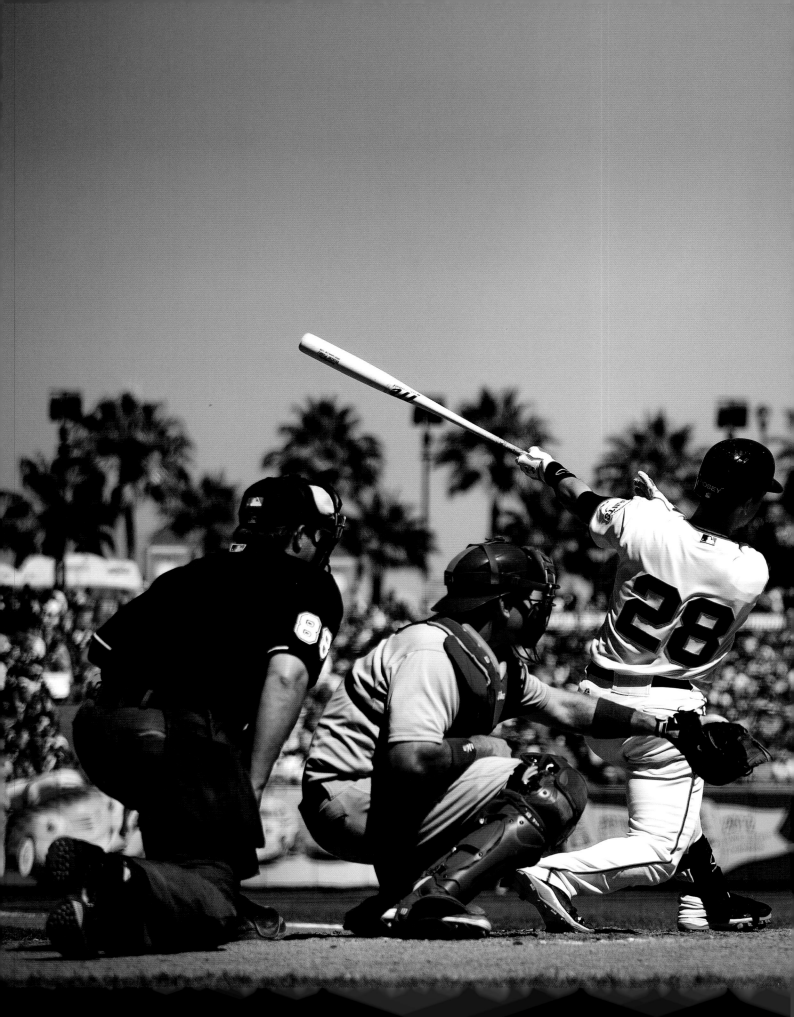

THERE TO COMPETE ▪ HUNTER PENCE

USUALLY, YOU SAY "HELLO" to catchers when you come to the plate, and usually, they're friendly.

When I played against Buster Posey, I definitely noticed that he was not very friendly. And you feel that. And then I realized later, getting to play with him, that that was intentional.

Not that he's mean. He's just not that interested in being friends with the other team. He's there to compete, and he's there to play. I think that it was like a competitive-advantage way to be, well, really fiery.

So, my first impression was that he was very disciplined, he did things the right way, and he was interested in playing the game and not that interested in talking to you.

When the Giants traded Bengie Molina, one of the great catchers of our time, in 2010, you realized what kind of a talent Buster was, and you were definitely interested to play against him and see what it was all about.

I noticed that a) he seems very humble—he's not a real flashy player—and b) if you think of Derek Jeter, who had an inside-out swing, a really good line-drive swing, Buster had such a good, natural, beautiful swing that was like a line-drive swing. If you take that swing and add some power, that's him.

I was with Philadelphia when he broke his leg in his collision with Scott Cousins in 2011. It was just awful to see. Obviously, you never wanna see Buster go through that, but I think it ended up being great for the catchers to come for our game to create this rule not allowing runners to collide with catchers, because we want to watch the skills, and we want to watch the best players play. I think baseball realized that the game is not better when our best players get blown up.

The Phillies were in Washington, DC, in 2012 when I saw on the ESPN ticker that I'd been traded to the Giants. I had thought that the Phillies were still trying to win, so I was shocked that they were trading me away. At the same time, I was very excited to be coming to the Giants, who were in contention.

I learned right away when I got to San Francisco that one of the coolest things about Buster, and the Giants at that time, is how relaxed they played. There was no tenseness, no uptightness. It was a lot more free, and learning that way really helped me in my career.

And it's exciting to be in a playoff race, and now I was really in one. Buster and Melky Cabrera were both insane—they obviously had an amazing pitching staff.

I don't remember my first encounter with Buster, but as we became good friends, as the story goes, I realized that he's definitely a very funny guy, probably something you wouldn't really realize if you didn't know him personally. He loves to crack jokes, and he loves to pick on everybody and rib a little bit, but for the most part, as far as baseball is concerned, he's very determined, very focused, and has one of the most competitive fires I've ever seen. The initial impression is reserved, calm, just like you would see in the media. You feel like he's thinking a lot more than he's saying.

And, of course, 2012 was the year he won NL MVP. (And when he won the batting title, we got him a kegerator, because he likes beer.) I'm glad he won MVP, because I was hitting behind him, and they just kept walking him. I think the only time I ever got 100 RBI was the year they walked Buster every time there was an RBI situation.

He was on everything. And he had the leg kick, and it was his timing, and he was young and so healthy. A lot of times, though, I think he was dealing with a lot more injuries than people realized. He's one of the toughest guys I've ever played with.

You could not fool him. He didn't leave the strike zone. He didn't get fooled by off-speed pitches—he was on the fastball. He was as locked in as I've ever seen a hitter. Obviously, he won the batting title, and he won MVP, and I think a lot of that was based on his offensive numbers, but truth be told, his defense is just as impactful—he was one of the best hitters in the game at one of the toughest positions to play.

It was absolutely insane to hit behind him and to see the power. I saw him hitting balls out of center field at the ballpark at night, which is one of the toughest things to do—especially back in those days, before the fences got moved.

When we got to the playoffs and were down 0–2 in Cincinnati, we were all in the clubhouse at a table, talking. The gist of the message was, "If we don't say anything, we're dead." And I said, "Well, I lost last year in the playoffs, and the pain of that year was like, 'I'll say anything,' but this is what I feel." *(Editor's note: This was the occasion when Pence made his now-famous motivational speech.)* Buster's one of the smartest players I've

ever played with. He told me after I talked, "You know, the one thing that it did was, it released the pressure of 'I've got to be the guy.'" For him, it did help. He said, "You know what? Yeah, who cares what's happened? Let's just go play to win."

So the fact that the calm guys allowed the rah-rah and jumped on board and said, "You know what? If this gets them going . . ." It was really nice, and nice of Buster to support it that way. The fact that Buster—a calm guy and not a rah-rah guy—got on board goes to show the level of teammate that he is and that he's got your back, whether he buys in or not.

Everyone talks about the grand slam he hit in Cincinnati in Game 5, but not many talk about his other big home run—in Game 4 in Detroit in the World Series, a two-run home run in the sixth when we were down 2–1. It was cold, the wind was howling in, and it was almost sleeting when Buster hit the home run to give us the lead. Who knows what would have happened if we hadn't won that game and they had turned their pitching rotation around?

But he pulled one right down the line through a very cold, stiff wind in Detroit. The grand slam, and that one—those homers were as clutch as you'll ever see, and I'll never forget. That's one of the swings that's implanted in my mind.

In 2014, he caught every pitch in our World Series run. We had gotten to Game 7, but the night before, Game 6, had been a Royals rout. And I know Buster was battling through some physical stuff more extreme than most people realize.

Buster took that on the chin, never told anyone, never said anything. And then he went out and played defense and caught the games and called the games like only he can, because he's a master behind the home plate at reading the hitter, reading the pitcher, having a feel for all of the things going on at once. He does it all so gracefully and so naturally that you don't realize how much he's impacting the game and how hard it is until you see another catcher come in that's not him.

The fact that he was that selfless means the world to all of his teammates and to all of us, and the Giants organization as a whole. I don't think he'll ever admit that, but I know that it meant the world to me that he was there catching those balls and making the calls in those moments that are as intense and pressure-filled as they've ever been. That series was so tight.

I'll never forget going through that. The chaos was so wild. Alex Gordon hit a tweener that hopped up on Blanco, and he couldn't pick it up, and the whole place was shaking. It was so loud.

And I remember being in love with the moment. I was like, *Thank you, God, universe, baseball gods, for letting me be a part of this moment—I'm in absolute love with it, and I'm ready. Let's play, and whoever wins deserves it.*

And I remember the tingly sensations of bliss, of joy, and thinking, *Man, if you hit the ball to me, I got you, but I'm watching Bum versus Salvy Pérez with a runner on third in Game 7 of the World Series.* I remember thinking, *I love this.* I was filled with this bliss even before the out.

When we won, I was extremely thankful. We were a very tight-knit group. We had gone through a lot together. They're family for life. And Buster, he's the same old nonchalant about his greatness. That's what I can remember most—his humility and his relief that we were able to get it done, because he's such a fierce competitor. I think it was a big relief that we were able to get that one done.

When I came back to the Giants in 2020, Buster was sitting out the year. You miss him in the clubhouse, and you definitely miss him on the field. What he's able to do behind home plate is second to none. You just can't fill that gap.

I don't think it's a coincidence the Giants won three World Series while he was there. He's in his own class. If there was another level beyond the big leagues, that's where I think Buster would belong.

I wouldn't say I was shocked when he retired. I know how much pain he's gone through and how much he misses his family. I've never known someone to miss their family more on the road.

And he opened my eyes to the perspective of how fun it was to come home. I think his longing for home leaked into me. And obviously, San Francisco is such a fun place to come back to, and our stadium was so amazing. But I think you felt how much he missed his time with his kids.

I sent him a video thanking him, congratulating him on a great career and wishing him the best. I cracked a few jokes. That's our relationship. Buster's always cracking jokes.

He's a dude. And the Dude abides.

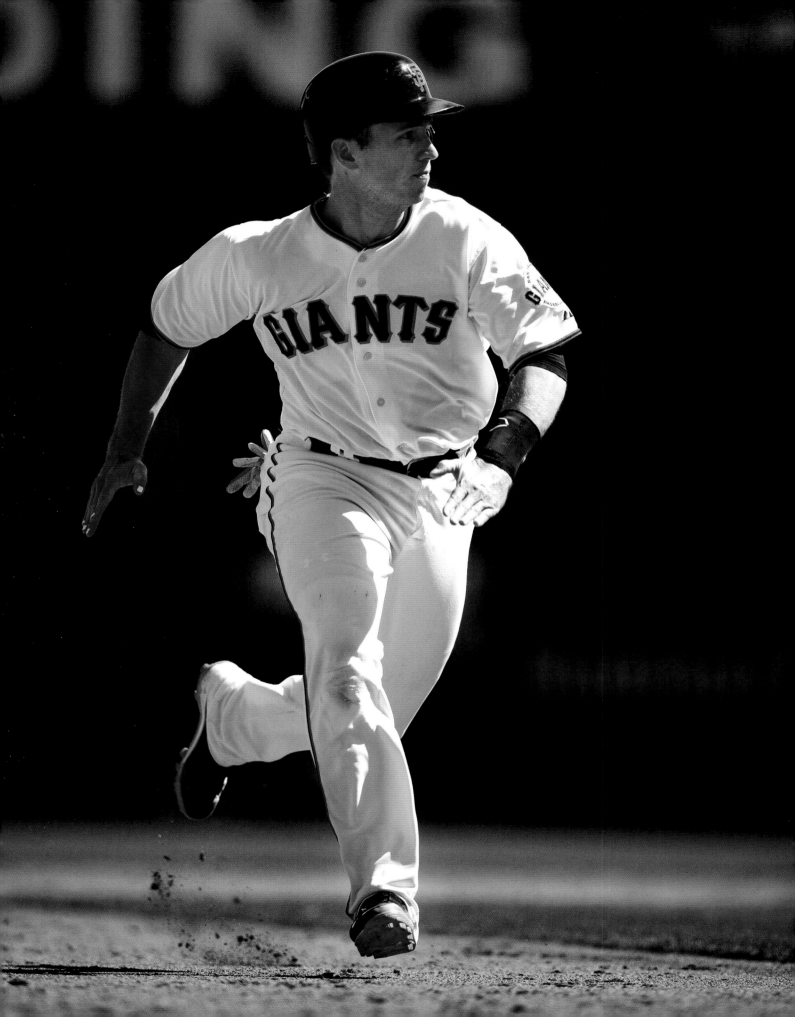

OPPOSITE: Going from second to third against the Diamondbacks, San Francisco, 2014

OPPOSITE: Gearing up before a game against the A's, Oakland Coliseum, 2014
OVERLEAF, LEFT: iPhone picture of the park at night
OVERLEAF, RIGHT: Champagne bath after beating the Cardinals in Game 5 of the NLCS to win the pennant, San Francisco, 2014

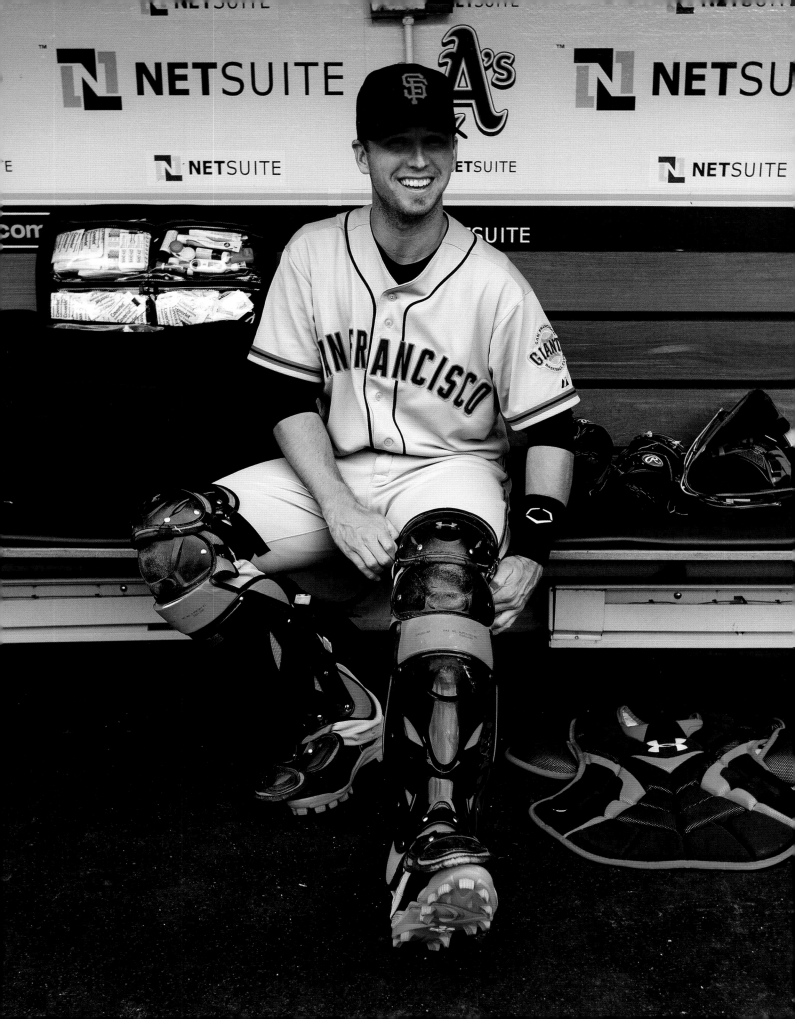

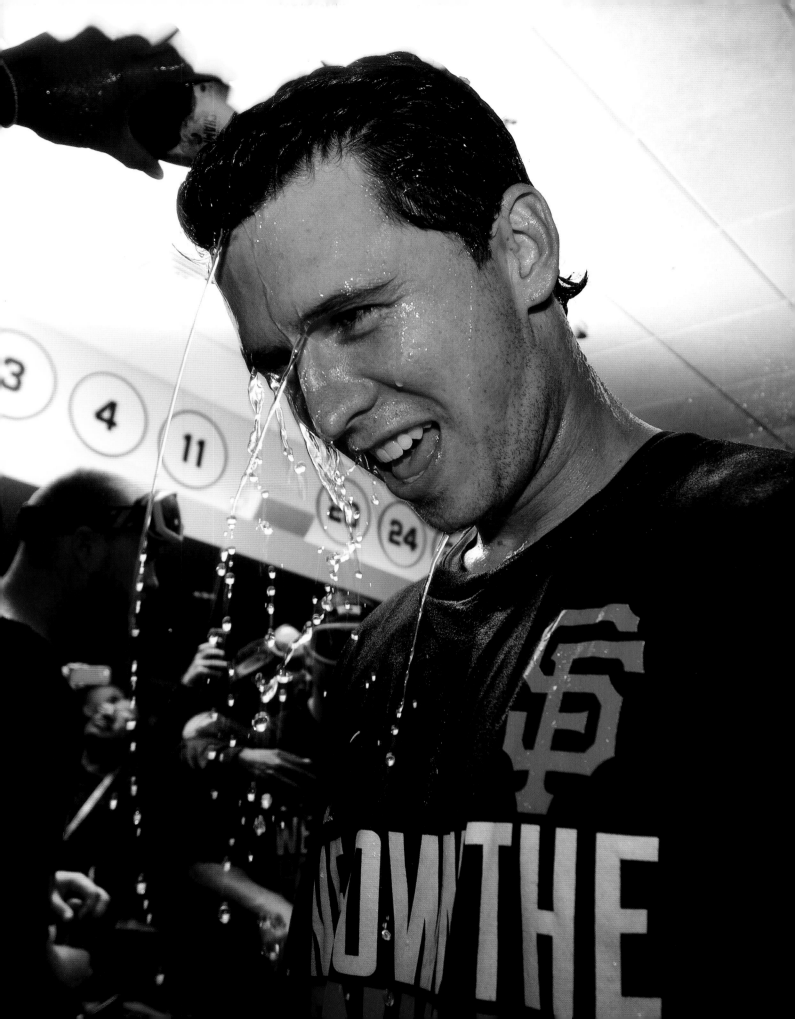

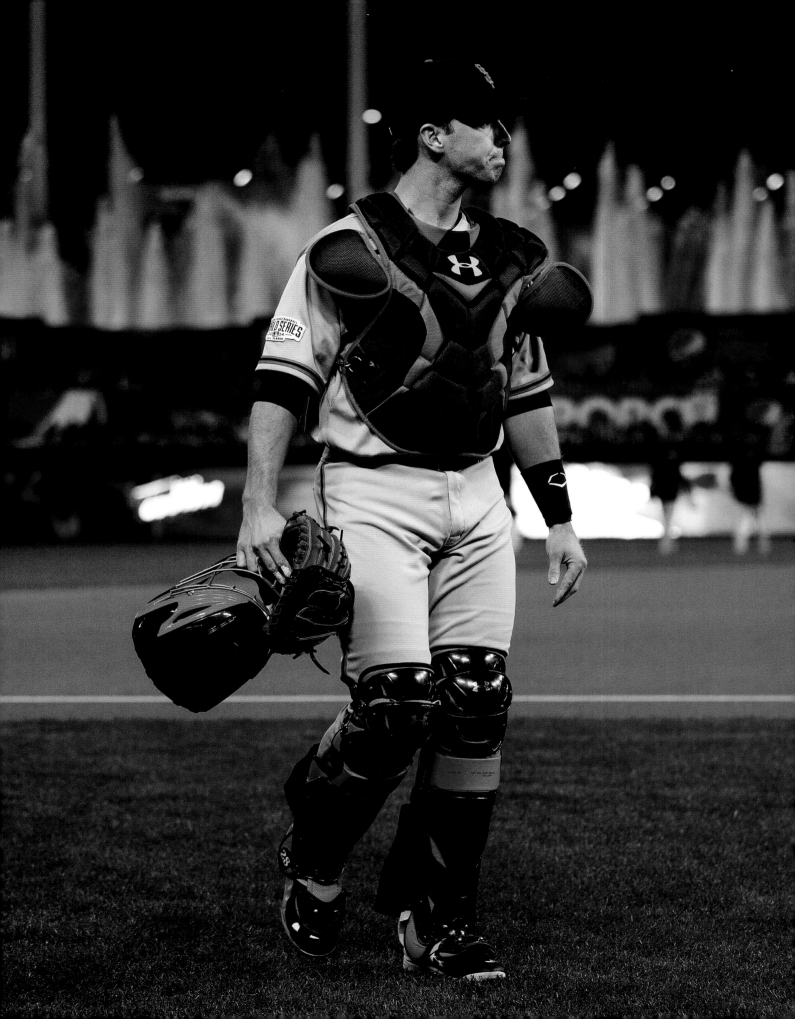

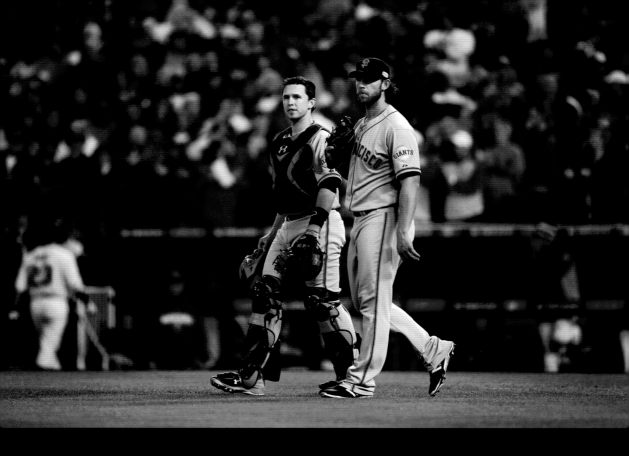

PREVIOUS SPREAD: Buster is all business before Game 6 of the 2014 World Series against the Royals, Kauffman Stadium, Kansas City

ABOVE: Buster and Madison Bumgarner talk during Game 7 of the 2014 World Series against the Royals, Kauffman Stadium, Kansas City

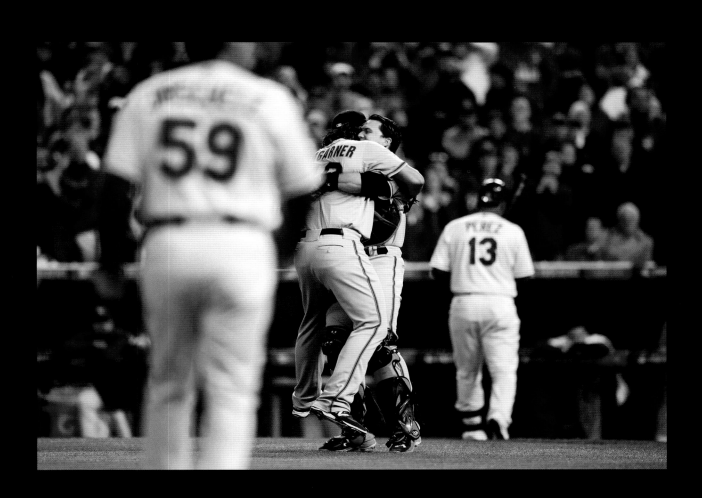

ABOVE: Buster and Madison Bumgarner hug after winning the 2014 World Series against the Royals, Kauffman Stadium, Kansas City

ABOVE: iPhone picture of champagne on ice in the Giants clubhouse after Game 7 of the 2014 World Series, Kauffman Stadium, Kansas City
OPPOSITE: Buster and Santiago Casilla on a bus down Market Street during the Giants 2014 World Series parade, San Francisco

"I knew how special it was, the bond I had built with the City, with the fan base."

2015
—
2016

ABOVE: iPhone picture of Scottsdale Stadium during 2015 spring training
OPPOSITE: Buster receives his 2014 World Series ring from Larry Baer, San Francisco, 2015
OVERLEAF: The Giants' 2010, 2012, and 2014 World Series trophies

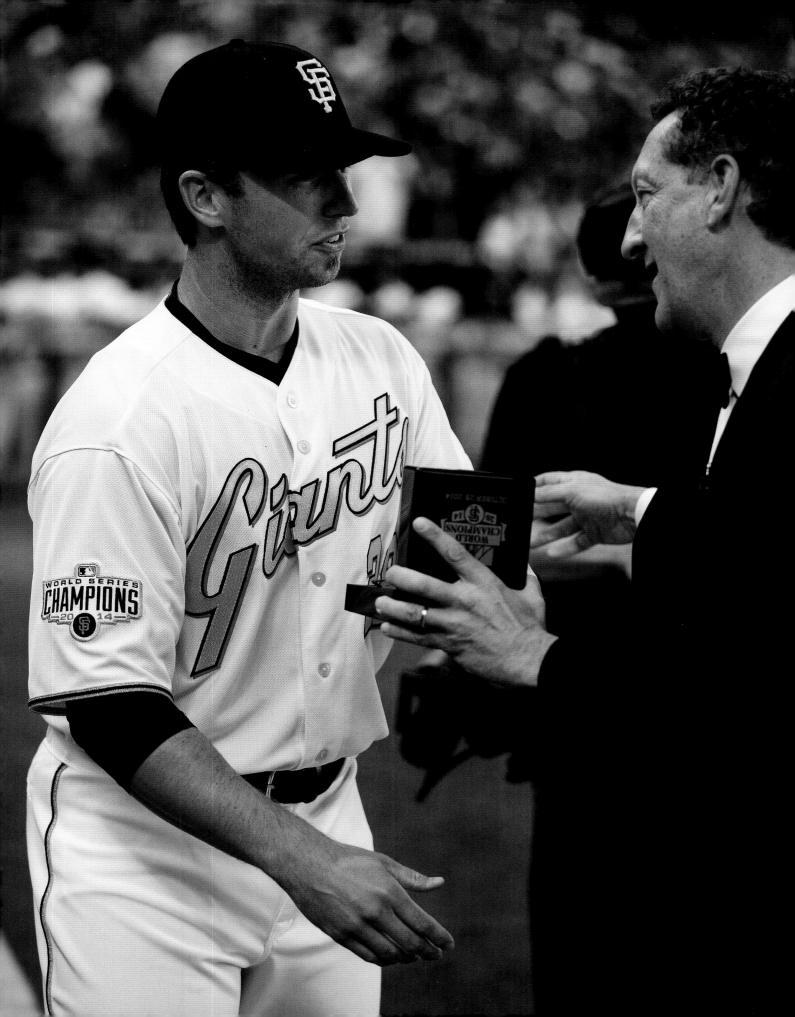

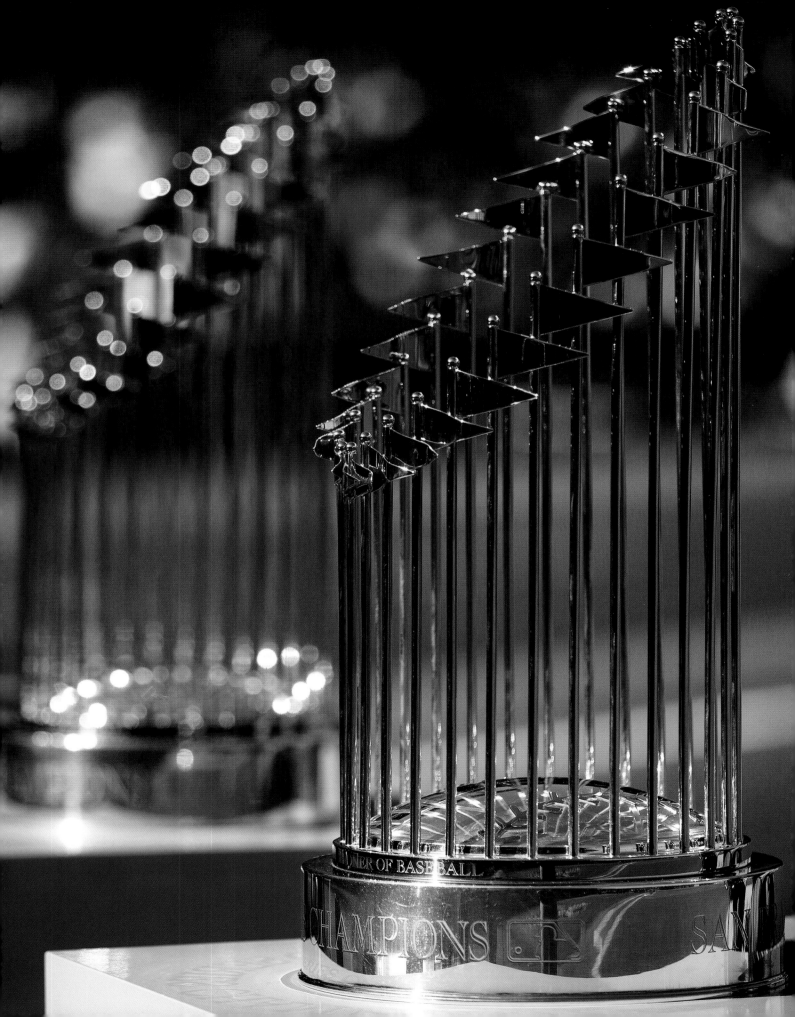

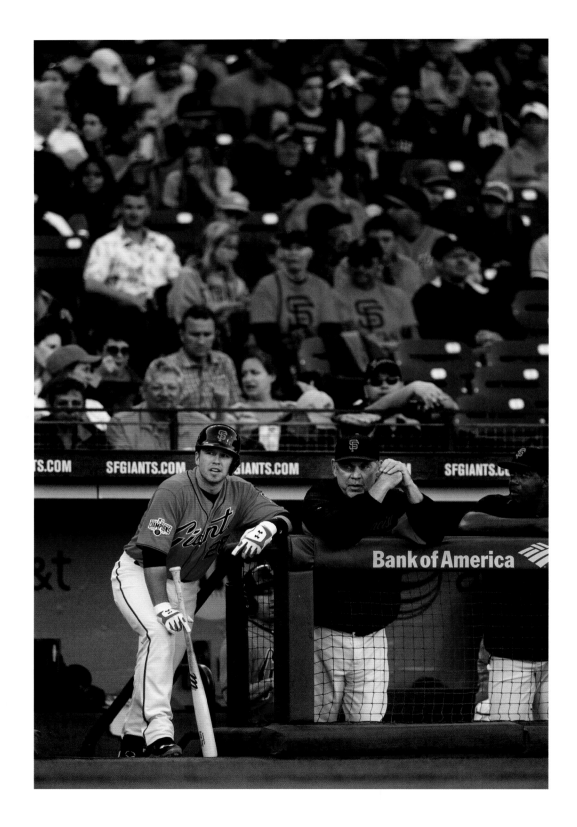

ABOVE: Buster and Bruce Bochy talk during a game against the Diamondbacks, San Francisco, 2015

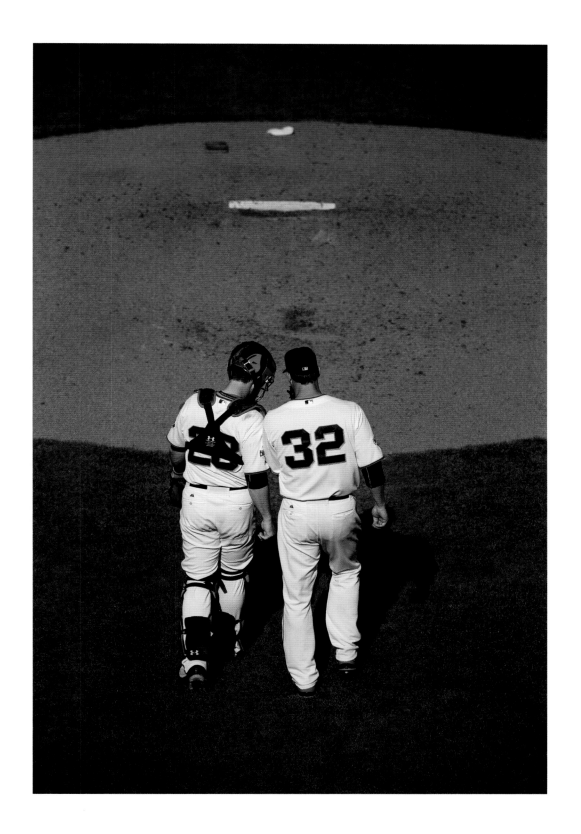

ABOVE: Buster and Ryan Vogelsong confer during a game against the Diamondbacks, San Francisco, 2015

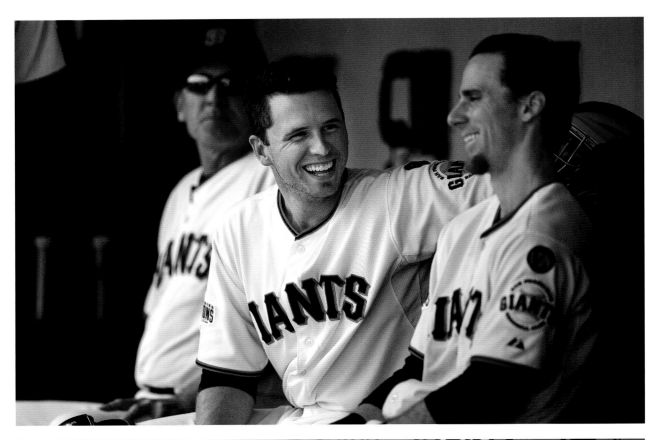

TOP: Buster and Matt Duffy laugh during a game against the Padres, San Francisco, 2015
ABOVE: Buster and Tim Lincecum sit in the dugout during a game against the Brewers, San Francisco, 2015

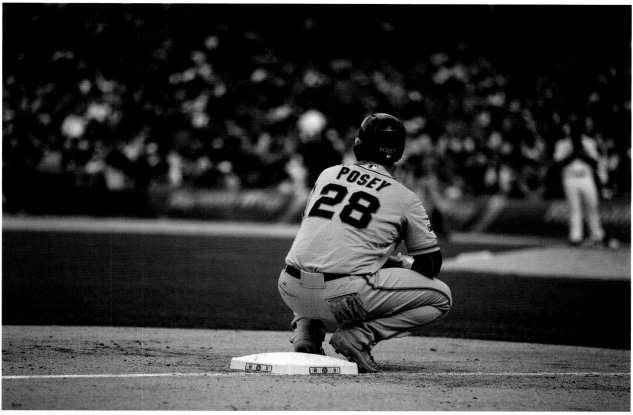

TOP: Buster isn't afraid to get dirty, Giants vs. Cubs, Wrigley Field, Chicago, 2015
ABOVE: Assuming his favorite position in a game against the Cubs, Wrigley Field, Chicago, 2015

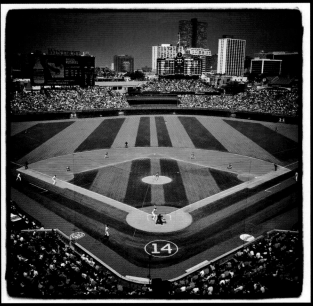

ABOVE: iPhone pictures of Wrigley Field, Chicago, during series between the Giants and Cubs, 2015

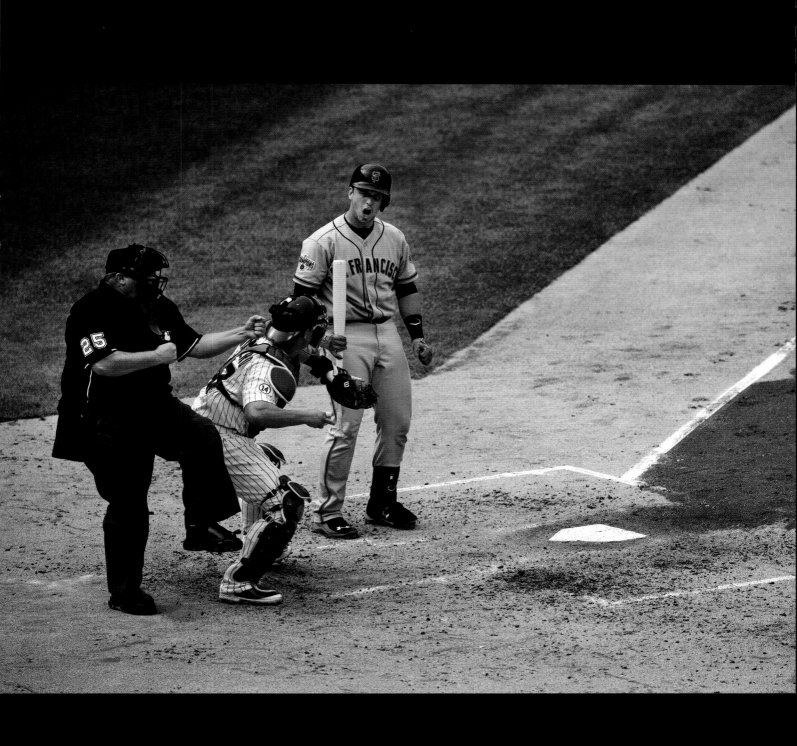

ABOVE: Getting called out on strikes by home plate umpire Fieldin Culbreth during a game against the Cubs, Wrigley Field, Chicago, 2015
OVERLEAF: Climbing up the dugout steps before a game against the Cubs at Wrigley Field, Chicago, 2015

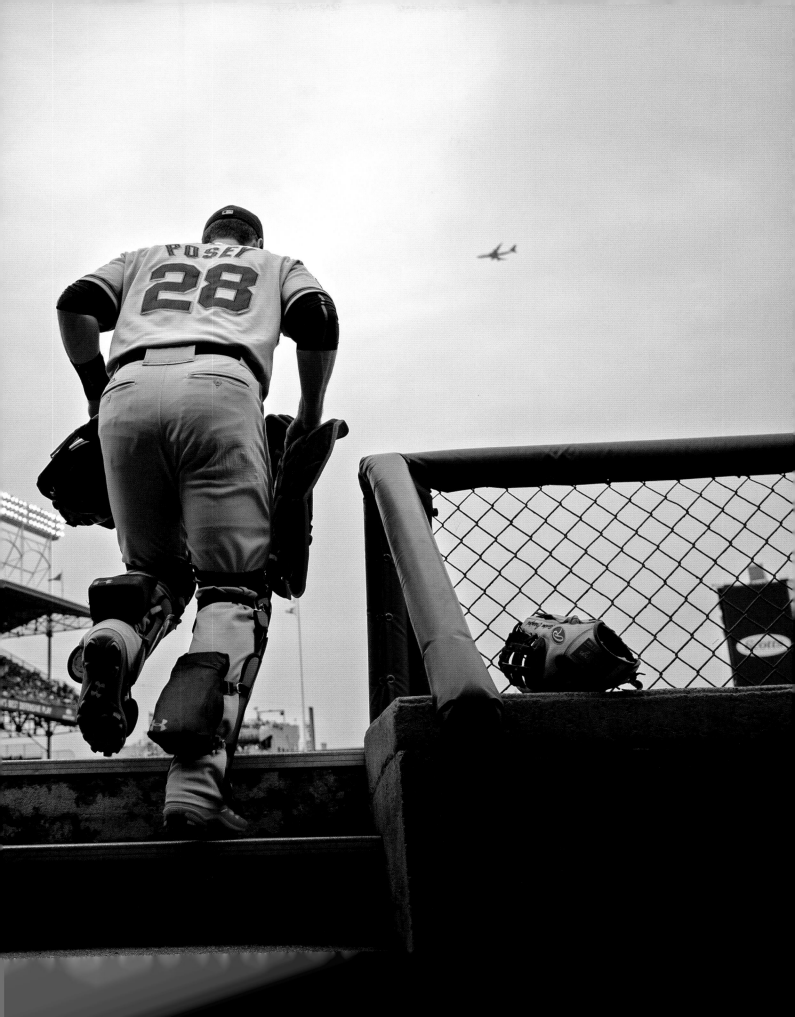

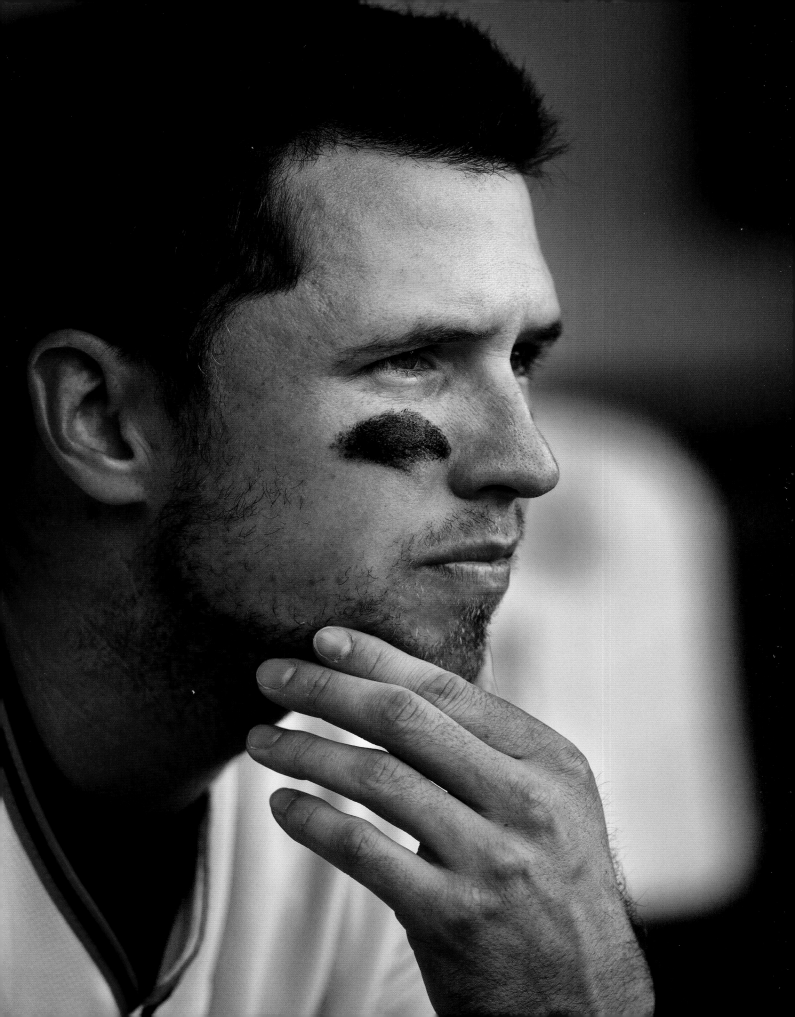

OPPOSITE: None of those fake stickers for Buster—he uses the real eye black, Giants vs. Braves, San Francisco, 2015

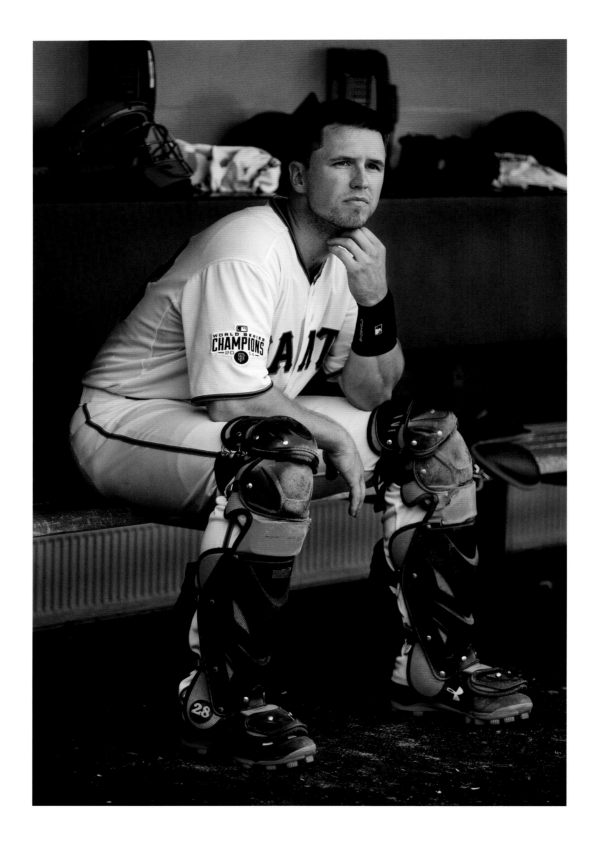

ABOVE: Observing pitches from the dugout in a game against the Nationals, San Francisco, 2015
OPPOSITE: Madison Bumgarner hugs Buster after a win over the Nationals, San Francisco, 2015
OVERLEAF, LEFT: Getting ready for a late-inning at-bat against the A's, Oakland Coliseum, 2015
OVERLEAF, RIGHT: Enjoying a day off during a game against the Cardinals, San Francisco, 2015
PAGES 142–143: Using his leg kick to time a pitch against the Dodgers, San Francisco, 2015

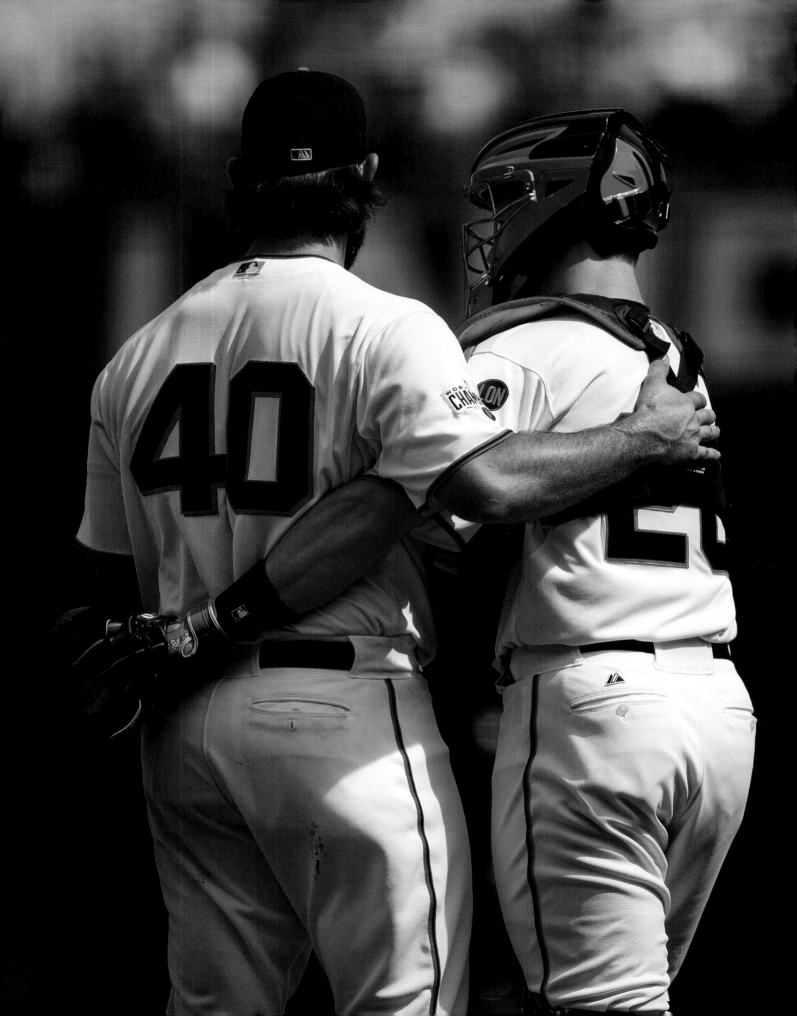

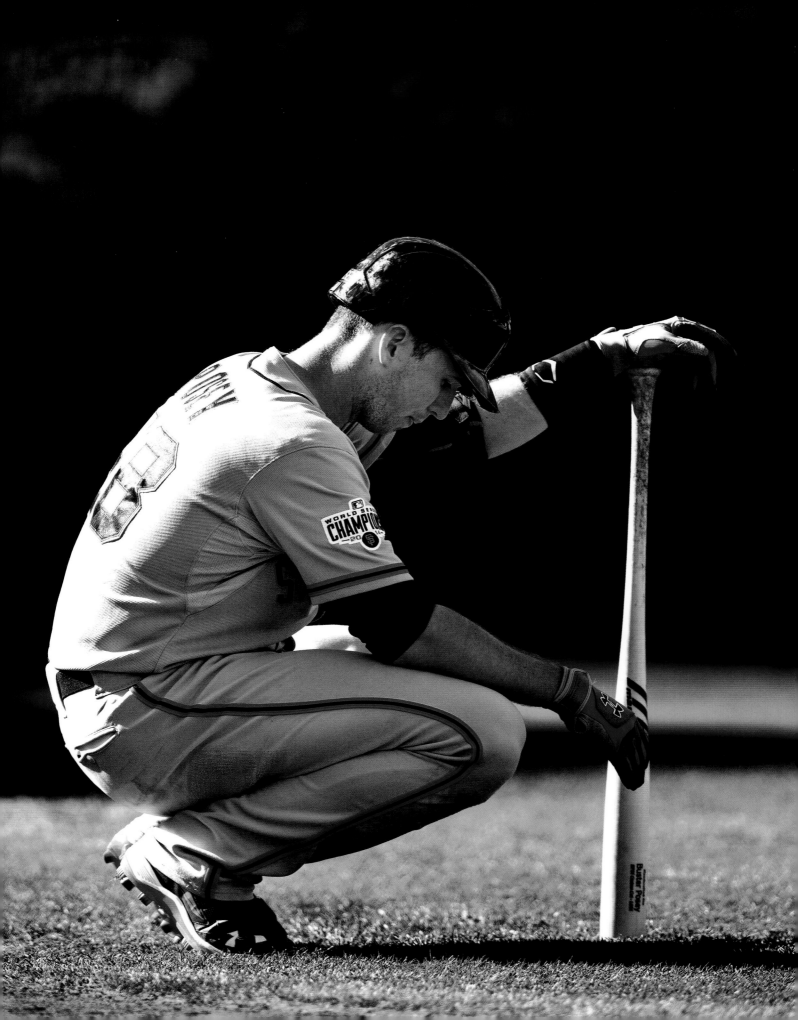

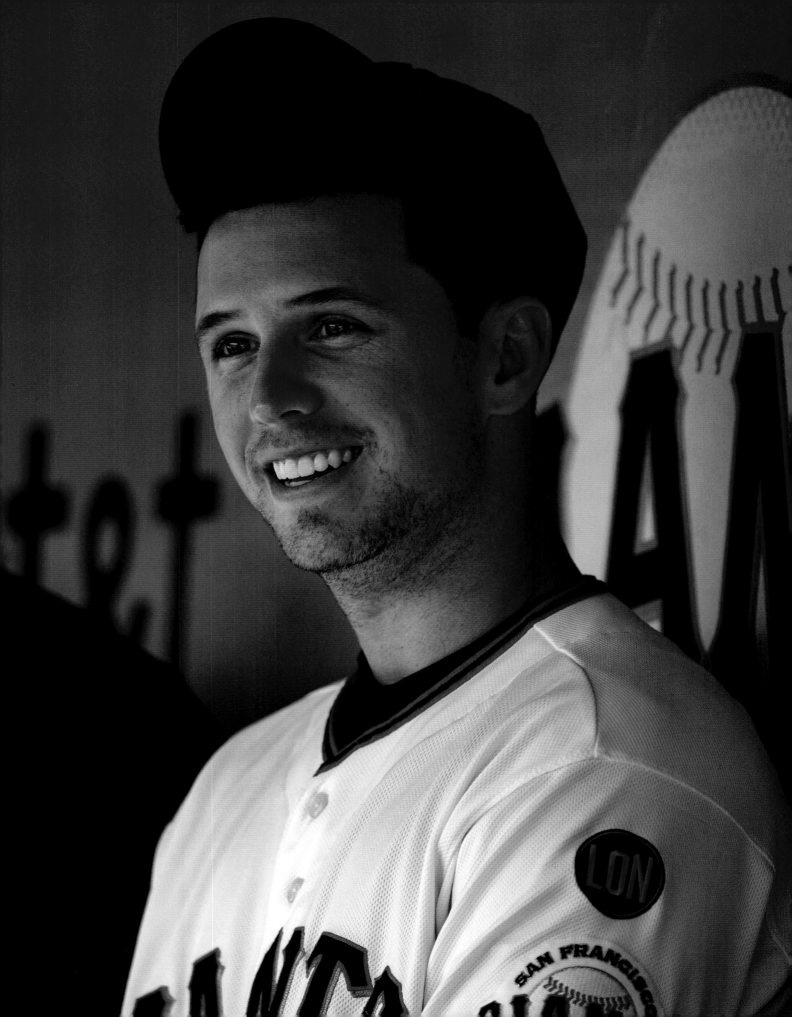

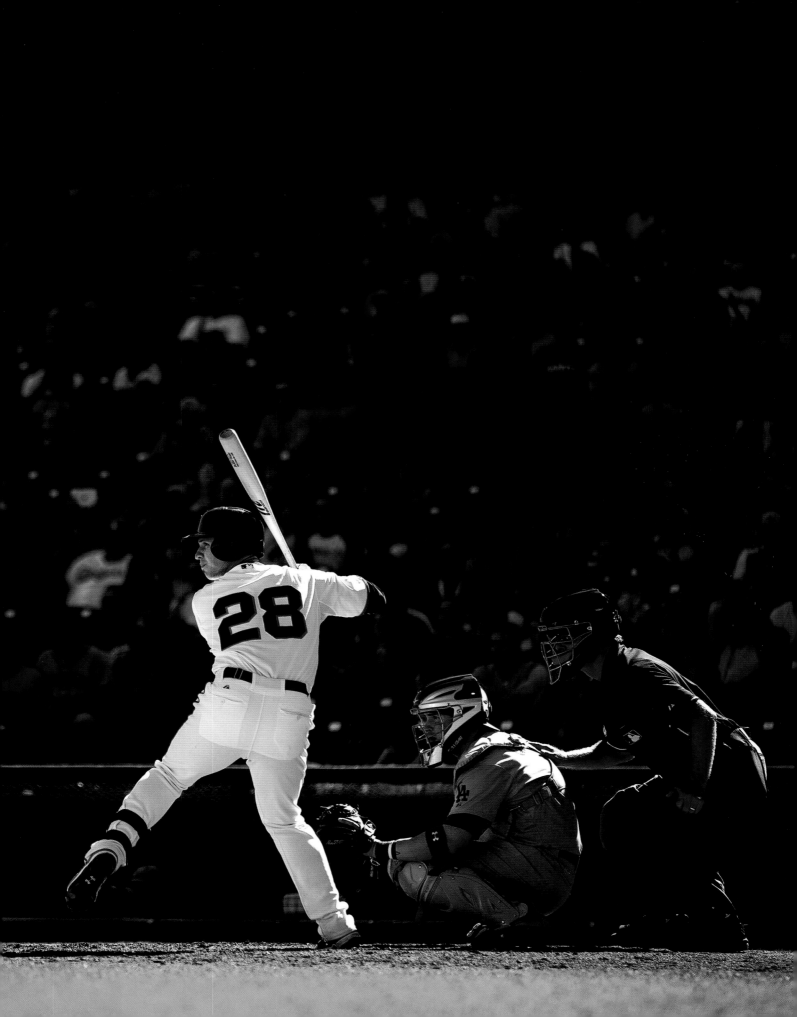

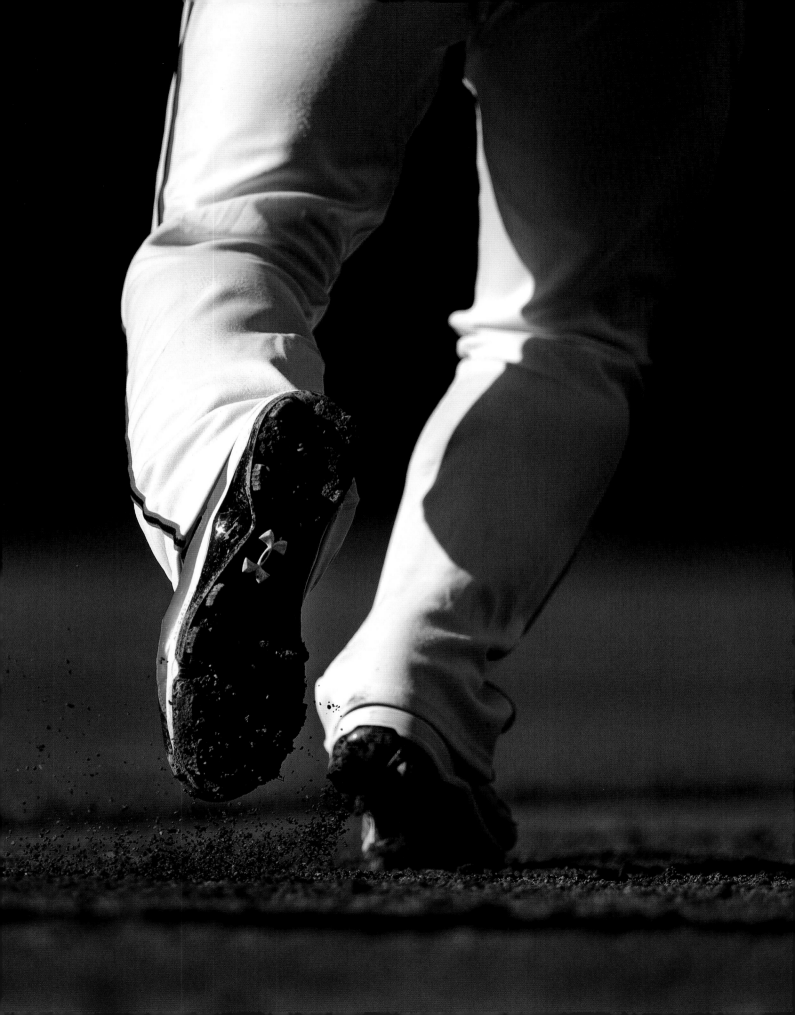

FOREVER GRATEFUL ▪ BRUCE BOCHY

OF ALL THE PLAYERS that we drafted during my tenure as manager of the Giants, there wasn't anything close to the excitement of Buster Posey getting drafted to San Francisco.

I've known our scouting director, John Barr, a long time. In the run-up to that draft, he would come down to my office, really excited and giddy about the chance to get Buster. And it wasn't just John. Brian Sabean and Dick Tidrow were saying, "We're getting a game changer here."

But it took having a bad year in 2007 to get to the point where we would have a shot at getting Buster in the first place. Once we knew that he was on our radar, though, it's something you keep quiet, because you don't want other people to know who you're looking at or who you really want. But I started bearing down on him. I went to Florida State also, so we had a connection there.

Every day we watched him, the guy did something incredible with the bat. And he was good behind the plate—it was Florida State coach Mike Martin's son who had suggested Buster go behind the plate. We're fortunate Buster wanted to do that. And when it actually happened, when we got him, everybody was giddy, so it was an exciting time for the Giants organization.

In 2010, we made the decision to trade Bengie Molina and give Buster the catcher's job. It was a tough decision, because Bengie was a good player. Bengie was a really good hitter, a clutch hitter. But Buster was much more athletic than Bengie. We wanted Buster behind the plate, so Brian finally found a place for Bengie to go.

Bengie didn't want to leave. He was emotional about it. He was professional about it, but you could tell it hurt him. It's not easy for a player to get moved for a younger player, so I think it did bother Bengie quite a bit. But he ended up going to a very good team. Lo and behold, we ended up playing against each other in the World Series.

I have to give a lot of credit to Billy Hayes, our catching instructor. He spent a lot of time with Buster in spring training and was in the dugout watching Buster. They spent a lot of time polishing up his game behind the plate. Buster continued to try and improve. The thing about Buster is that he wanted to be better. He would ask questions. If you wanted him to do something, it wasn't like he was just going to do it; he wanted to know how this was going to help him. He's a very

smart guy, and that's the stuff Billy Hayes did a great job with. His framing just got a lot better. The blocking, which was probably not his strong suit early on—he ended up being a great blocker back there. And he took pride in it, because there was another guy in the league who was getting the Gold Glove all the time, and other guys were getting accolades for framing, and I think Buster took that personally. He took it upon himself to become the great catcher that he became.

While he had great, great frames, I think about his throwing. It's effortless. He just made it look easy. There's times when I thought he had no chance, and he got such great carry on the ball, and he had a nice, quick release.

And the hitting—he has a great inside-out swing. His bat stays in the zone so long. That's why he didn't strike out much. There's contact with power. There were times when he would hit balls, and they would just carry. You're just amazed. When he'd hit it, you wouldn't think it was going out, and they just keep carrying.

I remember in Texas, in the World Series, he hit a ball, and I didn't think it was going out, but it just kept going. He hit a lot of balls like that. He would get on the plate and backspin it, and it would just keep going.

He was one of those hitters that had great depth perception. A ball away, he'd stay back a little bit; ball inside, he'd turn on it. That's what great hitters have. He was certainly a great hitter.

Buster's work ethic reminded me of another player I managed—Tony Gwynn. Tony had never felt that he had arrived as a player, and I don't think Buster ever did. But players like Buster and Tony, their actions are so consistent—how they come to the ballpark every day, ready to play, to become the best player that they can be, every day.

Another comparison I've heard for Buster is Derek Jeter. Jeter was not known for his defense, but he was known for his professionalism—how he showed up every day. Guys like that are just so consistent with who they are and how they play the game. They're not mercurial, not up and down. They're just incredible. Buster brought that every day.

It all peaked in Game 7 of the 2014 World Series in Kansas City. I still kid Bumgarner about all those high fastballs he threw to Salvy Pérez. I said, "All you had to do is bounce a breaking ball, and he'd have swung!"

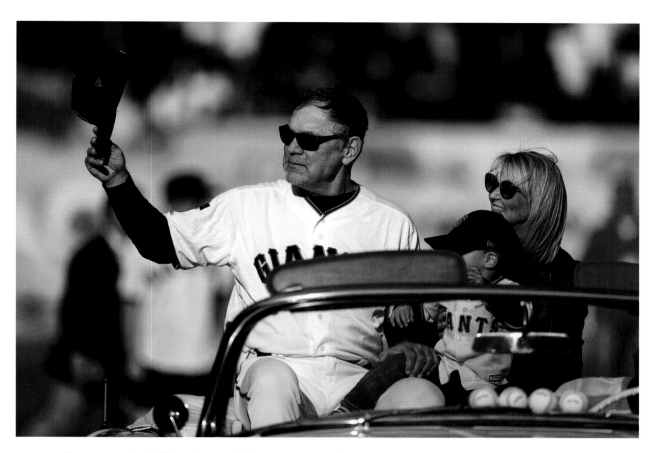

I was hoping maybe he'd break one off, but Bum said, "Well, I didn't want to bounce one, and he scores on a wild pitch." That was his thinking. He had so much confidence in that rising fastball.

Again, that's Buster having a good feel back there. Good catchers are just like good pitchers—they know what they want. Bumgarner knows what he wants to throw, and Buster knows what pitch he wants to call. There's no hesitation.

By 2018, he was in pain—he was. He was still going out there, though, and I was using Dave Groeschner, our trainer, to help me out. But it was evident he needed surgery. You could see. He couldn't even turn on the ball. He was just doing it by his amazing hand-eye coordination, the contact ability, to still get hits. His legs were not there. They were gone. He just did it with a lot of heart and determination.

Plus, he had the concussion thing. We were dealing with that, so there was a lot going on with him. He was pretty beat up. You look back—you look how much he caught all the way through the three World Series—I think it caught up with him a little bit. But we saw what

happened when he got a break. He got hip surgery, and he came roaring back in 2021.

That's what I really admire about Buster. It would have been easy to keep playing. He was playing great. The money was great. The team was playing well. But I think he saw this as a great time to go out. I respect him for that—to go out on his own terms. He's looking long-term. He wants to have his body and have the time with his family.

I flew in for his retirement announcement. We spent a lot of time in the dugout, and you realize pretty quickly that a great game is made up of great players, and it's made up of great teammates. That was Buster.

I'm forever grateful for all we accomplished. It wouldn't have happened without Buster. Trust me—I understand that. He brought his talents to the ballpark every day to play, and so that was my time to thank him—not just for what he helped us accomplish, but also what he did for me, how he helped me inside the clubhouse.

Buster, I can tell you, is just really, really special, so I considered myself lucky.

I loved having this guy be my catcher for ten years.

PREVIOUS SPREAD, LEFT: iPhone picture of fans after a game against the Padres, San Francisco, 2014
PREVIOUS SPREAD, RIGHT: Breaking for second base during a game against the Diamondbacks, San Francisco, 2016
ABOVE: Bruce Bochy waves to fans with his wife, Kim, during a ceremony celebrating his career with the Giants, San Francisco, 2019

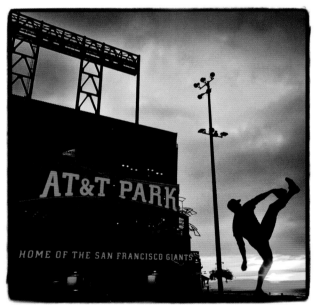

ABOVE & OPPOSITE: iPhone pictures of 2016 Opening Day, AT&T Park (now called Oracle Park), San Francisco

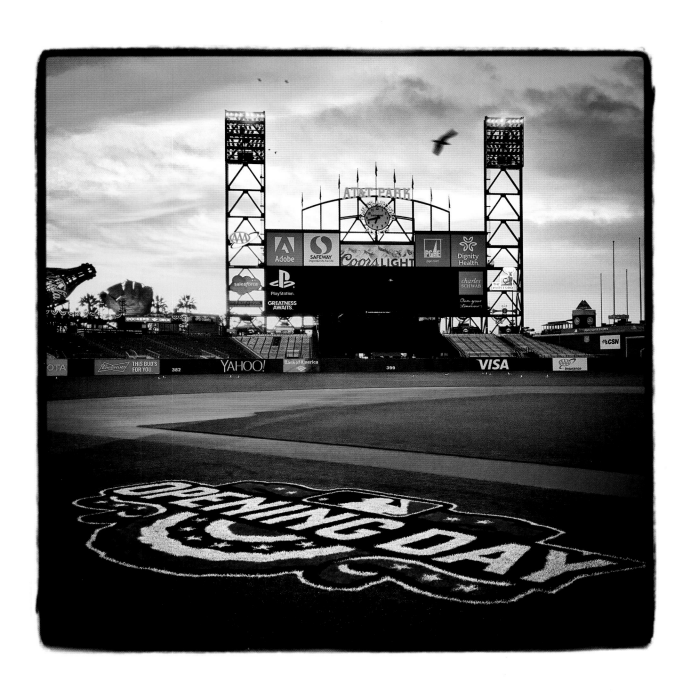

OVERLEAF: 2016 Opening Day against the Dodgers at AT&T Park, San Francisco
PAGES 152–153: It doesn't get much prettier than this: Buster to right field against the Diamondbacks, San Francisco, 2016
PAGE 154: A dirty uniform means you are doing your job, Giants vs. Dodgers, San Francisco, 2016
PAGE 155: Making a play on a bunt against the Dodgers, San Francisco, 2016

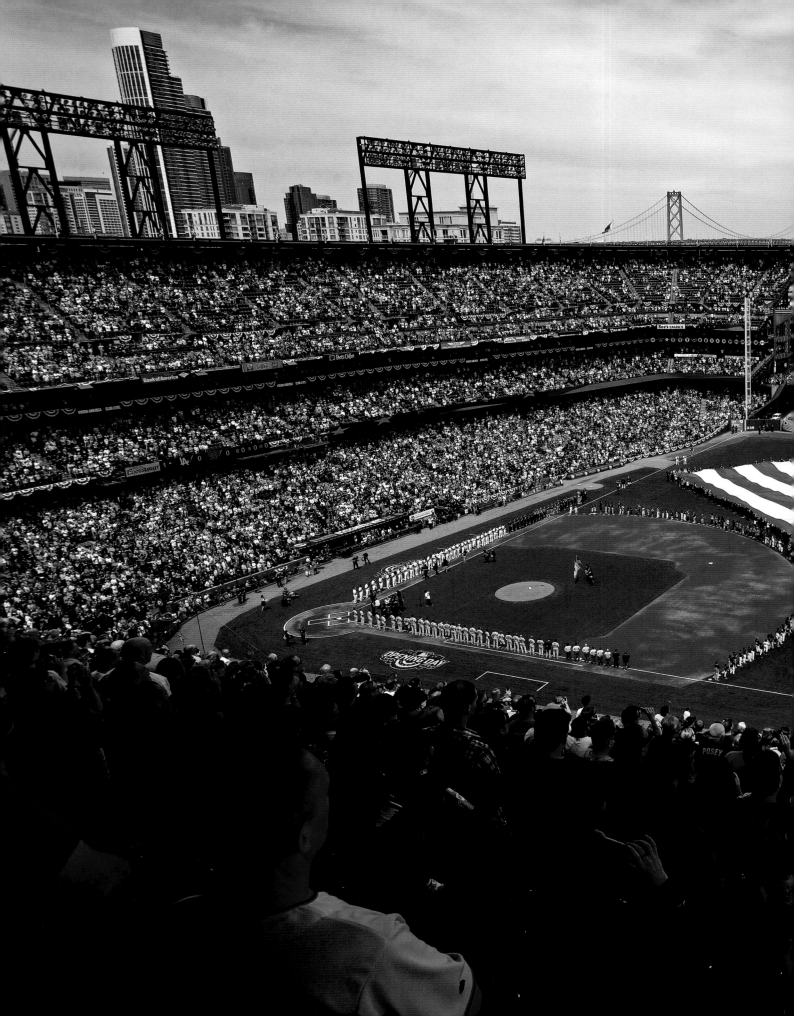

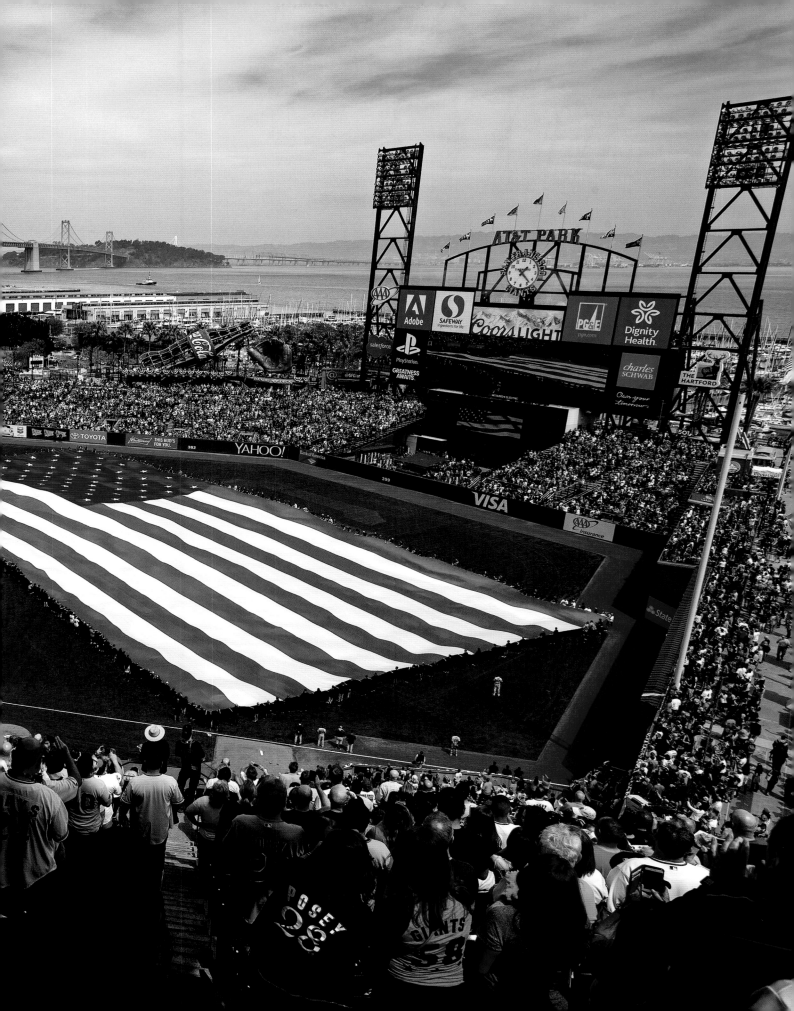

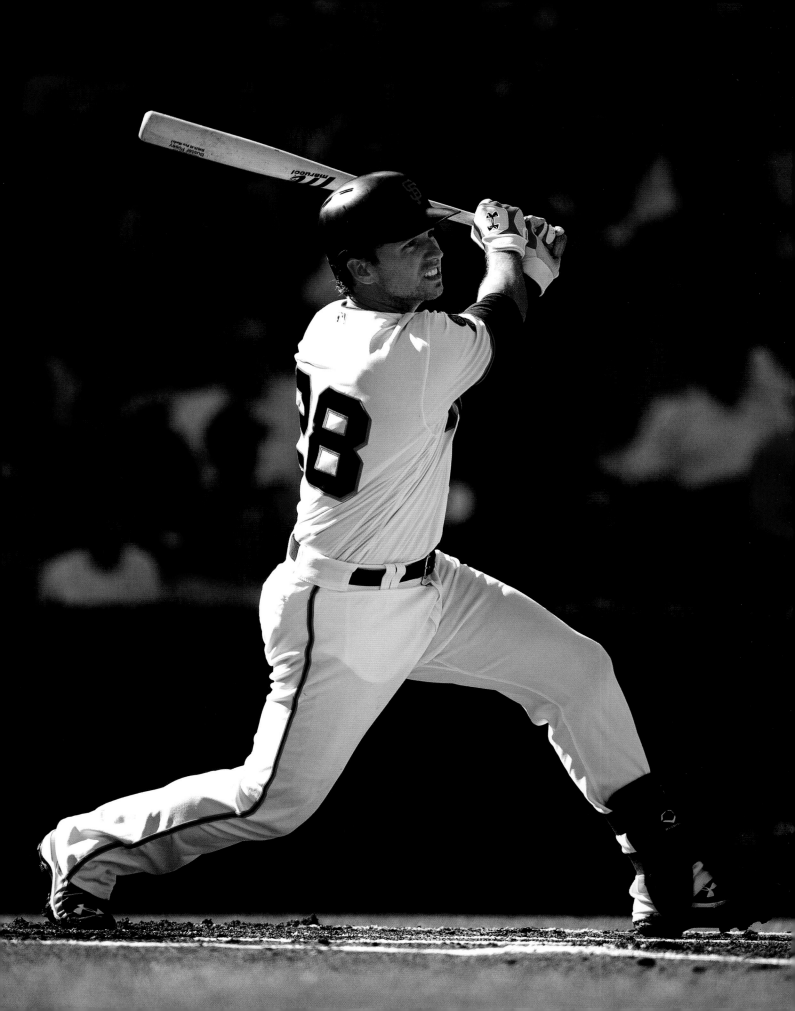

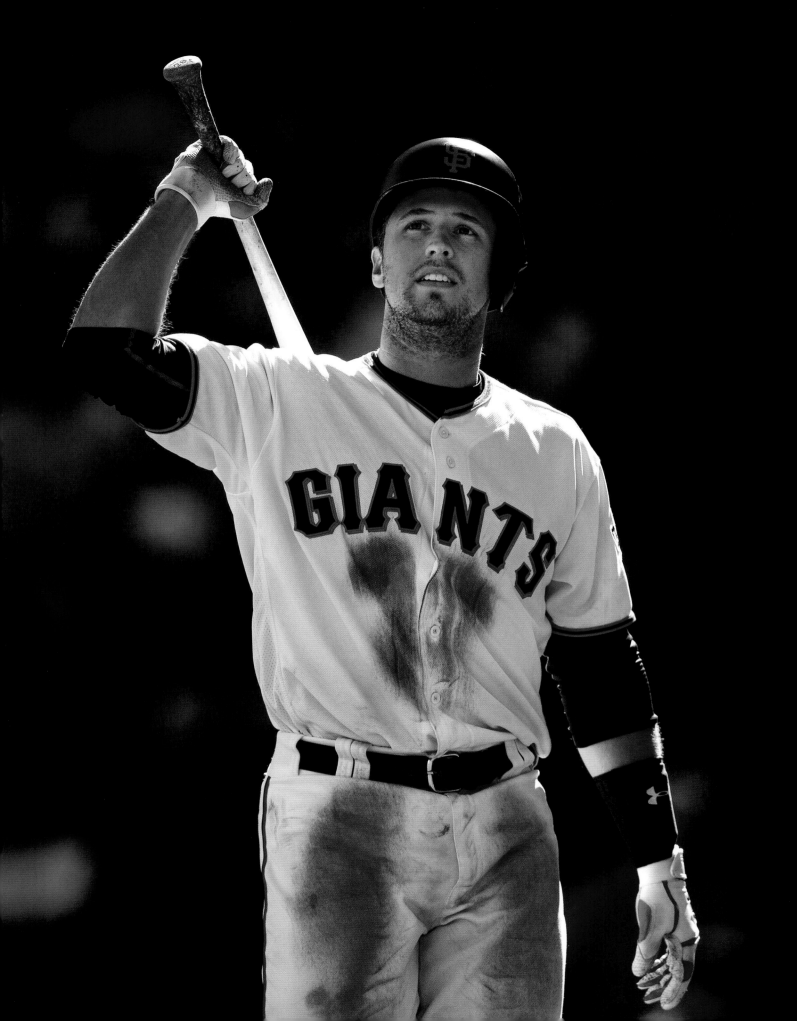

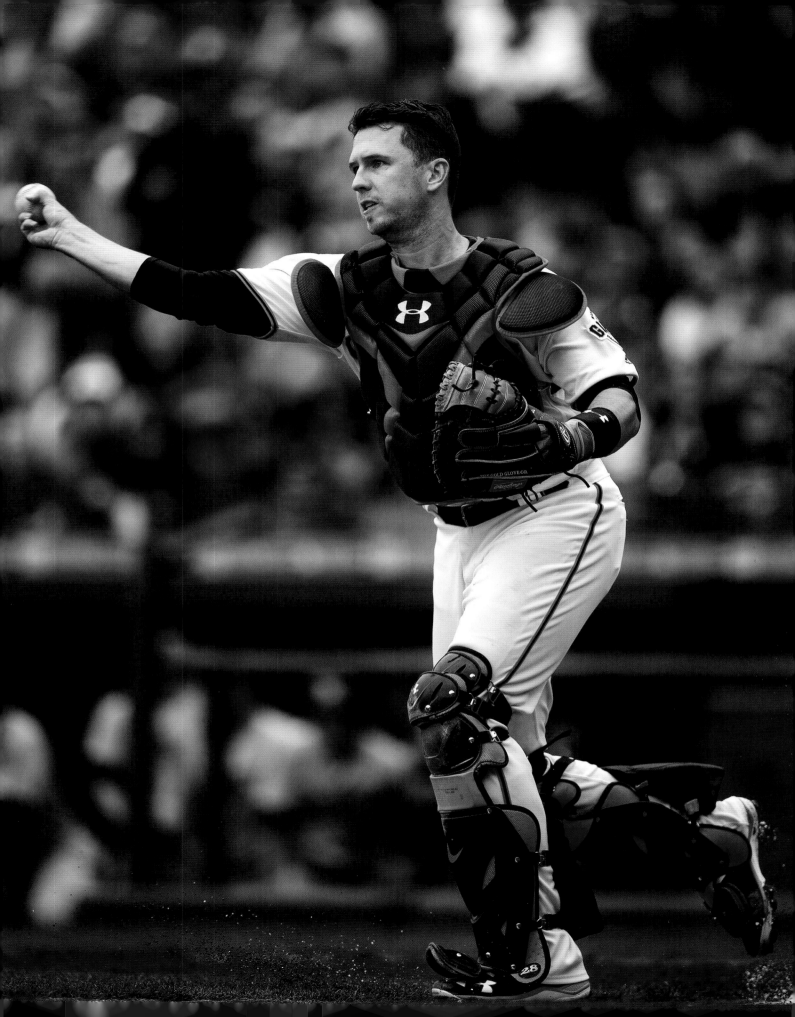

"I've always said San Francisco feels like a northeastern baseball town that's on the West Coast."

2017
—
2020

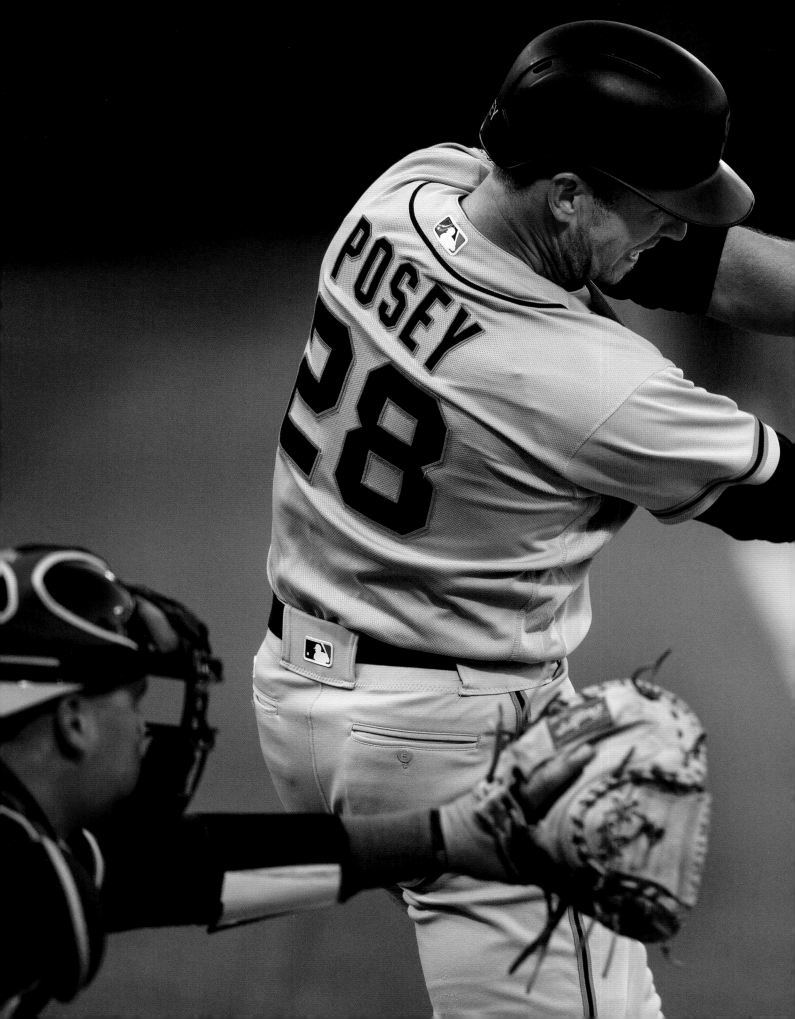

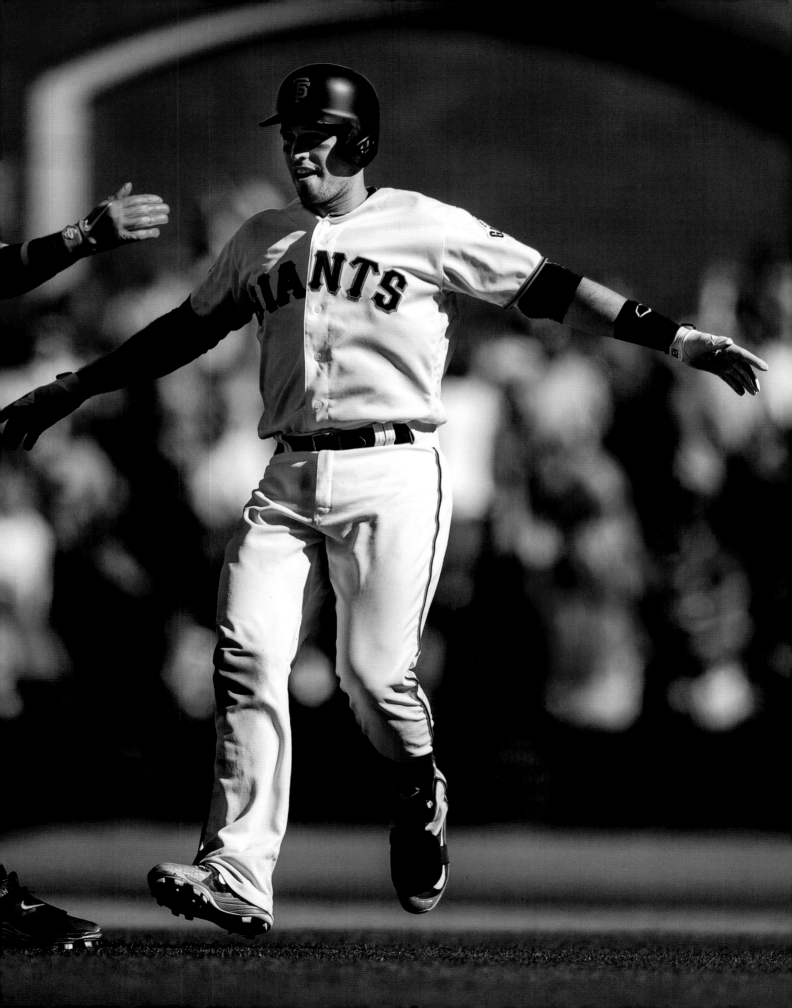

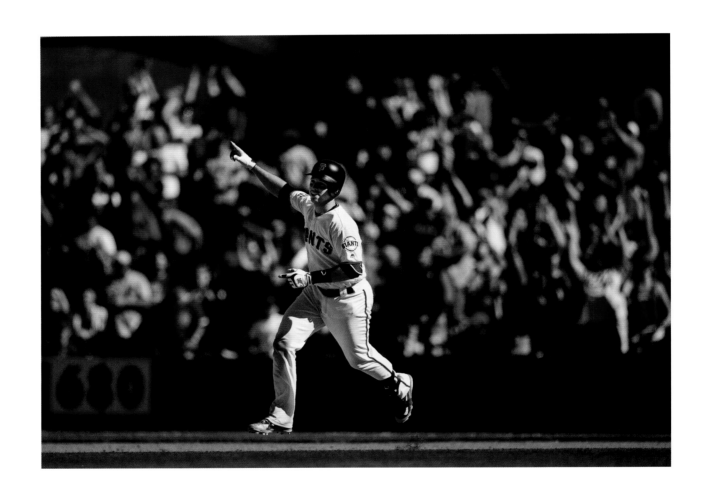

PAGES 158–159: Making contact against the A's, Oakland Coliseum, 2017
PREVIOUS SPREAD: Celebrating with Andrew McCutchen after hitting a game-winning
double to beat the Cubs 5–4 in the bottom of the thirteenth inning, San Francisco, 2018
ABOVE: Buster after hitting a game-winning double to beat the Cubs 5–4 in the
bottom of the thirteenth inning, San Francisco, 2018

ABOVE: Enjoying seeds in the dugout during a game against the Dodgers, San Francisco, 2017
OVERLEAF: Dawn of Opening Day against the Rays, Oracle Park, San Francisco, 2019

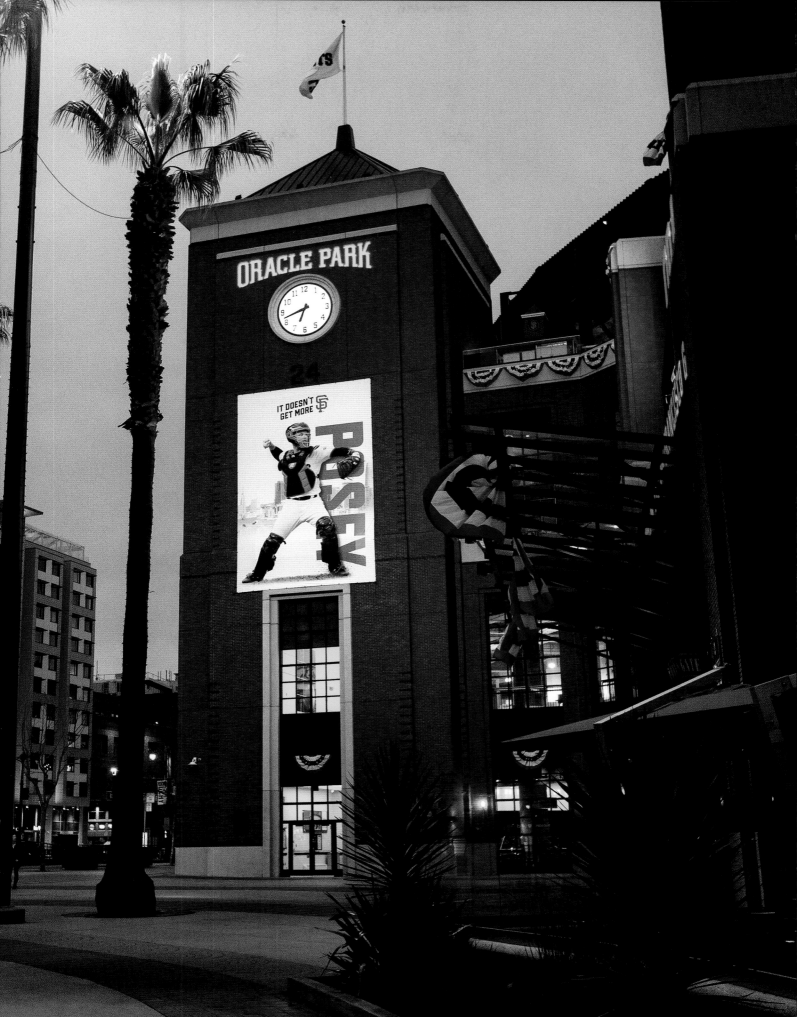

ABOVE: iPhone picture, dawn of Opening Day, Oracle Park, San Francisco, 2019
OPPOSITE: Buster wears a special chest protector with the signatures of children who are fighting cancer on Players Weekend against the A's, Oakland Coliseum, 2019

THANK YOU, BUSTER ▪ BRANDON CRAWFORD

Originally published on the Players' Tribune, November 23, 2021

A FEW WEEKS AGO, one of my best friends in the world, Buster Posey, decided to call it a career.

Buster's a Giants legend, obviously. Three world championships, seven All-Star Games, an MVP season, a batting title, five Silver Sluggers, three no-hitters caught, and on and on. He's one of the greatest players in baseball history.

But Buster Posey, for me, first and foremost . . . he's my friend.

Not long after he called me up to let me know he was going to retire, I knew I wanted to do something to show my gratitude and pay tribute to him. I needed to take some time to let it sink in, though. To get my thoughts together. I wanted to make sure I did this right. Because writing out something like this . . . let's just say it's not in my wheelhouse. So I'm going to do my best to get my points across here, but please stick with me if it doesn't come out perfect or whatever.

I want to start out by saying how happy I am for my friend, because I know he's completely content with this decision and is now going to be able to spend more time with his family.

Buster loves baseball for sure—loves the Giants, his teammates, our fans—but to be honest with you, that pales in comparison to how much he loves his family. And I truly admire and respect him for that.

Kristen and those kids, they've been his top priority from day one. And that's never changed over the years.

It's awesome to know that he and Kristen are going to be able to experience so many cool family milestones together as the kids grow up. All the memories that he'll be making at home—while his former teammates are off ordering bad takeout in some hotel all the way across the country—that's something you really can't put a price tag on.

So, at the end of the day, I'm mainly just super happy for my friend.

At the same time, though, it's definitely going to be tough not having him around. It won't be the same.

Buster's been there my entire professional career. We were part of the same 2008 Giants draft class. And we go back even further than that. We actually played against each other in a summer tournament in high school, so we go all the way back to 2004. He was on Team Georgia, and I was on Team California. This was before either of us had gotten too much hype, and I won't say who won, but I distinctly remember him being on the other team because, well . . .

You don't forget a name like Buster Posey.

There just aren't too many Busters walking around these days.

We crossed paths again four years later during rookie ball in Scottsdale and then played our first full season in the minors together in San Jose. Right away, I could tell he was going to be an exceptional player. Everyone who watched him could tell.

His talent as a hitter was clear as day. And because I was always at shortstop, playing behind him, I had as good a view as anybody at the passion and skill he brought to the catcher's position. I saw how he was able to work with all different types of pitchers, understand their strengths and weaknesses, and then partner with them to give our teams the best shot to win. You could almost see his brain working sometimes when it came to pitch selection and setting guys up, and it was just a very cool thing to watch.

But what really stood out to me was how Buster went about his business. How he carried himself, and prepared, and worked, and . . . just the mindset he took out onto the field every day.

It was like the guy was a walking baseball clinic or something, the perfect example of how to do everything the right way when it comes to playing the game.

Buster's someone who never seeks attention or praise. In fact, he actually prefers not to be the center of attention. He always just wanted to do his job and help his team win baseball games. And what I started to notice, both in the minors and early on in my career with the Giants, was that his approach to the game, and the seriousness and attention to detail that he showed . . . that stuff trickles down to everyone on his team.

When you see your catcher, your leader, showing up every day with a singular focus of doing everything he can do to help his team win, without wanting any credit for it? When it's not about ego? When it's like: "This is what I'm supposed to do. This is my job. And I'm going to do it as well as I can"?

That perspective is contagious.

It's definitely how I approach the game, too. And I could tick off a bunch of other guys who are the exact

same way—Brandon Belt, Matt Cain, and on and on. So the younger players who join the Giants, they've seen the leaders on this team be that way for years. They just hop on the train, and it keeps rolling.

I honestly think Buster's approach to the game is what you'd point to as the definition of "Giants baseball" during his time in the Bay. That's the brand of baseball we played. He was like the walking embodiment of the San Francisco Giants.

One thing everyone talks about with Buster, of course, is how he's always super calm and remains even-keeled at all times. He doesn't get too high or too low and never lets his emotions get the best of him.

But some of the Buster memories I cherish most are the ones where that emotion actually did sneak out somehow. In fact, what is maybe my all-time favorite Buster Posey moment is an example of that.

2012. NLDS. During what ends up being an absolutely magical run to the world championship. We lose the first two games to the Reds, but fight back to force a winner-take-all Game 5. And Giants fans, you remember this well, I'm sure. I don't need to tell you guys what Buster did in that game was special.

You guys know.

Goose bumps, right? Just straight up goose bumps.

But, for me, it's not even the homer, or the clutchness of it that sticks in my mind the most. It's Buster's emotion and excitement and just his . . .

Joy.

After he hit that grand slam against Latos, he was definitely fired up.

What I remember most about it is Buster rounding the bases and getting to home plate where the three guys he drove in were waiting for him, and then Buster just slapping the shit out of their hands. And then him coming down into the dugout and doing the same thing to all the rest of us in there because he was so jacked up about giving us a six-run lead in such a big game.

And that last part, that right there is the key. Because why he was fired up is really what makes it a signature Buster Posey moment for me. It wasn't about, "Hey, look at what I just did." This wasn't one of those deals where a guy hits a huge home run, watches it, does a bat flip, then takes sixty seconds to circle the bases. This wasn't that kind of emotion. It honestly wasn't even about him.

With Buster, it was always all about the team.

So yeah, it goes without saying that the Giants are going to miss Buster Posey.

It's going to be difficult not having him out there leading the charge next season. It'll be different for sure.

But, again, for me, the toughest part about this is going to be not seeing my friend for 162-plus days of the year. Not having those conversations, those moments that all good friends share—the little inside jokes, the laughs, the companionship. We've played together for so long, been through so much together. So, over the years, all those things have become part of what playing baseball means to me.

Even just sharing stories about our kids every day in the clubhouse—the dad stuff—as lame as it might sound, I'm really, really going to miss that.

Our families are super close. I've been to a bunch of his kids' birthday parties. Our wives are good friends. When you play with somebody for such a long time, and your personalities are so similar, that person pretty much becomes like family. And I know we'll still stay in contact and hang out, but yeah . . . it's gonna be tough.

You know what, though? Enough of me getting all emotional over here. Let me just end by saying this: Buster Posey absolutely loved the San Francisco Giants. And every time he ran out onto the field in that Giants uniform, he gave all he had for this team and our fans. He's a Giants legend, an all-timer for sure.

Buster was a special player. And he's an even more special human being.

A few years from now, it's going to be so cool to see my friend enshrined in Cooperstown, and then to visit the Hall of Fame and see that bronze bust of him wearing the San Francisco Giants cap.

I mean, you want to talk about special?

And lastly, Buster, if you happen to be reading this, I just want you to know that I am so proud of you, and that your friendship means the world to me.

I miss you already.

ABOVE: A fan wanting an autograph, San Francisco, 2019

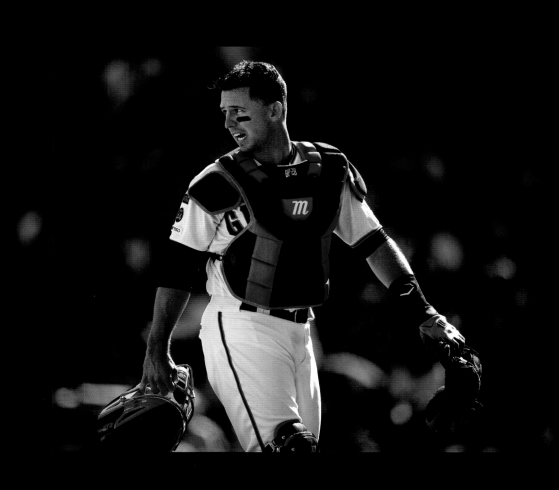

ABOVE: Working hard against the Dodgers, San Francisco, 2019
OVERLEAF: Batting practice during summer camp, San Francisco, July 2020

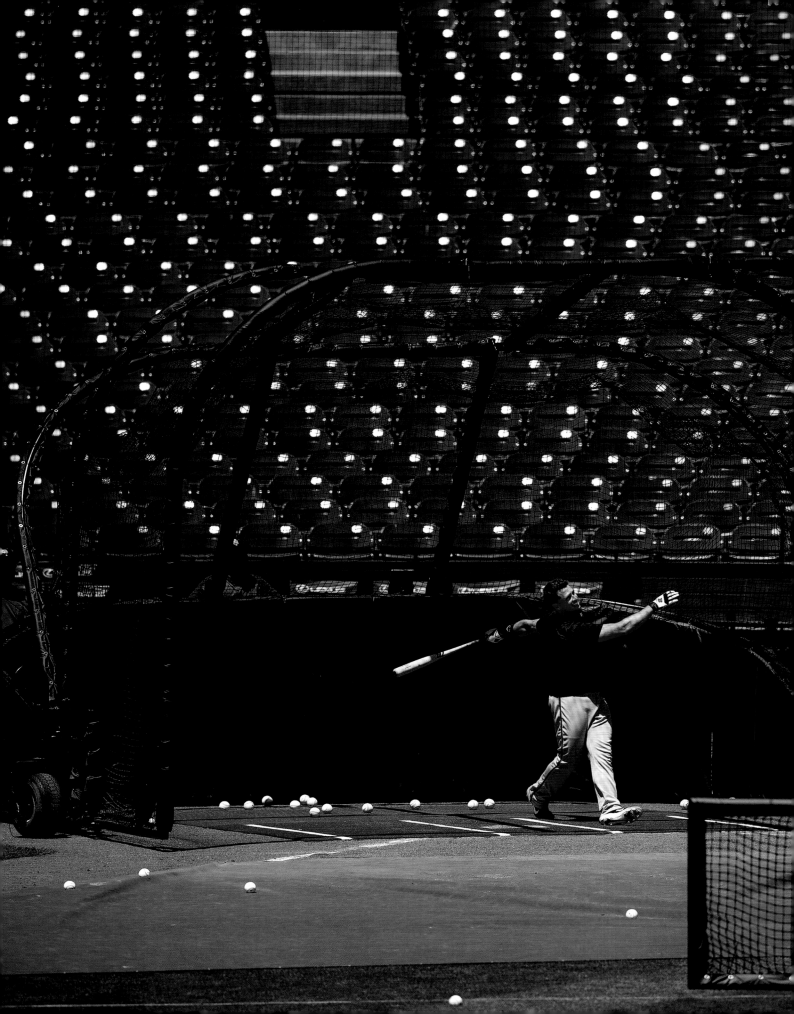

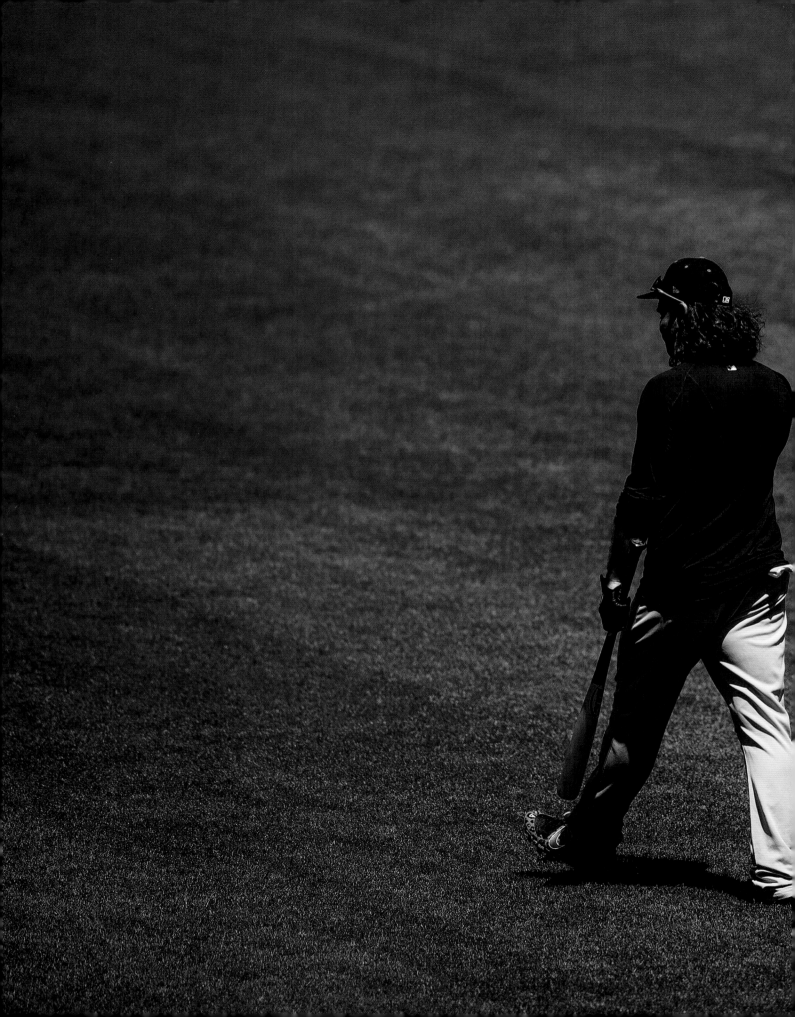

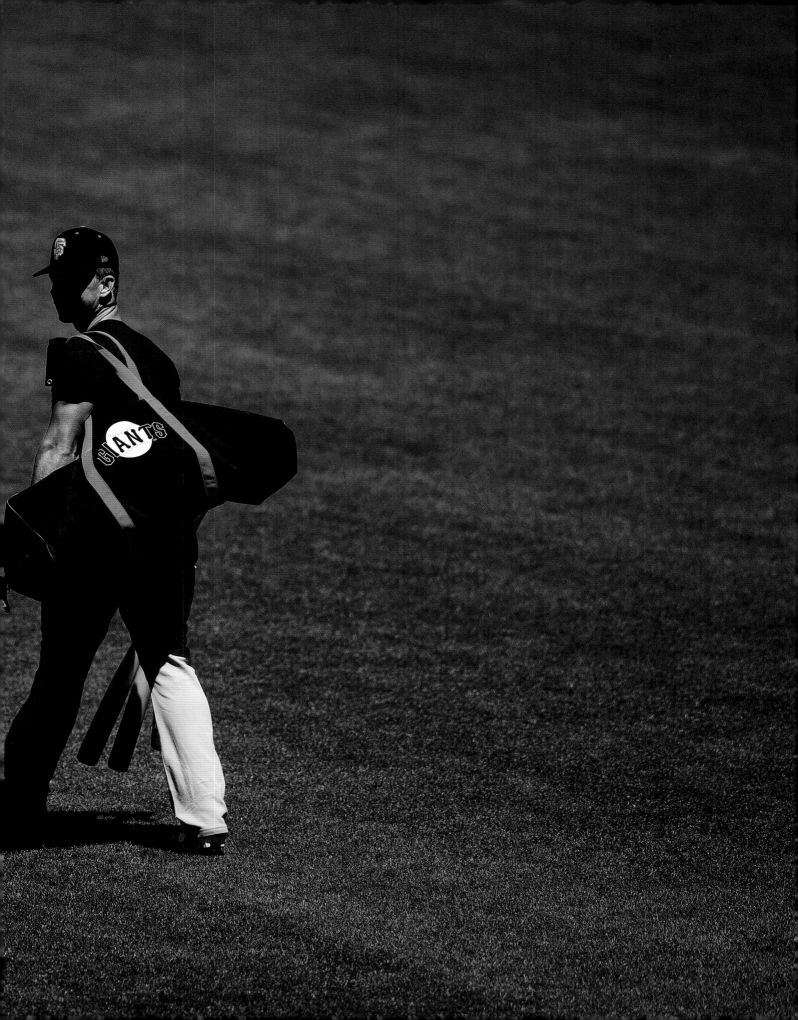

PREVIOUS SPREAD: Brandon Crawford and Buster walk on the field during summer camp, San Francisco, July, 2020
OPPOSITE: Buster honors the legacies of former Giants managing general partner Peter Magowan and former Giants great and Hall of Famer Willie McCovey with patches on his uniform during a game against the Rays, San Francisco, 2019

"That homer I hit in the first inning of Game I, it was almost like a dream homer that you have as a kid."

2021
—

DEFINING A GIANT ▪ LOGAN WEBB

'VE TOLD BUSTER this many times: He showed me—he shows everybody—what it's supposed to be like to be a San Francisco Giant.

I think he epitomizes what a San Francisco Giant really is.

Coming up through the minor leagues, the Giants organization, they want you to be like Buster Posey. They want you to watch him and see how he works. It stuck with me, and it'll always stick with me. Truthfully, I was already watching.

I grew up in the Sacramento area, and I was a high school shortstop. And then I booted a couple of balls and they took me out.

So I remember watching Buster in college, when he played shortstop and catcher.

I wanted to be like him.

You just saw how he kept his composure all the time. He didn't look nervous, ever. He didn't ever look like he was out of whack. There was something about him that you saw that was just calm.

There are a lot of Giants fans in Sacramento, and my high school coaches were Giants fans, so they would always talk about him. They'd say, "Go watch what Buster Posey did."

There's a term you hear a lot as a pitcher: "See how easy you can throw harder." Buster makes everything look easy: the way he throws. The way he catches. The way he hits. It was pretty special to see growing up.

And even though I grew up an A's fan, you couldn't help but want to be like him as a baseball player—to want to be like him when you grow up.

When I was drafted by the Giants in 2014—that was the year they won their third World Series in five years—I thought about playing with Buster instantly. It hit me pretty early—how cool it would be to be able to throw to him and be able to call him my teammate. The further you go up in the system, the more you realize, "Hey, if I keep doing this, I get a chance to play with a Hall of Famer."

To be a San Francisco Giant the way Buster showed us? He just does the work every day. There is no complaining. He does his job, and he's quiet about it. He's not showboating out there. There's just something different about it. I've gotten to be around Ryan

Vogelsong and Matt Cain, and you get to see why they won. I think that starts with Buster.

And I honestly feel like that's the main reason we won in 2021. And I think it'll keep going, because I feel like it's just embroidered into the organization: This is how we do things. This is how we go to work every day. And he's the poster child for that.

When I finally met him in spring training in 2019, I introduced myself—and, yes, I was incredibly star-struck.

I was nervous to even talk to him. And he's so nice, so helpful. He's always been like that, and finally I saw it in person. I finally threw to him in a big league game in my third start, on August 31, 2019, against the Padres at home.

He has a presence back there. When he's back there, it gives you more confidence. You don't want to shake, because you feel like, *He's gotta be right on this one. He has to know something.* He'll look at the hitter, take his time, and then he'll put one down real quick and then say, "Okay, let's go." Like, this just gives you that little bit of extra confidence.

And he told me that. He says, "You have to have the same confidence I have in your stuff, and believe in it." And I think it just helped me. I don't know how else to say it—it helped me so much. It was incredible.

It's funny, because I would shake him off every once in a while, and sometimes he would put the same pitch down. I'm thinking, *Okay, he must want this pitch.* So I throw the pitch, and it's always good.

And then I would shake him off sometimes, and then I give up a big hit, and I think, *Oh my God—I feel so bad.*

But he'll be the first one to say, "Hey, it's all good. Be confident in your pitches." And I think it was just that quiet confidence that he gives, and he makes the pitchers have that same quiet confidence. And I feel like that's something that I will use forever.

During pregame meetings, it was cool for me, because you get to hear what he has to say. So I'll say, "Hey, I wanna throw this pitch to this guy." And he'll look at you and be like, "No, no, no, no, no, no, no, we're not throwing that today." And I'll just say, "Okay." I'm happy, and he's right.

It's crazy. He's right all the time. And that's just how amazing, how confident he was in himself and what he believed was right. That goes back to that "being a San Francisco Giant" thing, because our team kind of had that quiet confidence—that confidence to be amazing and to do great things—and he exudes that.

Before Game 1 of the 2021 NLDS against the Dodgers at home, he came up to me and said, "Do not change a single thing that you've done for the last three months. Don't try to throw different pitches—don't try to be different. Do exactly the same thing. The hitters will try to change their approach because it's the play-offs. Guys want be the hero. You need to be yourself—you need to attack their zones with strikes."

And that calmed me down.

I think he saw, warming up before Game 1, that I was nervous. He slowed it down, took his time to throw it back. And, thinking back on that, he did that for a reason. He did that to show me, "Hey, it's gonna be all right." He did the same in Game 162, where I was super nervous again. He'll clap his mitt, or he'll say, "Calm down" or give the flat palms—I'm sure he did that multiple times.

I'll remember that forever.

In the first inning of Game 1, Mookie Betts singled to start the game. They had a runner on second with one out, and here come Trea Turner and Justin Turner. And he didn't change the game plan at all. Some people might be like, "Okay, let's try and go for a strikeout." Nope. Buster kept with the game plan. I was like, "Holy cow, I don't have to do anything extra here."

When we got to Game 5, I was saying, "Hey, maybe we should throw more sliders this time." And Buster said, "Nope. Nope, we're gonna keep going; we're gonna keep attacking; we're gonna do exactly what we did in Game 1." And we did it again.

Remember how I was telling you about how he said "Don't change a thing"?

When he hit the home run off Walker Buehler in the first inning of Game 1, if you would've told me that guy was gonna retire four days later or five days later, I would have been like, *There's no way.* We just knew we were going to win the game at that point. That's just Buster Posey.

Now, when I look back and see the video of him looking out at the crowd after Game 162, taking it in, you can see it. You can see it in his face—he just got his little grin. I went up to him after the game, and I gave him a big hug, and I'm like, "Hey. Are you gonna come back next year? Am I gonna see you next year?"

And he just said, "I don't know."

I think he gave everything he had.

I'm very sad he's not coming back—more for the friend part and having him as a teammate and seeing him every day in the clubhouse. But I'm excited for him. I'm excited for him to be able to spend time with his family.

I don't really think I ever thought about him retiring, because I was trying to be in the moment. When you're playing with someone special like that, you can't be thinking sad kinds of things.

I believe I will be able to use what I learned with him for my entire career. He's always one phone call away. So if I ever need anything, I can call him and say, "Hey." I know he'll be watching, so when I feel off, I might shoot him a text and say, "Hey, what'd you see?"

And he'll tell me straight up.

I feel like I can carry on what he taught me, because I was able to play with him. And not just him. We have Brandon Crawford, lots of special guys. Some of the younger guys that come up in the next two, three years, they didn't get to play with him and see how a San Francisco Giant is supposed to play. But they are San Francisco Giants, and I hope I can give as much as I can to try and show them that way to play.

I hope I can.

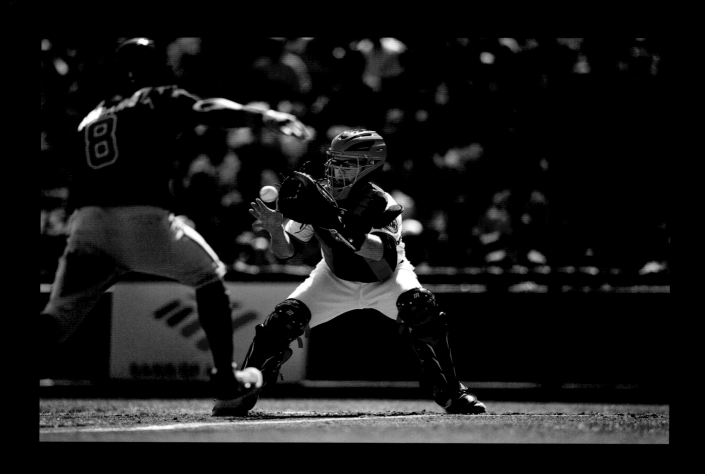

ABOVE: Preparing to tag out Eddie Rosario of the Braves at home plate, San Francisco, 2021
OPPOSITE: Batting against the Braves, San Francisco, 2021
OVERLEAF: Circling the bases after blasting a two-run homer to left field against the Dodgers, San Francisco, 2021

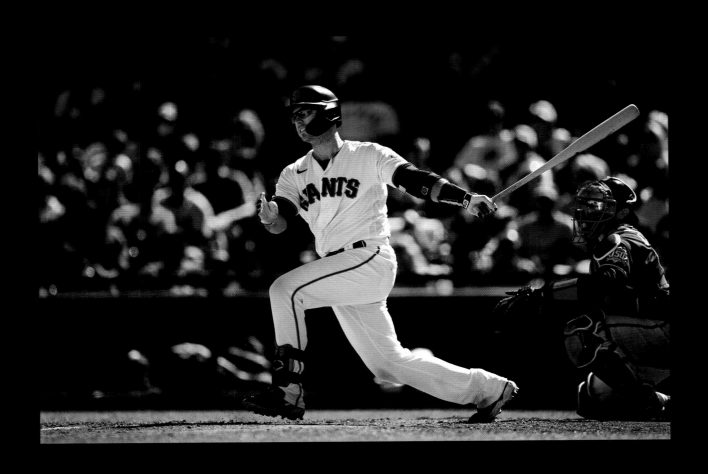

PAGES 186–187: "You're going to be hard-pressed to see another race like this for quite awhile," Buster said after the Giants beat the Padres 11–4 to win the National League West by one game on the final day of the season and notch a franchise-record 107th victory, San Francisco, October 3, 2021

PAGES 188–189: Dominic Leone gets a Buster hug after the Giants beat the Padres to win their 107th game of the season and clinch the National League West title, San Francisco, October 3, 2021

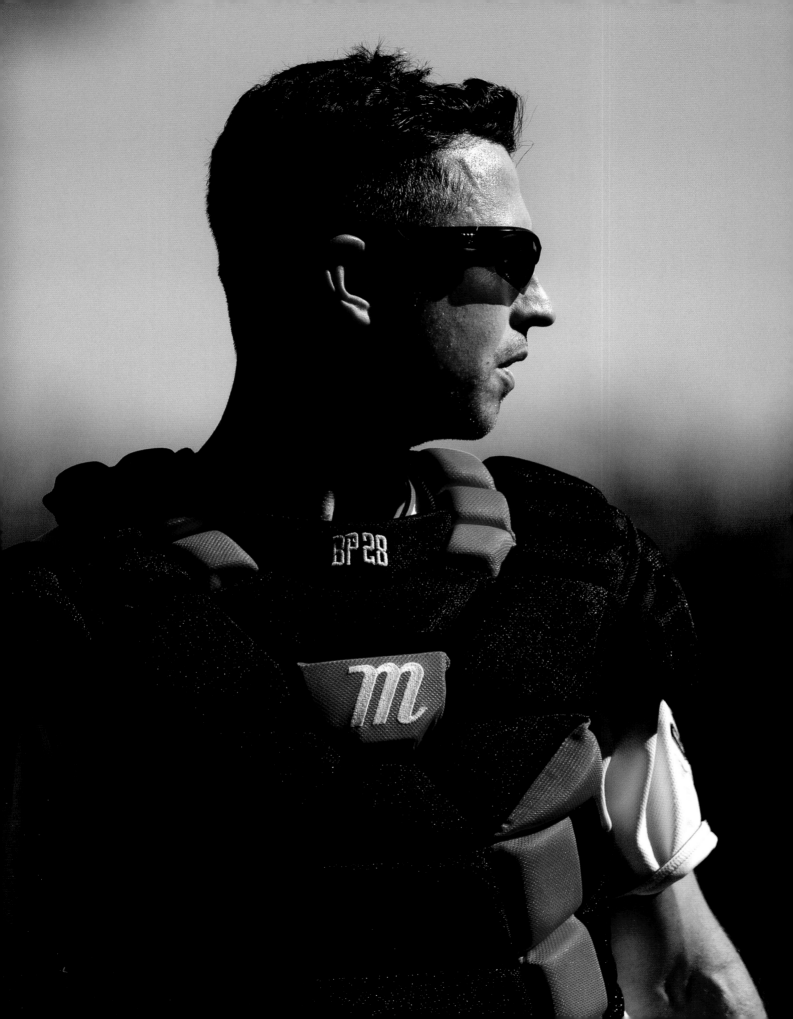

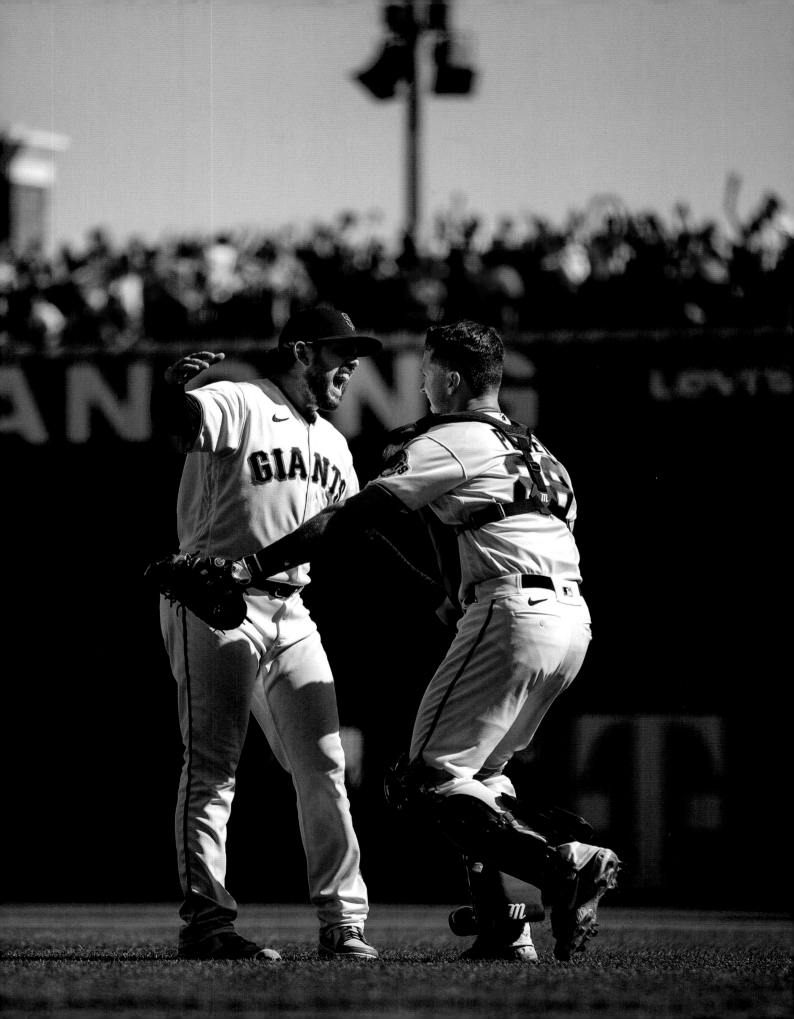

ORACLE

Fanatics

Adobe

HOME
RU

SAFEWAY.

PLAY
HAS NO
LIMITS.

50/50
RAFFLE $37,07

Adobe

AMERICA

399 KONICA M

PARK

coupa
BUSINESS SPEND
MANAGEMENT

Dignity
Health.

Blue Shield
of California

charles
SCHWAB

*Own your
tomorrow*

Coors LIGHT

MITSUBISHI
ELECTRIC
Changes for the Better

BANK OF AMERICA

VISA

PURESTORAGE PURESTORAGE

391

HIGH STANDARDS ▪ GABE KAPLER

MY FIRST real personal exposure with Buster was in the interview process with the Giants for the managing job in Fall 2019. He was the one player that Farhan had suggested I talk to. There wasn't anybody else.

The meeting was set up in my now-office. I sat down with Buster for an hour or maybe a little bit more, and we just chopped it up. I learned about him. He learned about me.

This is where I was first exposed to Buster as a listener and as a thoughtful human being. His job in that moment was to learn about me. My job in that moment was to help him understand that I could be a good partner to him and the rest of the organization.

I think Buster's excellent at vetting people and identifying good qualities in them and good leadership skills. I would do it in a very similar way if I was interviewing a candidate for a big position. I'd get Buster's perspective, and I would be asking for his feedback, because he really is that thoughtful and aware.

But there wasn't any one moment where I learned that about him. For me, at least, it doesn't work like that. It's consistency over a long period of time: Is this person the same? Does that intellectual curiosity and depth come day in and day out?

That's really what I noticed about Buster—from the day that I met him in 2019 to now, it's been quite consistent, and that is the most impressive part about it.

We got to spring training in 2020, and I noticed that his body was moving well. Before that, when I was managing the Phillies, I had noticed that Buster, as an opposing player, wasn't at his best. Now, I was getting a fresh perspective on a healthier Buster. His mechanics were in a good spot, and I think he was very driven and very motivated to be excellent in in the 2020 season.

Buster is a future Hall of Famer, but he's a human being first, so when the pandemic hit, I viewed his decision to sit out the 2020 season from that perspective.

I never had that moment where I thought, *Damn, Buster is not going to be available to the Giants.* It was more, *Buster has a very clear path to caring for and protecting his family, and that's what he's choosing, and we need to put aside our selfishness and support that.*

I applauded it. It's black and white. This is not to be self-congratulatory or holier-than-thou—I think we just are gonna put the people first.

And then I saw him at the ballpark in the winter of 2021, and he looked phenomenal.

He had clearly been working his ass off, and he added a layer of physicality that wasn't there in Spring 2020. Going into camp in 2021, he looked more agile and flexible, and his swing looked like it was in a good place. He was prepared to make mechanical changes and to dig in with our hitting coaches and to dig in with bullpen coach Craig Albernaz behind the plate, and he was an excellent leader, as you might expect. He had the attention of all the young catchers. Any time we were going through catchers' drills, people just stopped and listened when Buster started to talk.

That he bought into our approach as coaches—it was huge. Any one of the established veteran players could have thrown quite a bit of salt in the game of the coaching staff.

You need the veteran players, who the other players look up to, to buy into something a little bit progressive, a little bit new, a little bit different, or it can be really tough to get the entire group into that space, which is trusting and communicative. So yeah, Buster played a huge role. What we needed from him was to be a part of it, and he obviously stepped up and partnered with us.

I think it speaks to his growth mindset. There are times when Buster, at the beginning of a conversation, can come across as stubborn, and he believes what he believes, and he's not coming off of that position. But if you prove to him that you have a well-thought-out position on the matter, that you've done the work, and that you have a path to improvement, he's going to listen, and by the end of the conversation, he's going to come around.

And even if he doesn't come around in that conversation, I think he respects the work—and may come around another time if you're consistent and stay with it.

I think Buster sat back and waited to see what the coaching staff was going to do. And so, over a long period of time, I think we built trust with Buster and had to stay consistent, because he had such high standards. And he has such high standards through the finish line—the finish line being, in this particular case, the loss in Game 5 to the Dodgers.

We had a plan to rest him in 2021, and it helped that we won a lot of games when Curt Casali was behind the plate. That made the decision easier.

The biggest temptation was pinch-hitting. I have heard from a lot of veteran players that pinch-hitting is a major stressor. Every time Buster was not in the starting lineup, he was a really, really good pinch-hit option. So it took a lot of discipline to not have him pinch-hit, because the ramp-up to pinch-hit is not nothing. The physical preparation it takes to pinch-hit is not nothing.

Buster and I spent a lot of time talking about how to help his body recover best. And I mention this every time somebody asked me, "Was it dictated to Buster?" It was discussed with Buster—sometimes in my office, sometimes in a text message, sometimes on a plane, sometimes in a phone conversation—about how we were gonna manage workload.

And then, at the end of the season, when we decided to push him, that was also collaborative.

I don't think that we appreciated how athletic Buster really was behind the plate in 2021. We knew he was going to be a good defensive catcher, an excellent game caller. I think it was impossible for us to fully appreciate how athletic he could be at his age. And the best compliment that I can give Buster behind the plate in 2021 is that he looked a lot like J. T. Realmuto behind the plate in 2018 and 2019, and I saw J.T. as one of the more athletic catchers that I'd seen in my life. I saw Pudge Rodríguez in his prime, Jason Varitek of the Red Sox, and Will Smith of the Dodgers, and I have had exposure to a lot of other excellent catchers in my career, and he was right up there athletically, at his age, with all of that wear and tear, with some of the most athletic catchers I've ever seen. That was really eye-opening for me.

As far as his pitch-calling, there's no second-guessing happening because of who he is, his preparation, his intellectual firepower, and because he had more information at his fingertips than we did in the dugout. Even if we felt like a different pitch was the best pitch, at the line of scrimmage, with everything on the line, are you gonna question that play call?

No, because the preparation is second to none, the curiosity is second to none, and the vantage point he had in the stadium at any given time is second to none.

I think about Buster in the same way Tom Brady's coaches have thought about Tom over the years. I'm guessing there are a lot of similarities there.

I thought that relationship with Buster, our coaching staff, and our pitchers developed beautifully over 2021 and was at its peak in Game 5 of the NLDS. We could not have asked for a better called, caught, or pitched game than Game 5 of the Dodgers series. That was exactly as we drew it up, and we exceeded what we would have found to be just an excellent start by Logan and a beautifully called game by Buster.

And that Buster home run in Game 1—the more distance I get from those moments, the more I appreciate them, and that's largely because the sting has subsided. So yeah, I can now appreciate the season—and that moment, and moments like it, as some of the most important moments in Giants history.

When Buster called me and said that he was going to retire, it was 1,000 percent support. He made this decision to care for his family. That's everything. There doesn't really need to be more said than that.

But it is tough, because he's a huge piece of what we accomplished in 2021, and it is an impossible void to fill. It will be a great challenge, and we're very excited about meeting a different kind of bar, but there's no sugarcoating: It's gonna be tough not having that presence in various capacities.

I don't think our conversations are going away. I'm still going to be leaning on Buster for perspective. They might not be as frequent, but I think Buster is still going to want to contribute to our organization, to our clubhouse, and to the success of the 2022 Giants.

And I'll be seeking out those conversations. And I know Buster will be active in wanting to participate.

PREVIOUS SPREAD: Rounding the bases after hitting a towering home run to right field to help beat the Dodgers 4–0 in Game 1 of the NLDS, San Francisco, 2021
OVERLEAF: Kristen and Buster Posey speak to the media at his retirement press conference, San Francisco, November 4, 2021

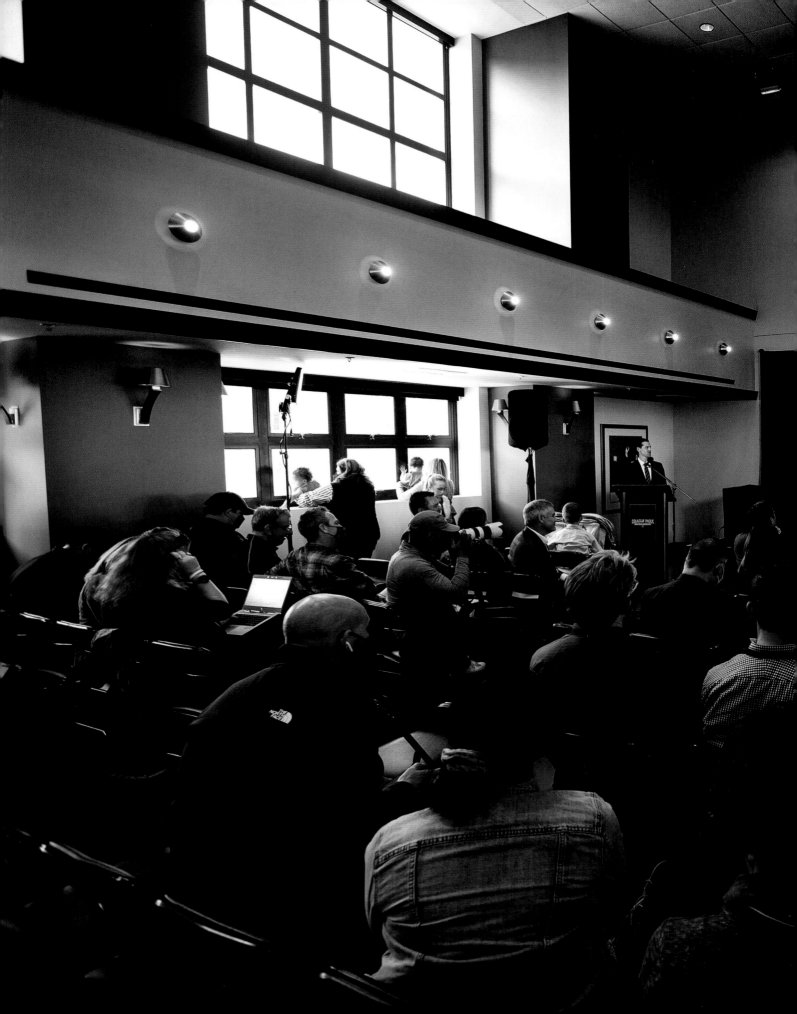

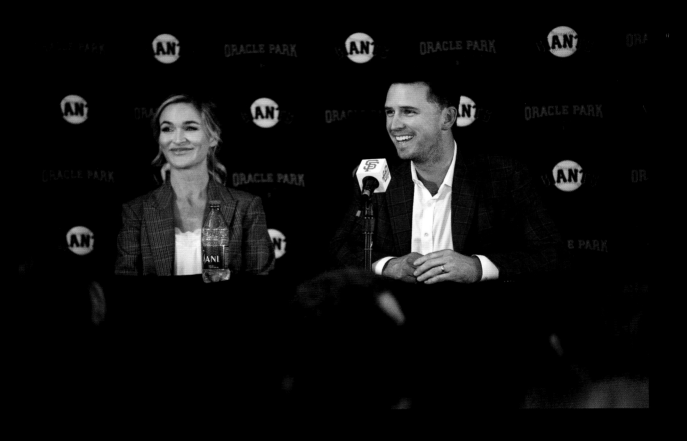

ABOVE: Kristen and Buster Posey at his retirement press conference, San Francisco, November 4, 2021

ABOVE: Buster reacts after his retirement press conference, while Kristen holds their daughter Livvi, San Francisco, November 4, 2021

AFTERWORD ▪ MIKE KRUKOW & DUANE KUIPER

DUANE KUIPER: We found out that the Giants had drafted Buster Posey when we were on a plane to Washington, DC, for a road trip.

The 2008 MLB draft was going on, and everybody wanted us to take Buster. But we weren't quite sure if we could. Tampa had a shot to take him, and because Buster went to school in Florida, and he's from the South, there were thoughts. But once we found out that it was indeed Buster, it was great.

The first time I saw him, I thought, *This is the all-American boy.* Just with his haircut and the way he wears his uniform, and the way he carries himself and the way he walks around—shoulders held high, chin held high—you could see that he was a proud guy.

When he got called up in September 2009, you could see that he just wasn't gonna say much. He was just gonna take everything in. He just wanted to get himself ready for when the time came when he was gonna be there all the time. And, of course, that came the next year.

But when he did say something in 2010, everybody stopped and listened, because he wasn't going to waste any time with small talk. He was a leader right off the bat. As soon as he put that uniform on, you could tell he was gonna be a leader—and he was gonna be a leader every day that he wore that Giants uniform. And it was a thrill for us to be able to watch him.

MIKE KRUKOW: We didn't really get a real good insight until 2010. I'll give you one story: Aubrey Huff could say some things that were a bit outrageous. So, we're standing around the batting cage at batting practice, and I don't think Buster's got three months in the big leagues. We're around the cage, and then Huff says something outrageous, just outrageous. It was quiet—we're just kind of letting it all sink in.

And Buster, standing around the batting cage, just quietly says, "That from a guy that's got *Transformers* tattooed on his back." And everybody laughed.

If you ever saw Huff coming out of the shower, on his back he had two *Transformers* tattoos. Why would a grown human being have *Transformers* things on him? They were about the size of a hardball, and he had two of them. But Buster, here's a rookie saying that to a veteran, and the response from everybody around there—you know, most veterans are little sensitive if the rookie's

getting on a veteran, but it wasn't the case with Buster.

My point is, the perception of him as an old soul in that clubhouse came very early on. Very early on, he was the chapel leader, and that doesn't happen from a young player. But I saw those things, and I realized that he was an old soul. He was having a presence, and we didn't know how deep it was until the end of that season.

When the Giants traded Bengie Molina in the middle of that 2010 season, it was another great example of just how special Buster was. When you are putting together a run—and we could sense that the thing was coming together—the last person you're gonna trade is an established veteran catcher, because you can't have enough leadership going down the last couple months and into the playoffs. You can't. And the catcher is the catalyst in so many ways: he runs the field, he channels the pitching staff. To give the keys to the new kid on the block, that just doesn't happen.

But Bruce Bochy realized that he had a leader coming up. He had a guy that prioritized winning more than anything in this game. Bochy talked about this in spring training. He said, "This kid's special in that regard."

So, you go into the middle of the 2010 season, and you're about to make a run, and if you think about the courage that you as a general manager, and the courage that you as a manager, have to have to be able to make that call—to not only replace the guy in his position but also to trade him out of the organization. And I don't know if that's ever happened. I can't remember it happening in baseball history. That's how significant it was.

KUIPER: I remember when Bengie was traded, the Giants were flying to Denver. And I was sitting on the bus right next to the airplane after we all got off the plane, and everybody started to go over and hug Bengie. That's when we all found out that Bengie had been traded.

But also, part of that trip was the Milwaukee trip. The Giants went from Denver to Milwaukee, and that was the trip where Buster Posey was designated the everyday catcher. And in a stretch of four games in Milwaukee, he probably had the best four games in a row that he ever had in his career. Buster went 9-for-15, with four home runs, nine RBI, and six runs scored. So, that's a pretty good first impression to make as the everyday catcher.

You know, you can never make a second first impres-

sion. And that was the beginning of their push to try to catch the Padres.

KRUKOW: And it was seamless. It just flowed. And this kid took over and took complete control of that pitching staff. And it was one of the more remarkable things that we had ever seen. We talked about it when it was happening, because we were skeptical. We loved this kid—we thought he was going to be great—but to take away the presence of Molina and trade him out? That just didn't happen. And then, the way he responded was something that I'll never forget.

And when that whole run got made, I'll never forget when they beat the Phillies in Game 6 in Philadelphia, and they were going to the World Series. That night, we all celebrated at the hotel back in Philadelphia. And it was deep morning—it was 4:30 or so—when Jennifer and I said, "It's time to go back and get some sleep." We were heading up, and lo and behold, we get in the elevator, and here's Buster. A couple other guys were in there, so there's five of us going to our rooms. And as we started it up, I just said, "Hey, enjoy this time. It doesn't happen very often." And Buster looks at me, and he goes, "Why not?" And I didn't have an answer for it. But I did just think, *This is a clear example where this guy's coming from.*

KUIPER: In May 2011, he was in that collision with Scott Cousins of the Marlins, and it ended his season. First of all, it was totally unnecessary, and it was uncalled for. And I'm glad that they changed the rules.

That game and then the very next day—the two quietest days that I've been associated with at Oracle Park were the game after Buster got hurt and the game that Melky Cabrera got caught flunking a drug test. Those were the two quietest games from our fans and in our broadcast booth, because we were all in mourning. We played a game—and I don't remember who it was against—and then we got on a plane to go to Milwaukee. And there was definitely a void. Buster Posey was not on the plane.

KRUKOW: Well, it was the way the game was played, and Scott Cousins was the twenty-fifth man on the team, and every time he got on the field, he was playing like this was going to be his last game. And when he came in and took Buster out and leveled him, I don't think Buster had ever been hit like that, because he really didn't put himself in a position to protect himself. There's a trust that you think, *A guy's not gonna blow me up.* That was just inexperience. This kid came in there and just crushed him, and we knew immediately this was serious. And it really could

have been a career-ending injury. And as we found out years later, talking to his wife, Kristen, that bothered him, really, for many years after the injury.

When you come back from an injury like that, you don't know if you're gonna be able to come back and if you're gonna be the same player. You don't. It sits there in the back of your mind—it's something you don't even talk about as an athlete when you're going through it. When you get back on the field, it's a test every day. But the mental toughness that we saw from that guy in 2012 inspired everything.

I think that was the catalyst for that mental toughness that 2012 team had, and they were tough. Their mental toughness was their edge, because they were the underdog in every series that they played. But I do believe that the core of that mental toughness was Buster. And I don't know if he ever even talked about it. He just led his comeback by example, and everybody pulled for him.

KUIPER: The remarkable thing about his comeback in 2012 was to come back from an injury like that, a really bad one, and to have to do it as a catcher. You're putting a lot of stress on that ankle when you get into a squat, and you do it every day. I know he didn't play in all of them, but he played in a lot of them.

So he came back with a chip on his shoulder. He ends up being Comeback Player of the Year. He ends up being MVP. He ends up with his batting title. All of those things were pretty remarkable when you consider the type of injury he went through.

KRUKOW: The vengeance that he brought back into his game in 2012 to lead the league in hitting and be an MVP—it just burned inside of him. This game that he loved had been taken away from him because of an injury like that.

By 2014, this was their prime. All these guys were in their prime. And they weren't necessarily the favored team in any of those postseason series going in. But the expectations within that clubhouse were solid. They had expectations because of the success that they'd had in 2010 and 2012, because of where they were in their careers.

That clubhouse, it was amazing. You walked in there; you could feel it. And when they got into this run, it was quite remarkable. Think about the Wild Card Game in Pittsburgh. And then the eighteen-inning game in Washington. And the Cardinals series—come on!

And then on to take on the Royals, and nobody really thought that they had a chance because of the Royals' bullpen, because of the vibe they had going. It was a very powerful dynamic coming out of Kansas City.

And the Giants took a 3–2 series lead going into Game 6 back in Kansas City, and then they just get their ass handed to them. And after that game, the one thing that I will never forget was that it was no big deal. The fact that they got beat so badly, it didn't make a difference. They focused right into the seventh game, and they never doubted they were gonna win that game. Never doubted. And the centerpiece of this was the catcher. He was just business as usual: We're gonna win. And the consistency of vibe coming off of him was calming in so many different ways—not just to the guys wearing numbers on their back, but also to all of us who surrounded the entourage as well.

And there was a very solid confidence that we all had going into that game, and then, when he went out there at the end and he bear-hugged Madison Bumgarner, the exhaustion of both guys—arguably, when they came up together in 2009, you could say that's one of the best pitcher-catcher combinations in the history of the game. And here they were, just completely spent in each other's arms. That said it all. It was a picture truly worth a thousand words.

KUIPER: The thing I remember a lot about that night was how exhausted he was, and it really affected him at the plate. He really wasn't himself at the plate. He was exhausted. And I don't think it was a Buster hug at the end of Game 7. I think it was a Buster collapse. I think he was so far out of gas that he needed somebody to fall into.

But those two were on the same page—all the time, but they were especially on the same page that night, especially in the 9th inning, especially in the at-bat to Pérez. Buster was not going to allow Bum to throw anything inside and anything off-speed. He was just going to go at him with fastballs and take their chances. And that's how it ended up.

The clubhouse celebrations are always unique, because the families are in there, and the champagne is falling. I remember Buster said to me, "This is the best one." And I don't know if he means that now, but at that given time, when you think about what that team went through to get to that last inning, I can see how he would have said, "This is the best one."

KRUKOW: By the later part of the 2010s, he had a labrum tear in his hip. That's like a labrum tear in the shoulder. You can go on, but you ain't gonna be the same.

He'd lost his foundation. He wasn't turning on the inside pitch. He was serving dead birds to right field and a bunch of ground balls through the hole—that's how his average was staying alive. He did that on brains. But so many times, the swings that he was taking, there was no lower body there. His skills were eroding because his body was not allowing him to be himself.

And then, when we saw him going into 2020 in spring training, it was like, *What has happened to this guy?* He's spinning on the inside pitch. That hip healed. He had skills back.

He took 2020 off for COVID-19 and his family, but in retrospect, had he been there in 2020, they would have gone to the playoffs. They made a run without him. Had he been there, it would have been different. They had a rookie catcher, Joey Bart—he wasn't ready. If they had Buster behind there, that's at least a five- or six-game difference, and they'd have walked into the playoffs.

KUIPER: The hard part for us as broadcasters is that when we see a guy struggle, we don't really want to make excuses, because we as players tried not to make excuses. But the fact is, he was hurt, and even though we tried to point that out from time to time, I don't think our fans really understood how badly he was hurt and what it took for him to get on the field with those two or three years you were talking about. So, when he came back and was healthy in 2020, before COVID-19 hit, it was a sign that he had a shot to really come back and have a great year.

Of course, it got wiped out. But then, in 2021, he really did come back, and oh boy.

KRUKOW: In 2021, he's got the lower-body foundation, and he's back. And he's hitting the inside pitch, staying inside the fastball, with his hands, at 97 mph and hitting it out the ballpark, or hitting it to the gap. He had his legs back. He just looked like he had set the clock back six years, and it was inspiring. And the way they managed him was different—he didn't play first base on days off. And I think that had everything to do with him having a consistent season and staying healthy and strong all the way through the season.

I had thought his skills were gone; I had thought his lower body had left the building. And for him to be the Comeback Player of the Year for the second time in his career, to watch him do it—it was so cool.

And it enabled him to say, "I'm leaving this game under my terms. There isn't a doctor telling me that I can no longer play this game. I'm going out because I want to, and I did it on my terms. And I left the game, and I was an All-Star, I was a Comeback Player of the Year, I was a catcher on a team that won 107 games."

Who gets to ride off in the sunset? Him and Ted Williams.

KUIPER: Yeah, I checked all the boxes the day he retired. I was emotional when I found out. And then I was hacked off at him for selfish reasons. And then, like Mike, I was really happy for him, because he got to make the call on his own.

I don't think he's ever gonna regret his decision. He might think a little bit about it when spring training starts, but the bottom line is that he's definitely going to miss it. But in his mind, he made the right decision, and we're really happy for him.

KRUKOW: He went out on top; I thought that was just extremely cool.

Kuip and I have talked about it with Jon Miller and Dave Flemming. We don't think that Buster's peaked out with personal accomplishment. I think he's gonna be a difference-maker. And I say this because Kuip and I were asked by Buster to host the BP28 dinner, which raised money for the Cannonball Kids Cancer Foundation at UCSF Benioff Hospital. And we watched him and Kristen, the way that they embraced their commitment to raising money for children's cancer. They were hands-on. He would get to the ballpark early to meet kids, he'd go to the hospital, he'd go to the children's wards. You didn't hear a lot about it. And Kristen was tireless in her work with the foundation.

They've inspired Jennifer, my wife, and me—we're involved with the Northern Nevada Children's Cancer Foundation up here, and Kristen has flown here during the season and attended fundraisers. They're really involved with this. And I think that as he's gone from what we believe is a Hall of Fame career as a player, we think he's gonna do something as admirable and meaningful in the private sector. We don't know what it is—we don't know what it will be—but we just sense that it'll be something big and very meaningful.

Think about his career. One of the most difficult things in any profession—the entertainment world, the athletic world, just the world in general—is when you come up as the golden child, you're labeled with potential. It's slapped around your neck. And then he goes on to Florida State and becomes the best player in college baseball—potential, slapped around his neck. And then he walks into professional baseball, and his presence is felt almost immediately.

In his career, he justified the label of potential. He realized every dream that he could possibly have dreamed as a player, and his career, from the first day to the last day, is completely laden with accomplishment and awards and championships.

And I don't know too many athletes that have been able to consistently put up accomplishments every year that they've been in the game and been able to realize all the potential—and he justified everybody's expectations. And some of the most difficult expectations to justify are the ones coming out of your small hometown in Georgia. And you think about all the people who anticipated, expected, and then applauded the accomplishments that he justified.

And I think that's the thing: I look back on his career, and I just shake my head, and I'm absolutely in awe of it because of what he did, how humbly he received the accolades, and how quick he was to dish out praise—not from him, but to his teammates and his organization. He was just one of a kind.

KUIPER: When first time I saw him, I said, "You look like the all-American boy." And when he was speaking at his retirement gathering, he still looked like the all-American boy.

And from September 2009 to a press conference in 2021, where he's retiring—name somebody that did more in that stretch than he did. I'm sure that there are people out there that can come up with four or five names, but in that ten-year stretch, it's pretty remarkable what he accomplished and what his team accomplished. And as far as I'm concerned, he's the one that got them to the top of the mountain. And he's the one who helped them stay there.

BP28 ▪ KRISTEN POSEY

I**T ALL STARTED** when I read a story on the Internet that a woman named Melissa Wiggins had shared about the cancer journey she and her husband were experiencing with their young son Cannon. Cannon had been battling cancer since the age of two, and he was then four, the same age as our oldest twins at the time. Addi and Lee could have just as easily been Cannon. The Wiggins family could have been our family. I reached out to Melissa, one mom to another, and after hearing about the Wiggins family's experience with various treatment options (or lack thereof), financial hurdles, and the toll it was taking on their family, I felt sadness, anger, and frustration—and that we needed to try and do something about it. I told Buster that this is not right; this little guy should not have to be going through the types of cancer treatments and procedures that are designed for adults. I knew we were blessed to not only have healthy children but also a platform, created by Buster's profession, to make others aware of the need to raise awareness and funds for pediatric cancer treatment and research. I wasn't sure how we would do it, but I knew we had to do something!

In partnership with the Giants in 2016, Buster and I formed BP28 to support the families, just like the Wiggins, who deal with the reality of childhood cancer every day. In addition to visiting with kids in the hospital, we strive to raise awareness and much-needed funds for pioneering research and treatment in hopes of changing the outcome for these kids.

We started meeting with families of children who had undergone treatment at local Bay Area hospitals and began learning about their experiences navigating a whole new world of doctors and treatments and their side effects. We felt their fear, their anxiety, their grief. But we were deeply moved by their unwavering hope for a treatment that would save their children.

As we learned more, we were shocked to discover that only about 4 percent of cancer funds raised in the United States go to pediatric research. Yet as we became more deeply involved, we were heartened by the tremendous progress being made through the pioneering efforts of many brilliant physician-scientists around the country who have dedicated their lives to research. We began hosting our annual fundraising event, the BP28 Gala, at Oracle Park, to get these researchers the funding they need to be successful. Through the generosity of so many community members, Giants fans, and partners, BP28 raised over $4 million between 2016–2021 for groundbreaking research into safer and more-effective treatments for childhood cancer.

While most people only know Buster as a baseball player, he is one of the kindest and most generous people I know. He's always thinking of others. Baseball has provided us with this unique platform to help, yet this isn't about us; we're not looking for a pat on the back. The most rewarding thing for us is that the funds that we've helped raise could possibly create better options for these young patients, or perhaps save a child's life. And it's always special to see young faces light up when they meet Buster.

BP28.ORG

OPPOSITE, TOP: Buster plays ball with children at Family House in San Francisco, 2017. *Photo by Michael Urakami/SF Giants*
OPPOSITE, BOTTOM: Kristen and Buster Posey host their annual BP28 Gala at Oracle Park in San Francisco, 2019. *Photo by Stacey Pentland*

CONTRIBUTORS ▪ BIOS

BUSTER POSEY

is a former catcher who spent the entire tenure of his twelve-year career with the San Francisco Giants. He was the 2012 National League MVP and is a seven-time All-Star and a three-time World Series champion. Along with his wife, Kristen, he is a cofounder of BP28, a charity that aims to change outcomes for children with pediatric cancer.

BRAD MANGIN

is a freelance sports photographer based in the San Francisco Bay Area. He shot his first San Francisco Giants game in 1987 for the *Contra Costa Times*. Mangin worked for legendary sports photographer Neil Leifer as a staffer at the *National Sports Daily*, shot ten *Sports Illustrated* covers, and photographed twenty World Series. He donated his archive of over 120,000 baseball photographs to the National Baseball Hall of Fame and Museum in Cooperstown, New York. Previously, Mangin and Brian Murphy coauthored *Worth the Wait* (2010), *Never. Say. Die.* (2012), and *Championship Blood* (2014). Mangin also published *Instant Baseball: The Baseball Instagrams of Brad Mangin* in 2013. He lives in Pleasanton, California, with his cat, Willie.

BRIAN MURPHY

is the cohost of the popular *Murph & Mac* morning show on KNBR 104.5/680, the flagship of the San Francisco Giants. Prior to joining KNBR in 2004, Murphy was a sportswriter for fifteen years for the *San Francisco Chronicle*, *San Francisco Examiner*, *Santa Rosa Press Democrat*, and *Los Angeles Times*. He coauthored *Worth the Wait*, *Never. Say. Die.*, and *Championship Blood* with Brad Mangin. Murphy has also written *The San Francisco Giants: 50 Years*, *San Francisco 49ers: From Kezar to Levi's Stadium*, and coauthored *The Last Putt: Two Teams, One Dream, and a Freshman Named Tiger*. The UCLA graduate lives in the North Bay with his wife, Candace, and two sons, Declan and Rory.

MATT CAIN

is a former professional pitcher, spending all thirteen seasons with the San Francisco Giants. He is a three-time World Series champion and a three-time All-Star, and on June 13, 2012, Cain pitched a perfect game. In 2018, a year after his retirement, Cain was inducted into the San Francisco Giants Wall of Fame.

BARRY ZITO

is a former professional pitcher who pitched fifteen seasons in MLB, seven with the SF Giants from 2007 to 2013. Zito is a two-time World Series champion, a three-time All-Star, and the recipient of the Cy Young Award in 2002.

SERGIO ROMO

is a professional pitcher who finished his fourteenth season in MLB in 2021, and pitched from 2008 to 2016 as a Giant. Romo is a three-time World Series champion and was an All-Star in 2013.

HUNTER PENCE

is a former professional outfielder who played fourteen seasons in MLB, from 2012 to 2018 and 2020 as a Giant. Pence is a two-time World Series champion and a four-time All-Star. Since his retirement in 2020, he has started a coffee brand called Pineapple Labs with his wife, Alexis.

BRUCE BOCHY

is a former professional baseball player and was manager of the Giants from 2007 to 2019. He is a three-time World Series champion and won MLB's Manager of the Year Award in 1996. At the time of his retirement in 2019, he was one of only eleven managers in MLB history with at least 2,000 wins.

OPPOSITE: Opening Day, San Francisco, 2012

BRANDON CRAWFORD

is a professional shortstop that has spent eleven seasons with the San Francisco Giants. Crawford is a two-time World Series champion, a three-time All-Star, a four-time winner of the Gold Glove Award, and a two-time winner of the Wilson Defensive Player of the Year Award. He has also represented the United States at the FISU World Championship and the World Baseball Classic, and in both appearances, he won gold.

LOGAN WEBB

is a current pitcher with the Giants who was drafted out of Rocklin High School in 2014. He made two starts in the 2021 NLDS vs. the Dodgers, winning Game 1.

GABE KAPLER

is a former professional outfielder and the current manager of the San Francisco Giants. In his twelve-year MLB career, he became a World Series champion in 2004. Kapler, the successor of Bruce Bochy, won the National League Manager of the Year Award in 2021.

MIKE KRUKOW

is a former pitcher for the San Francisco Giants and is currently a color commentator and radio and television broadcaster for the Giants on NBC Sports Bay Area and KNBR, alongside his former teammate Duane Kuiper. Krukow was an All-Star in 1986, and in 2016, was inducted into the San Francisco Giants Wall of Fame. Krukow is a thirteen-time Emmy Award winner.

DUANE KUIPER

is a former second baseman for the San Francisco Giants and is currently a television and radio play-by-play broadcaster for the Giants on NBC Sports Bay Area and KNBR, alongside his former teammate Mike Krukow. Kuiper is a thirteen-time Emmy Award winner.

KRISTEN POSEY

is a cofounder of BP28 alongside her husband, Buster. The Poseys have raised over $4 million since 2016 in their endeavor to improve outcomes and raise awareness of pediatric cancer.

ACKNOWLEDGMENTS

THIS BOOK would not have happened without the support of Kristen and Buster Posey. Having them behind this project and being able to support BP28 means the world to me.

Matt Cain, Barry Zito, Sergio Romo, Hunter Pence, Bruce Bochy, Brandon Crawford, Logan Webb, Gabe Kapler, Mike Krukow, and Duane Kuiper took the time to share their Buster stories with us. Thanks to all of you.

Shana Daum and Tess Oliphant of the San Francisco Giants and Marissa Dishaw of CAA Sports were invaluable behind the scenes.

It was so cool that my good friend and coauthor, Brian Murphy, decided to work with me again. There is no one I would rather author a book with than Murph. I can't believe this is our fourth book together!

Thanks to publisher Chris Gruener, managing editor Jan Hughes, editorial assistant Krista Keplinger, and designer Iain Morris from CAMERON + COMPANY for pulling this book together in record time. I have worked with Cameron on so many books that I have lost count. This crew in Petaluma always has my back. I will never be able to thank them enough for all they have done for me.

Huge thanks to Kit Vogelsang of the Topps Company for granting us permission to use the Buster Posey baseball cards.

Nate Gordon and Cindy Li of the Players' Tribune were very gracious in allowing us to publish the Brandon Crawford essay.

Maxx Wolfson, Michael Klein, and Carmin Romanelli of Getty Images were huge supporters of this book. You were all there when I needed you.

Thanks to *Sports Illustrated* picture editors Steve Fine, Maureen Cavanagh, Matt Ginella, Nate Gordon, Brad Smith, Marguerite Schropp Lucarelli, Chris Chambers, and Erick Rasco for assigning me to shoot so many Giants games over the years. Being able to photograph baseball for the magazine since 1993 has been a dream come true.

Thanks to Giants team photographers Suzanna Mitchell and Andy Kuno for making Oracle Park such an amazing place to work. Matt Chisholm, Maria Jacinto, and the rest of the Giants media relations staff make covering the Giants a pleasure. Club executives Mario Alioto, Staci Slaughter, and Russ Stanley have always been there when I needed a favor.

My dad, Al Mangin, would have loved watching Buster play ball. My sister, Paula Mangin, helped make me a Giants fan. Joe Gosen taught me how to take pictures and how to juggle. Kirk and Teri Reynolds are always there when I need them. The Duffy family—Cathy, Tom, Erin, Matt, and Rachael—adopted me when I needed a family. Elizabeth and Eric Risberg have been such amazing and loyal friends for so many years. Jean Fruth is always there to make me an amazing pizza when I need a friend. Rick Swig brings out the kid in me when he treats me to a Giants game in his great seats. Matt Maiocco reminds me to always go to a game that you have tickets for, especially if it's a doubleheader against the Mets.

Last, but not least, Michael Zagaris has taught me how lucky we are to spend our life being around the game we love, meeting great people, and witnessing history.

—BRAD MANGIN

MY PRIMARY THANKS goes to the guy on the cover of this book; the one with the sweet swing.

Buster Posey was always professional with us in the media during his brilliant career, but he went to the next level in granting us access and providing his thoughts on this book. Like all the teammates I interviewed said about Buster: the man's professionalism and excellence shines in all his endeavors. Thank you, 28.

Getting to talk to Barry Zito, Matt Cain, Hunter Pence, Sergio Romo, Logan Webb, Bruce Bochy, Gabe Kapler, Brandon Crawford, and of course, Mike Krukow and Duane Kuiper made this project nothing like work at all. It was so fun. Many thanks to each of you for your time.

Shana Daum has been with the Giants for decades now and has always been a terrific representative of the team. For this book, she rose to Buster-like levels of production. We truly couldn't have done it without her. I'm honored to work with Shana on the Giants Community Fund as well, where she helps us at the GCF do our best for the kids of Northern California, and I'm honored to work with her on this book as well.

Buster's CAA agent, Marissa Dishaw, was so helpful in getting the project going.

The crew at CAMERON + COMPANY has become a second family. Chris Gruener, who still hasn't fixed his iPhone avatar, is as stress-free a book boss as you'll find. Chris pushed us on this book idea the day Buster retired. Nice vision, my man.

Jan Hughes coolly and capably guided my text; thank you for never making me feel I was behind the timeline, even if I was! Her recommendation that I use the transcribing skills of Laura Warner was perhaps the most critical moment in the book's arc. Laura, you will receive MVP votes on my next writer's ballot.

And Iain Morris is the Brit who can't quit—being amazing at design, that is.

The boys at KNBR's *Murph & Mac* show—Paulie Mac, Adam Copeland, Markus Boucher—put up with my frazzled brain during the project and always kept me laughing. See you in the morning, dudes.

My warm and loving mom died in October, 2021, and this is my first book without her. I have a picture of her at the 2014 World Series. She looks so happy. Thanks, Mom, for all those bags of peanuts you bought at Safeway and gave to me any time I went to Candlestick Park.

And of course, on the home front, I "checked with" my lovely wife, Candace, and she forever remains my best teammate ever. We have two pretty cool prospects in the farm system, too: Declan and Rory, it is your generational obligation to keep learning your Giants history. I love you all.

The book wouldn't have happened unless my main man, Brad Mangin, my partner in crime and my coauthor on our *fourth* Giants book (!), willed it to happen. After all, we had to have a place to show off Brad's pictures, which are only the best in the world.

See you at Boyle Park, photog. You're the best.

—BRIAN MURPHY

COLOPHON

CAMERON + COMPANY

www.cameronbooks.com

PUBLISHER: Chris Gruener
CREATIVE DIRECTOR & DESIGNER: Iain R. Morris
MANAGING EDITOR: Jan Hughes
EDITORIAL ASSISTANT: Krista Keplinger
COPY EDITOR: Mark Nichol
TRANSCRIBER: Laura Warner
PROOFREADER: Christopher Cerasi

For more information, visit www.BusterBook.com

Photographs copyright © 2022 by Brad Mangin, unless otherwise noted
Photographs copyright © MLB Photos, page 10 (bottom), 46–47, 48, 49, 50–51, 53, 63, 74, 76, 77, 78-79, 82–83, 84, 116, 118, 119
Photographs copyright © Candace Murphy, 25; SF Giants, 202; Stacey Pentland, 202
Page 6: Topps® trading cards used courtesy of The Topps Company, Inc.

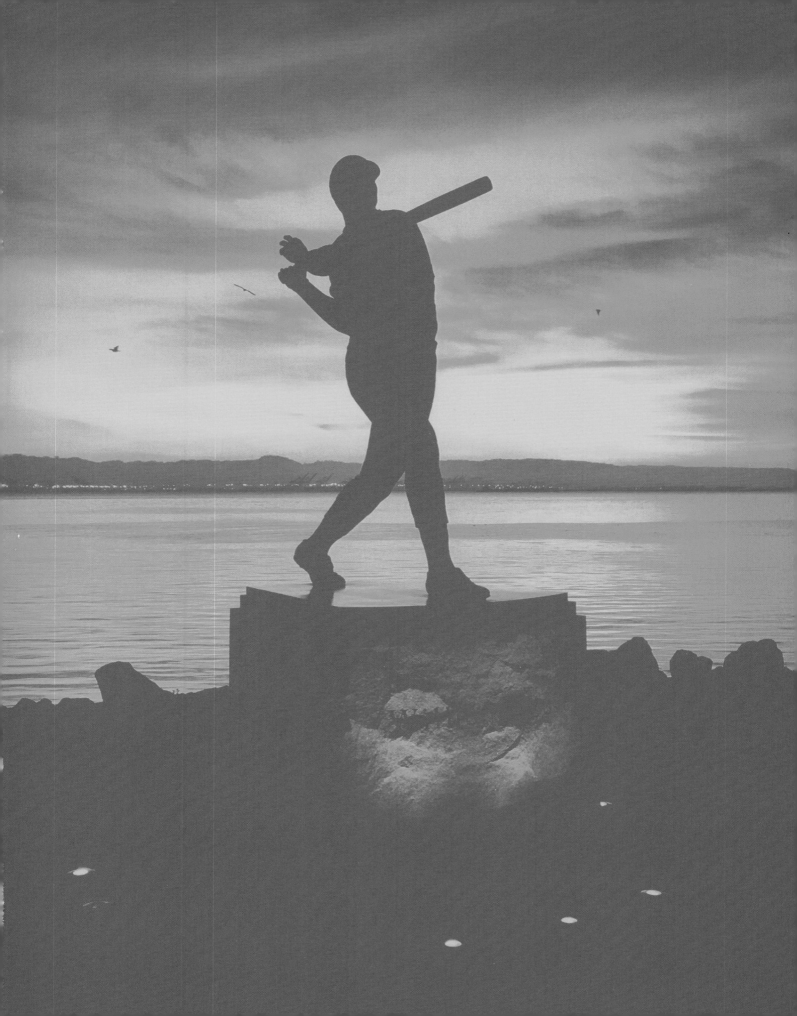